I AM PLASTIC

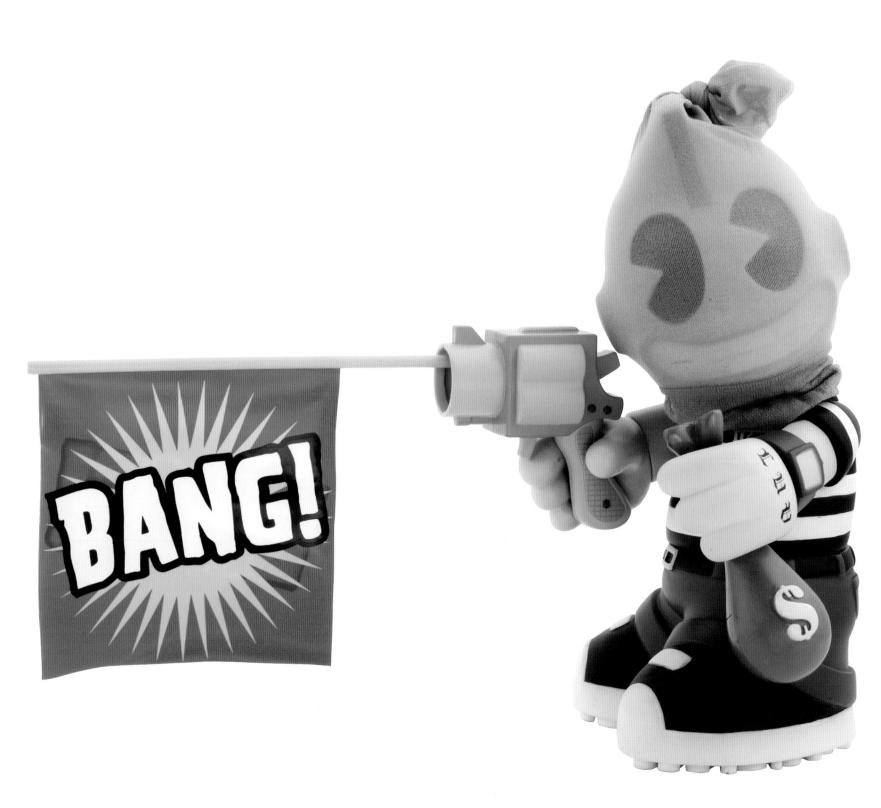

I AM PLASTIC

the designer toy explosion

paul budnitz

abrams, new york

Editor: Deborah Aaronson
Designer: Binocular, New York
Production Manager: Kaija Markoe

Library of Congress Cataloging-in-Publication Data
Budnitz, Paul.
 I am plastic : the designer toy explosion / Paul Budnitz.
 p. cm.
 ISBN 10: 0-8109-5846-5 (hardcover)
 ISBN 13: 978-0-8109-5846-3
 1. Plastic toys. I. Title.

 NK8595.2.T68B83 2006
 688.7'2—dc22

 2006005834

Published in 2006 by Abrams, an imprint of
Harry N. Abrams, Inc.

Printed and bound in China 10 9 8 7 6 5 4 3 2 1

HNA ▌▐▐▐▐▐
harry n. abrams, inc.
a subsidiary of La Martinière Groupe
115 West 18th Street
New York, New York 10011
www.hnabooks.com

Page 2: Kidrobot 06 by Tristan Eaton and Paul Budnitz.
Page 5: Sameru Kun by Bounty Hunter.

Front cover (left to right): Snake by James Jarvis; Boom Trexi
by Pixel Munky; Kiiro by Devilrobots; Nervous Cosmonaut
Bear Qee by Frank Kozik; Jeero by David Horvath.

Back cover (left to right): 2-Faced Dunny by David Horvath;
Ice-Bot by Dalek; Horror Be@rbrick; SK8 Punk Ape by
MCA/Evil Design; Skull Bee by Secret Base.

Note: Toys on the cover are not reproduced to scale.

CONTENTS

Everybody's plastic, but I love plastic. I want to be plastic. —*Andy Warhol*

This wasn't very long ago, in early 2001, when designer toys began sneaking into the United States. I was making an animated film with my friend Tristan Eaton and friends in Asia began e-mailing me pictures of bizarre toys they'd seen in little stores in Harajuku, or found in a back alley shop in Hong Kong. The pictures were always excitingly blurry: a stylized mechanical shark with glow-in-the-dark eyes; what looked like a big blue monkey with a stereo speaker for a head; modified GI Joes with orange afros and highly detailed miniaturized hip-hop clothing. It was as if artists were taking toys that I remembered from my childhood and imposing an adult aesthetic on them. They were cute, scary, hip, violent, scarce, expensive, and beautiful.

I remember the first time I saw some of the toys in this book.

I immediately fell in love with them, and as soon as the film project ended I hopped on a plane to Hong Kong and started a toy company called Kidrobot.

We call these toys "designer toys" in deference to the fact that it is the designer (or artist) that is so important to the character of the toy, not the other way around. The toys in this book are true works of art; like a painting on canvas, the artist imposes his or her particular vision on the final object, only instead of a flat piece of fabric, the "canvas" is a three-dimensional sculpture made of plastic, vinyl, plush, or even metal or wood.

Most people agree that designer toys seemed to have appeared simultaneously in Japan and China in the mid-nineties. Hong Kong artists such as Michael Lau, Jason Siu, Brothersworker, and many others began taking apart GI Joes, recasting their heads and hands, and selling them at toy and comic book conventions in Asia. They also began

approaching toy factories in nearby Guangdong Province to help them produce their toys. At the same time, a small Goth-rock clothing designer and boutique in Tokyo, Bounty Hunter, began creating limited edition vinyl toys to supplement their Halloweenesque clothing line. Also in Japan, a toy company called Medicom had created the Be@rbrick, the first "platform toy," which share a single physical design, but may be painted different ways by different artists. Pretty soon Japanese and Chinese toy fans were lining up around the block to buy the latest limited edition toy before it sold out.

This trend—artists, small stores, and small toy companies producing their own limited edition runs of toys— is at the heart of the designer toy movement. The artist is never very far from the manufacturing process and, because of this, the materials and the making of the toys themselves are integral parts of the art. Even as

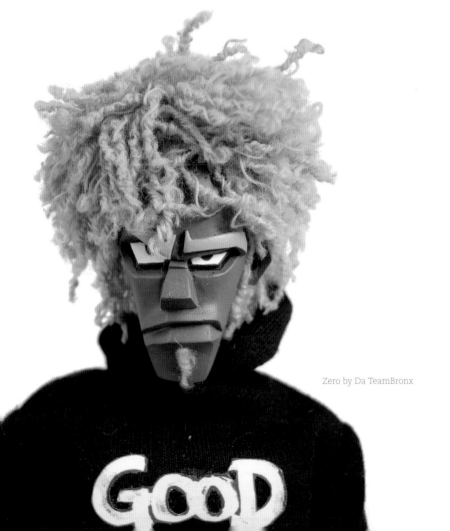

Zero by Da TeamBronx

Double Click by Jason Sui

designer toys moved west from Asia and gained a following in the United States and Europe, there is rarely a substantive disconnect between the artists and the object. In many ways, the toys in this book are a form of folk art, or pop art—folk art because many of the artists are not formally trained and pop art because the toys appropriate aspects of popular culture in their design, but do so in a way that creates new objects that have aesthetics and meanings that far exceed the culture that they refer to. What emerged out of a very insular subculture in Asia has now grown outward to become a worldwide art movement.

Making and designing toys themselves, in limited editions, means that artists can take extraordinary risks. Think of it this way—if a giant entertainment corporation commits to manufacturing one hundred million pieces of a purple dinosaur, they are going to have to make that dinosaur in a way that at least one hundred million people are going to buy. So the toy design can't be too risky, it can't offend anyone. Since a lot of money goes into making one hundred million toys, the entertainment company is going to have to somehow convince, cajole, basically buy their way into the mass psyche in order to make back their investment.

On the other hand, if an artist's goal is to make just 250 pieces of a designer toy, they only have to please 250 people in order to have a smashing success and sell out. So, for example, if an artist decides to make a six-inch-tall plastic glow-in-the-dark blob of snot with rolling eyes and a wobbling tongue and call it "Barrow" (I have Barrow here over my desk, made by Japanese designer DJ Zap), he only has to find 250 people disturbed enough to look at it and somehow say to themselves, "Barrow is for me!"—and then plunk down forty bucks. I am one of those people. And fortunately I am not alone.

That said, making your own toy is very risky. Since many of the toys are manufactured by very small companies, or paid for by the artists themselves, a single failure can mean financial doom. On my last trip to Hong Kong, I visited a friend who makes designer toys. He's a pretty famous designer, and I'm not going to embarrass him by giving out his name, but he works in a windowless cement room that is in a garage behind a dried fish distributor. There isn't a lot of money for the artist in designer toys.

But once you put everything you have into what you are doing—I mean all of your time and your energy and your money, too (most people flinch at the latter)—real and exciting things invariably start to happen. There is no guarantee you won't go bankrupt, lose your house, and end up drinking rotgut in the gutter, but in my experience it's impossible to get anywhere worth going without making a sacrifice, or to make something truly new and exciting without taking a risk. And the toys in this book often required personal sacrifice on the part of the artists just to get made. You can sense that looking at them.

The designer toys' close connection to graffiti art is no coincidence. Many toy designers were or remain graffiti artists. There's an obvious aesthetic connection between characters stenciled, spray painted, or pasted on walls in New York, Los Angeles, Paris, Berlin, Barcelona, Tokyo, or Hong Kong and designer toys. And, on top of this, graffiti artists take immense risks to do their work. They get beat up, arrested, their pieces are bombed, scrubbed, and painted over. Another interesting aspect of graffiti art that is similar to the current toy movement is that it is evolutionary and collaborative in nature. It is not abnormal for a toy artist to build on the work of another artist. Artists sometimes work in pairs, or in groups. There is a lack of ownership (sometimes) between artists and the strength of the work artists are doing in toys has something to do with the fact that people feel open and relatively free to

MAD*L Splat by MAD Toy

Be@rbrick by Medicom

work together. And there is a healthy borrowing, or even stealing, between artists and designers, and from the surrounding culture in general. This appropriation, this borrowing of art and culture from a variety of sources, transforms these pieces into something that is greater than the sum of the parts.

Small-run toy production is itself a form of appropriation. The technology used to manufacture toys was created by large corporations at great expense and small-run toy producers are appropriating that technology to create art. The technological development and machinery has been paid for by the giant corporations and we, as designer toy makers, are showing up and using their equipment to make tiny editions of truly wonderful and bizarre objects. Nevertheless, small-run production generally follows a great deal of begging, bargaining, dinners in remote restaurants in southern China, late deliveries, unsatisfactory quality and rejected

samples, horrible digestion, and hours of late-night hand wringing. Some factory owners make the toys out of curiosity or out of obligation for the nice dinner you bought them; some make them in hopes that by helping a small company get off the ground they will someday end up with a big client. The best ones do it simply because they actually love the toys.

From a purely artistic perspective, one of the most interesting things about the toys in this book is that there is very little nostalgic about them. Nostalgia is remembered emotion; when we see something "nostalgic" our reaction to that thing is generally not a reaction to the thing itself—it is a reaction to something not present, something in our past that we are remembering and reacting to again. A toy that we might think of as nostalgic (a tin airplane, an old fashioned rocking horse) invokes feelings from a past that is either long gone, or that we never had. Nostalgic feelings don't do anything for the human race but drag it backward.

As far as I am concerned nostalgia is a creativity killer, and a life killer. Real, exciting, original art does not depend on nostalgia. Real art is the conveyance of something that is here, now, and immediate—in the object itself. It is a complete feeling, or an idea. Mori Chack's Gloomy Bear toys have a real tension between the cute, cuddly safety of a pink teddy bear and the blood on its fangs that reminds us that bears are dangerous, and that baby bears are likely to grow up and eat you. And, unlike current "mass produced" toys, these toys reflect a simple cultural reality. Pink bears, like much of modern life, look nice but may really be dangerous.

Then again, what draws a person to an object is not always an idea—it might just be an intense love for the material reality of the object itself. Kidrobot has developed as part of my love affair with plastic and its shiny, malleable, wonderful texture. This is certainly not politically correct, and

particularly not environmentally correct, and it has even been suggested that I am demented in this respect, but I love the tension between plastic's cheap, ordinary quality and the beautiful things we are making out of it, so different from just another plastic Coke bottle.

Nostalgia (and its cousin sentimentality) just kills that. There's a giant poster on the wall of our office that says **NOSTALGIA IS DEATH** in giant bold type. This poster is there to keep us in line, and remind Kidrobot what we're doing, and what we are definitely not doing. We're here to present the real deal, here and now. So when you are looking at the toys in this book, notice this quality. They are plastic because, being cheap and readily available, plastic is the most here and now of all materials.

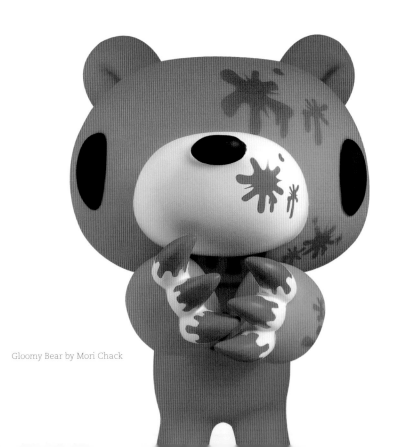

Gloomy Bear by Mori Chack

Many of the Bounty Hunter toys in the first section of this book are based on characters from Japanese cereal boxes that have somehow been mixed up with movie monsters and dressed up in remnants of urban Goth culture. That's a lot of cultural reference embodied in a robotic plastic shark with "BXH" engraved onto its head! But at the same time the toys' here and now-ness comes from the power of the designs themselves, their viciousness, and their playfulness. The cereal box characters (you will recognize toys that resemble Frankenberry if you look closely) are the canvas and the context, not the subject.

When the Kidrobot store first opened in San Francisco people would walk in and look at the toys and say, "That's really very nice…what's it from?" I remember this specifically in the case of a woman who was staring at one of Pete Fowler's early Monstrooper

figures. I explained to her that the toy wasn't "from" anything at all. The big, red camouflage-clad monster with a Cyclops-eyeball mace is a character that Pete invented as a toy, nothing else and with no other purpose. It is what it is. The woman just couldn't understand that and said, "Well if it's not from something, why would I *want* it?" We'd only been open about a week and after she stomped away one of my co-workers looked at me and said, "Thank God it's a limited edition."

The impulse to label and package things, to box up ideas into previously understood packets of information is terrifying because it shuts out anything new. Take a trip to Toys-R-Us and try to find something that isn't "from" something else, or based on a license of trademarked characters that have been pounded into our culture through repetition and advertising. A *Jurassic Park* plastic Brontosaurus may be a cool toy in and of itself, or it may not be, but the fact is it is being sold not because

it's a really amazing plastic dinosaur (which it usually isn't) but rather because it is a character from a movie and it depends on our memory of the movie for appeal.

So if you're selling a memory of a movie, how great does the toy itself really have to be? On the other hand, if you're going to create a ten-inch-tall walking piece of tofu wearing a spaceman outfit (To-Fu Oyaku by Devilrobots), then you have to try to convince your customers to buy it for no other reason than that it's really, really weird, and well—that takes some serious guts. Especially since you're probably putting up your own money to make the toy and your own time to sell it. And you're going to ask your customer to do the same thing—take a risk and spend their money on a work of art.

This is one of the reasons why the designer toy customer is a hero, too. They are the ones willing to step up and say, "I need that."

Looking at things with a fresh eye and taking the risk of simply not understanding what you're seeing, that takes courage. "What the hell is that?" is a great question. Not being able to find an answer is a bit disturbing, but always compelling. Living with that answer and investing in it is, in a cultural sense, heroic.

So this book is a love letter to the artists and patrons that have created the designer toy movement.

Enjoy!
Paul Budnitz

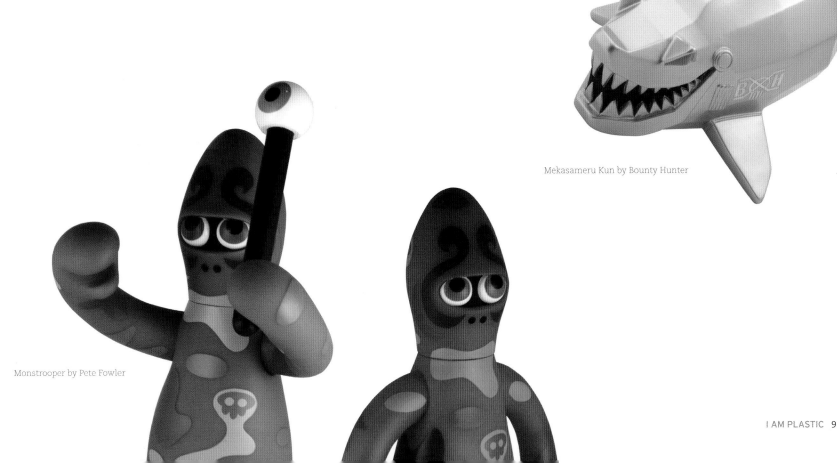

Mekasameru Kun by Bounty Hunter

Monstrooper by Pete Fowler

I AM PLASTIC : JAPAN

BOUNTY HUNTER

Designer: Hikaru

Nationality: Japanese

Based in: Tokyo, Japan

Website: bounty-hunter.com

1. DX Skeru Kun, 2005
2. Sameru Kun (Glow in the Dark), 2001
3. Sameru Kun, 2001
4. Mekasameru Kun, 2002

2–3

4

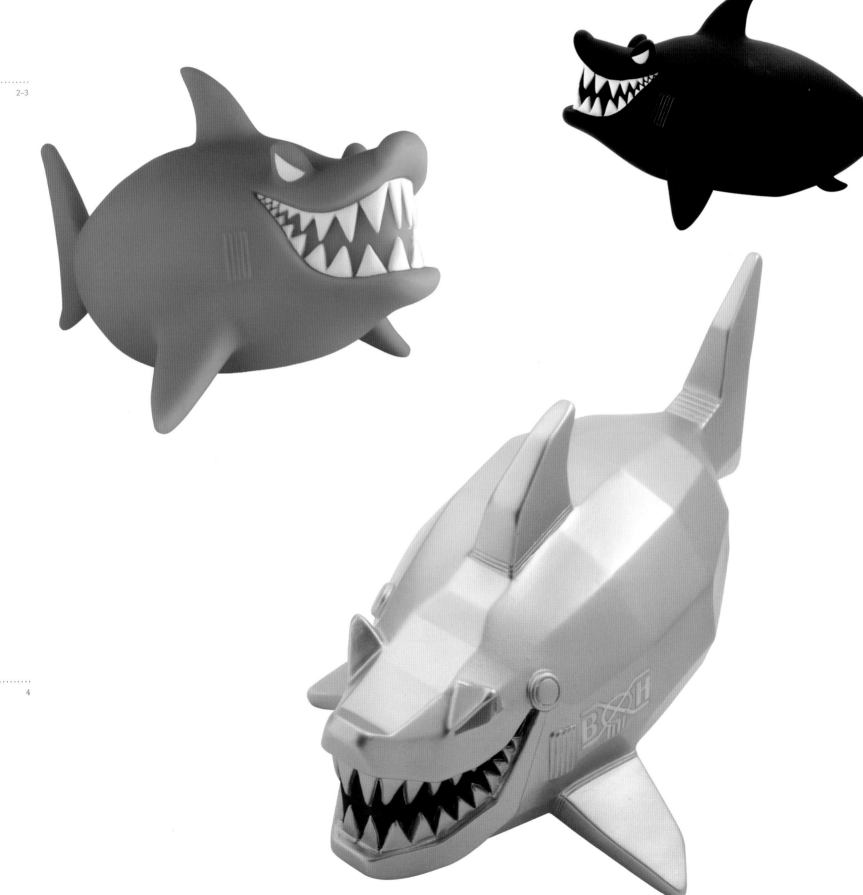

1–5

6–7

8–9

10. DX Skeru Kun, 2004
11. DX Skeru Kun, 2005
12. Mekaru Kun (Glow in the Dark), 2001
13. Mekaru Kun, 2001
14. Mekaru Kun, 2002
15. Skum Kun, 2003
16. Giant Mekaru Kun, 2002

10–11

12–14

15–16

From the set *Kaibutsu-
kun*, 2004: **1.** Franken
2. Kaibutsu-kun
3. Dracula **4.** Wolf Man

1

2

3–4

5

1. Kid Hunter, 1997
2. Julius, 2004
3–6. Mojaru Kun (Plush Doll)

1

2

3–6

7

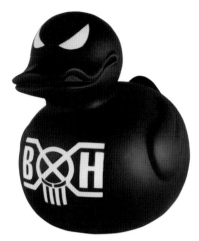

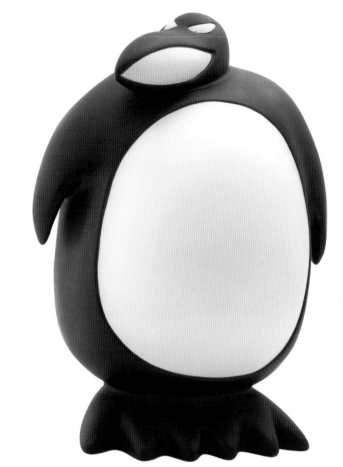

8–9

10

1. Kaijin Hachiotoko
2. Water Skull Bee

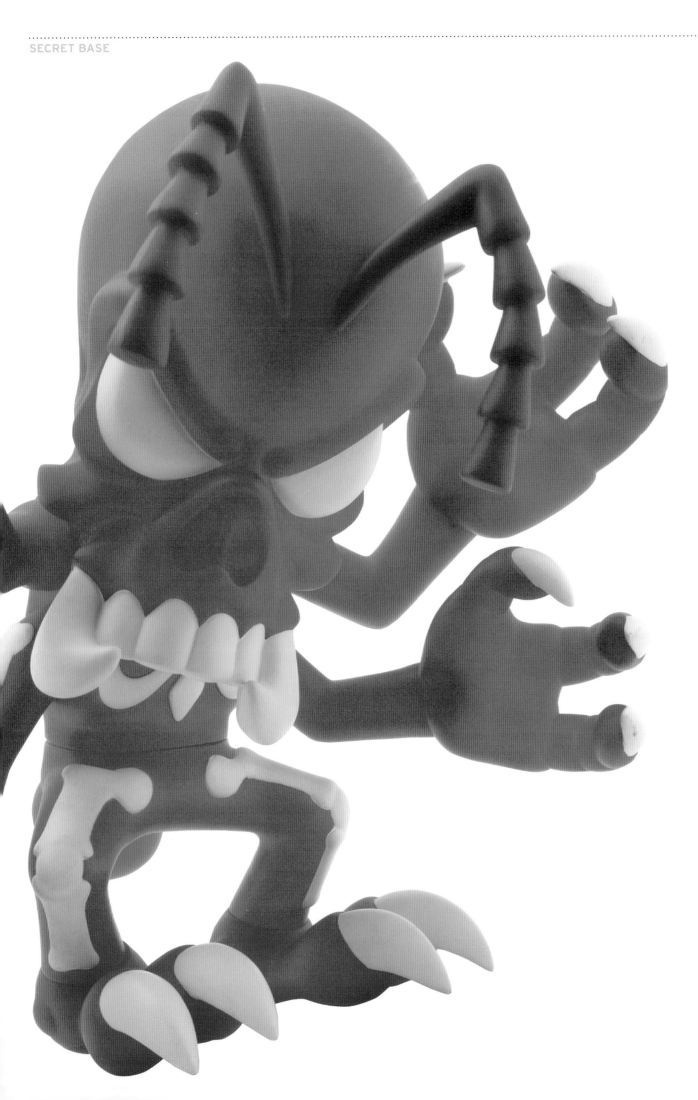

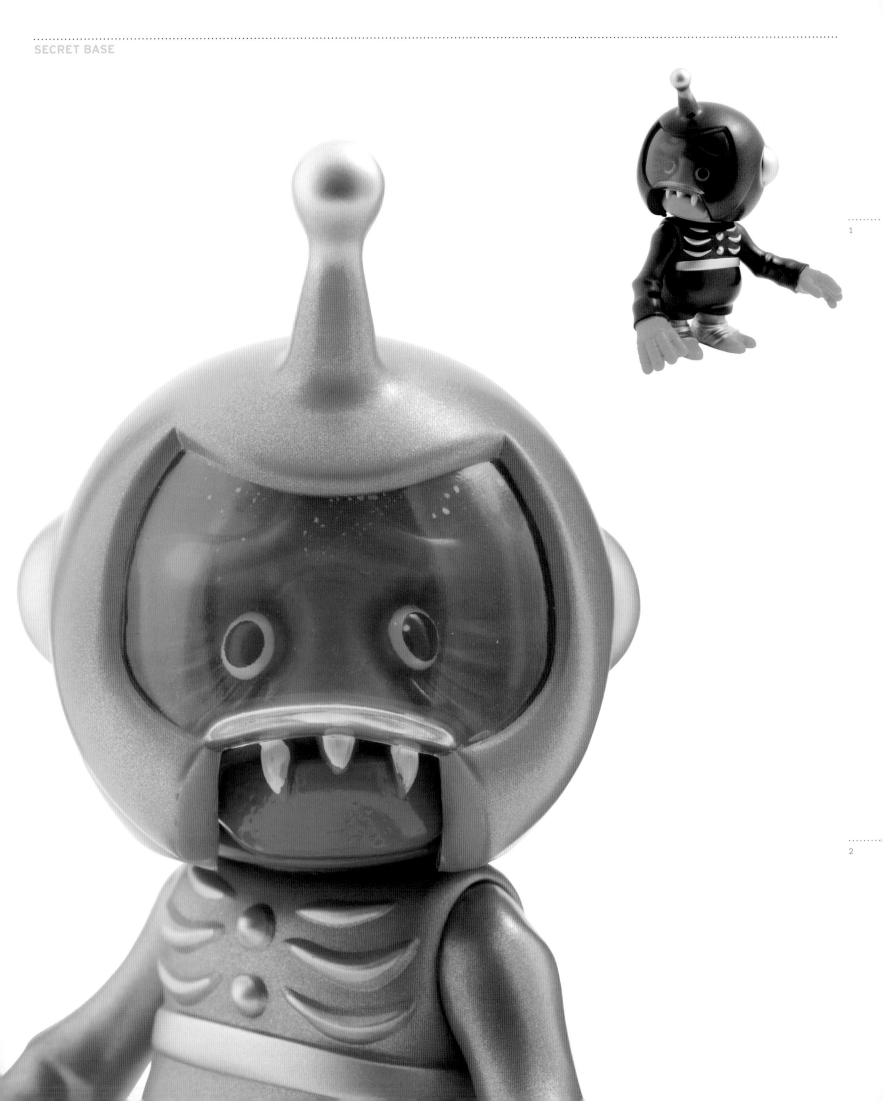

3–4

5–8

9–11

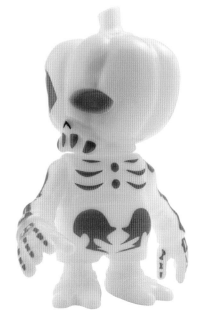
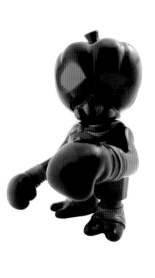

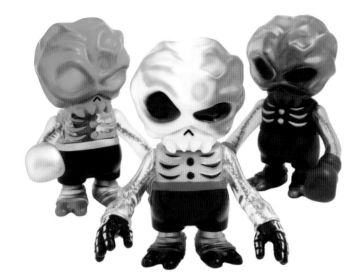

1–3

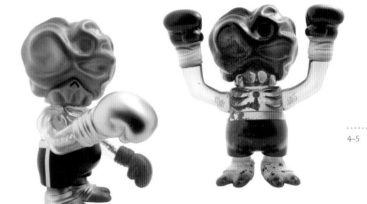

4–5

6–7

8–9

10–12

13–14

15–17

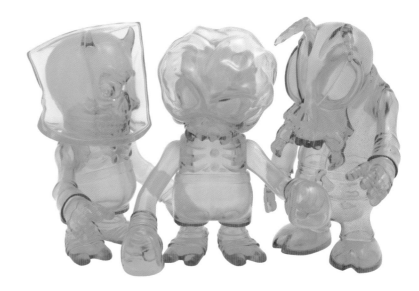

18

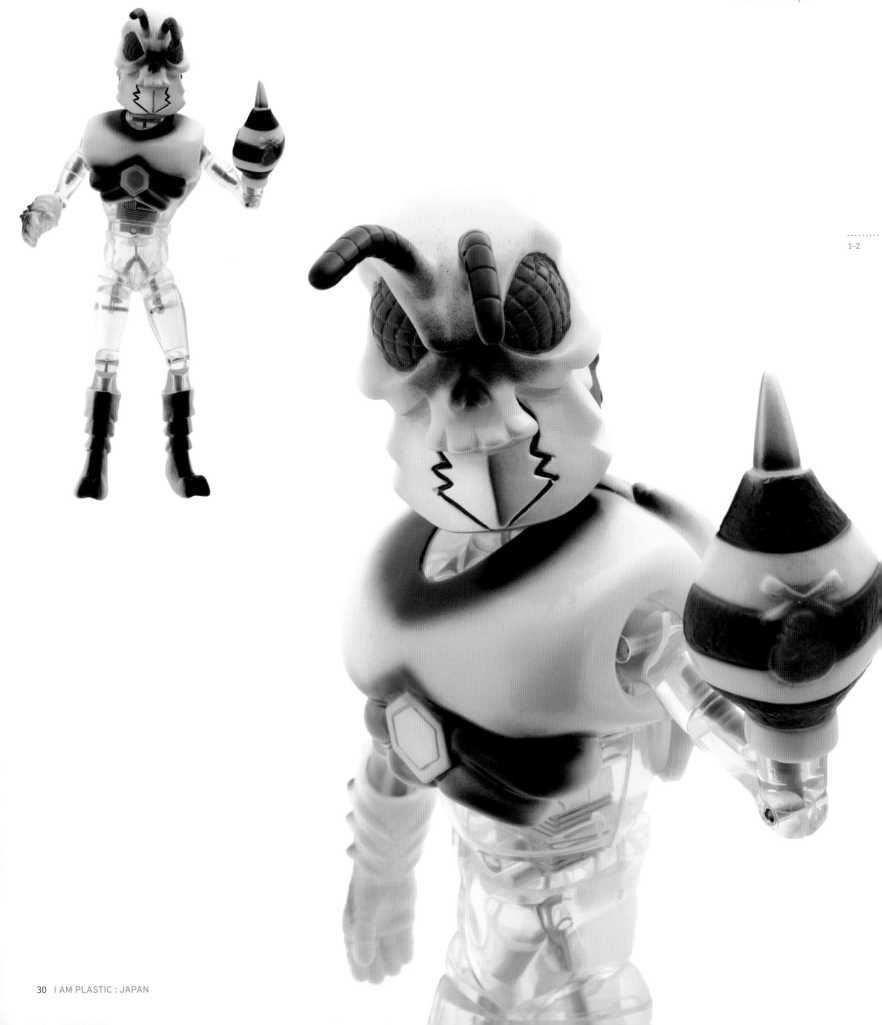

1–2

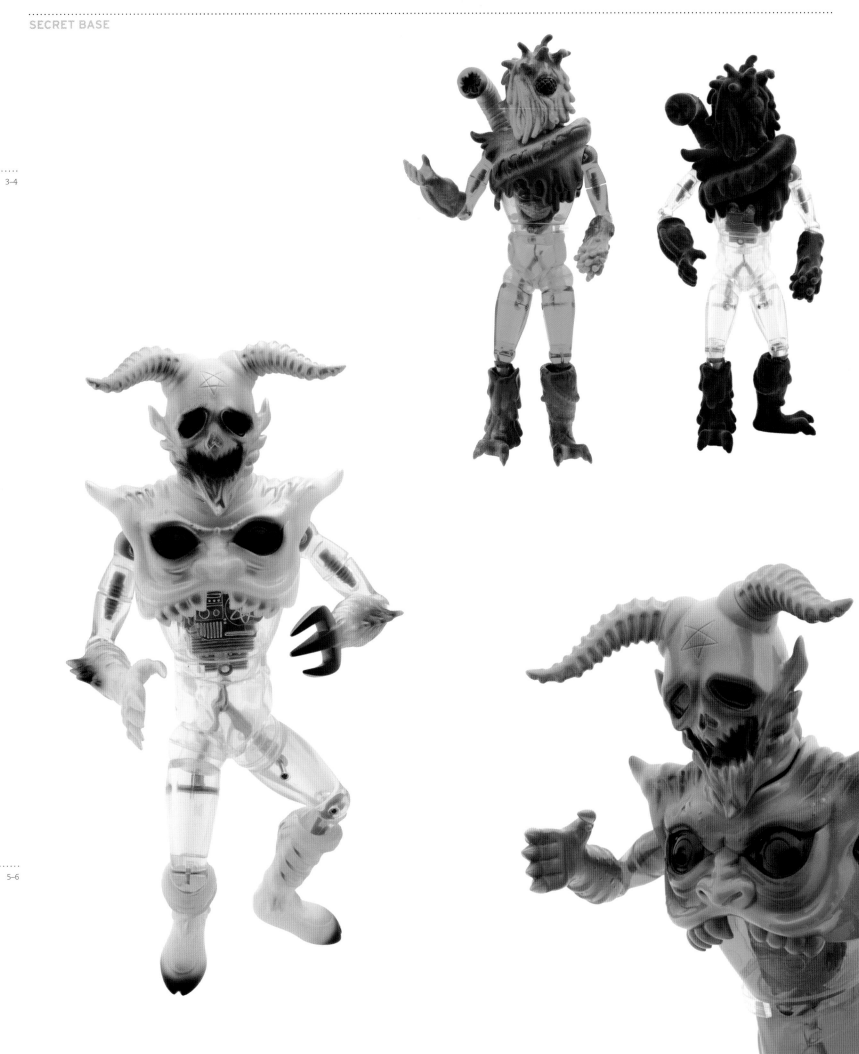

DEVILROBOTS

Nationality: Japanese

Based in: Tokyo, Japan

Website: devilrobots.com

1–6. Kiiro, *Devil Heads* (*Soft Vinyl Doll*), 2005 7. Peck, 2005 8. Kiiro (*Plush*), 2004

1–6

7–8

From the set *Maffy Kubrick*, 2004: **9.** Maffy Milk **10.** Maffy **11.** Maffy Café Mocha **12.** Maffys Milk **13.** Maffys Orange **14.** Maffys Café Mocha **15.** Maffys Strawberry **16.** Maffys

From the set *Snack Detective Pudding and Jelly*, 2005: **17.** Ichigo-Chan **18.** Chocho Soft **19.** Jelly

9–11

12–13

14–16

17–19

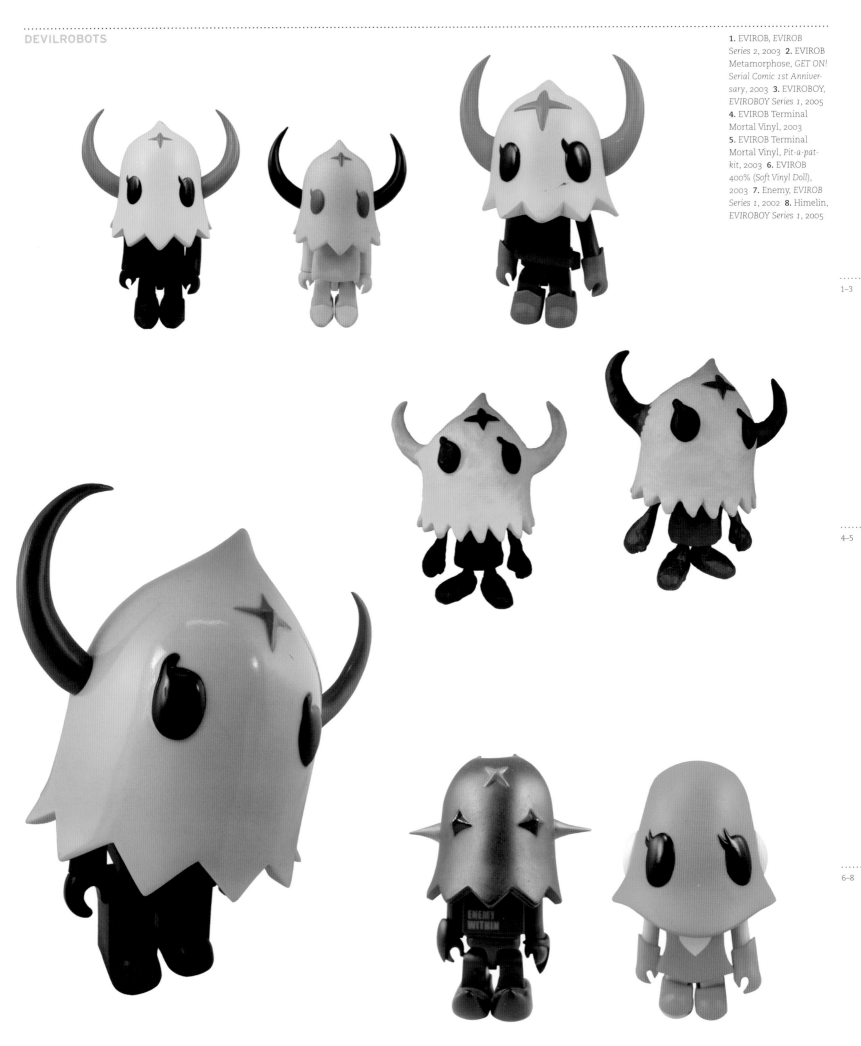

1. EVIROB, EVIROB Series 2, 2003 2. EVIROB Metamorphose, *GET ON! Serial Comic 1st Anniversary*, 2003 3. EVIROBOY, *EVIROBOY Series 1*, 2005 4. EVIROB Terminal Mortal Vinyl, 2003 5. EVIROB Terminal Mortal Vinyl, *Pit-a-pat-kit*, 2003 6. EVIROB 400% (Soft Vinyl Doll), 2003 7. Enemy, EVIROB Series 1, 2002 8. Himelin, *EVIROBOY Series 1*, 2005

1–3

4–5

6–8

9. Combine, *EVIROB Series 3*, 2004 10. Gaki Gaki, *EVIROBOY Series 1*, 2005 11. EVIROB Power Armor, *EVIROB Series 3*, 2004 12. Evirobull, *GET ON! 6th Anniversary*, 2003 13. EVIROB Zero, *GET ON! Serial Comic 1st Anniversary*, 2003 14. EVIROB, *GET ON! Special Future Comic Edition*, 2004

9–11

12–14

1. To-Fu Oyako, *TO-FU
Kubrick Series 1*, 2001

From the set *GIANTO-
FU*, 2004: 2. To-Fu Son
3. To-Fu Mother

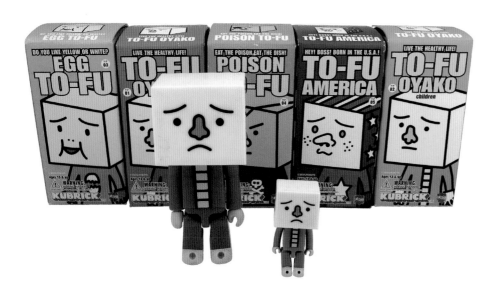

1

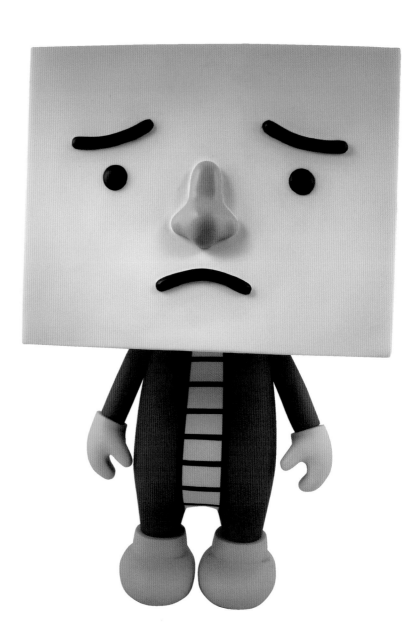

2–3

From the set *Yujin TO-FU OYAKO Riding Mascot,* 2004: **4.** Strawberry To-Fu **5.** Pudding To-Fu **6.** Egg To-Fu **7.** Milk To-Fu **8.** To-Fu China **9.** Eco To-Fu **10.** Poison To-Fu **11.** To-Fu Gang **12.** To-Fu Mother

4–5

6–8

9–12

From the set *Devil Heads* (*Soft Vinyl Doll*), 2005: **1–2.** hellcatz (Cream) **3.** hellcatz (Red) **4.** hellcatz (Blue) **5.** hellcatz (White)

From the set *VANIMAL ZOO*, 2004: **6.** hellcatz Skeltoon **7.** hellcatz Paul Smith Jeans 04 for Summer Sonic **8.** hellcatz Paul Smith Jeans 03 for Summer Sonic **9.** hellcatz Vanishing Vanimal Vitals

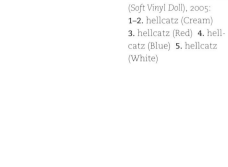
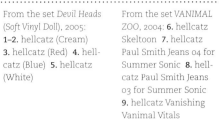

1–2

3–5

6–9

10–12

13–14

Memorial Model from
the set *Kubrick Tokyo
Toy Show*, 2000: **1.** Black
2. Red **3.** Yellow **4.** Blue
5. White

1

2–4

5

1. Kubrick Gloomy, 2002
2. Kubrick Kumakikai,
2002 **3.** Kubrick Evirob
400%, 2002 **4–6.** Kubrick
Balzac (Black Version),
2000

1–2

3

4–6

7–9

10–13

14–15

1–3

4–6

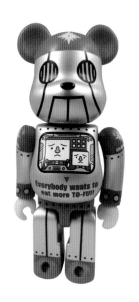

7–9

10–11. Be@rbrick SF21
(Black), 2001 **12.** Horror,
Be@rbrick Series 1, 2001
13. Animal, *Be@rbrick
Series 3*, 2002 **14.** Flag,
Be@rbrick Series 2, 2001

10–11

12–14

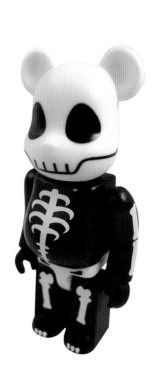

From the set *Rolling 60s Statue*, 2005: **1.** Wonder Girl **2.** Mermaid

1

2

3–5

6–7

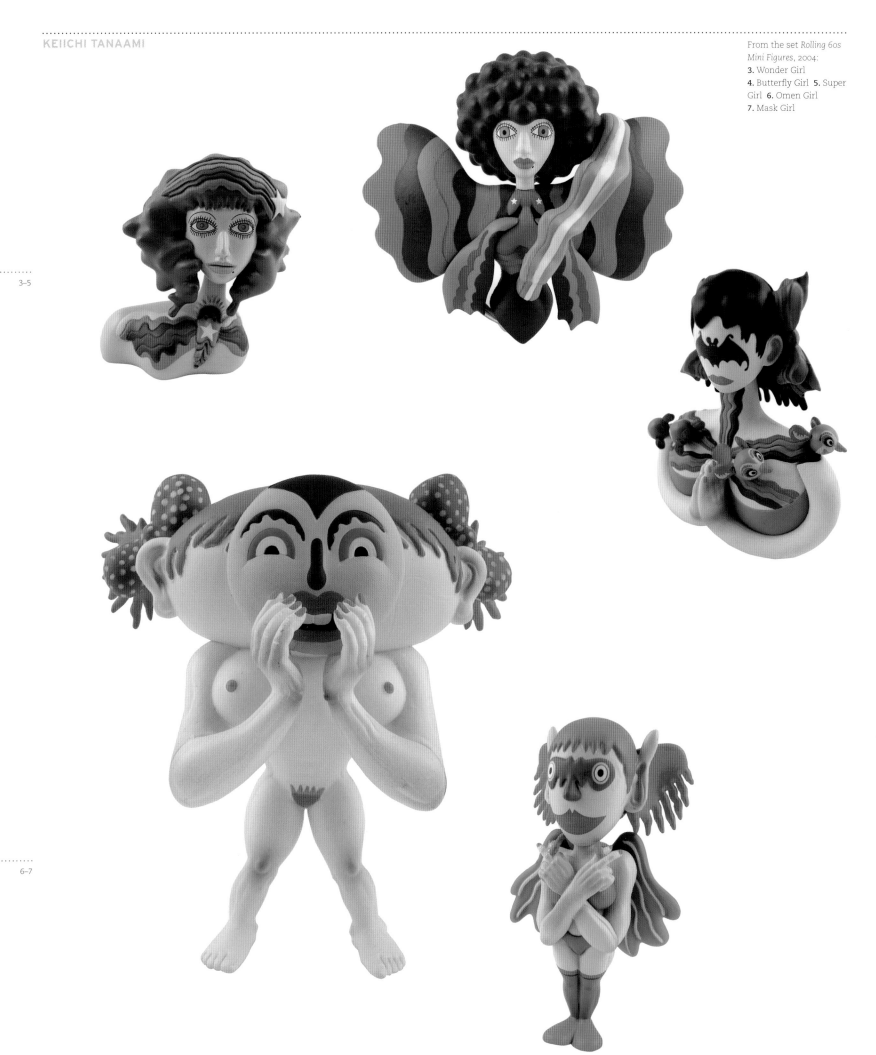

Nationality: Japanese

Based in: Tokyo, Japan

Website: mizuno-junko.com

Manufacturer: Art Storm/Fewture Models

1

2. Dokuro-San 3. Buta-San (Pink), *Mizuno Friends*, 2004

From the set *Miznotic Fantasy:* 4. Chika Fantasy, 2002 5. Peach Night Fantasy, 2004 6. Shiori Fantasy, 2002 7. Chika Peach Night, 2003 8. Chika Mint Night, 2003 9. Shiori, 2003 10. Fumi, 2003

2–3

4–6

7–10

MAD BARBARIANS

Designers: Katsuya Saito, Masumi Ito

Nationality: Japanese

Based in: Tokyo, Japan

Website: madbarbarians.com

From the set *GalleColle 01*, 2004: **1.** Gas Curry & Spice (Red Curry) **2.** Gas Curry & Spice **3.** Gas Curry & Spice (Tower Records Rock Star Exclusive)

4. Spice-kun (Exclusive), 2004

1

2–3

4

5. Weakling Gang, 2-inch Egg Qee, 2004
6. Pecchan, 2-inch Qee APM x TOY2R Exclusive, 2003 **7.** Black Porkun Cat Qee (NYC Edition), 8-inch Cat Qee, 2004

From the MAD BARBARIANS 2-inch Qee Series, 2003:
8. Crobo-kun **9.** Porkun **10.** Melt-kun

From the Qee Series (3 Designers Edition), 2003:
11. Atomic Bear
12. Atomic Dog
13. Atomic Cat
14. Atomic Bear (Pink Private Exhibition Exclusive)

From the set Manager, 2006: **15.** Border Pop **16–18.** Riddle **19.** Vice Man

5–7

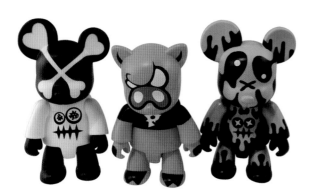
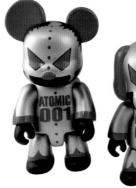
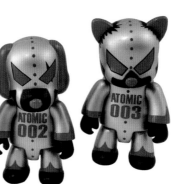
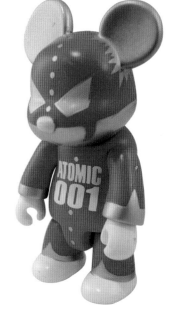

8–14

15–19

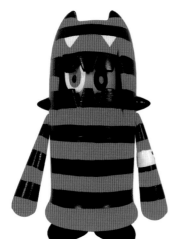

TOKYO GUNS

Designer: Takumi Iwase

Nationality: Japanese

Based in: Tokyo, Japan

Website: tokyoguns.com

1–4

5–8

9

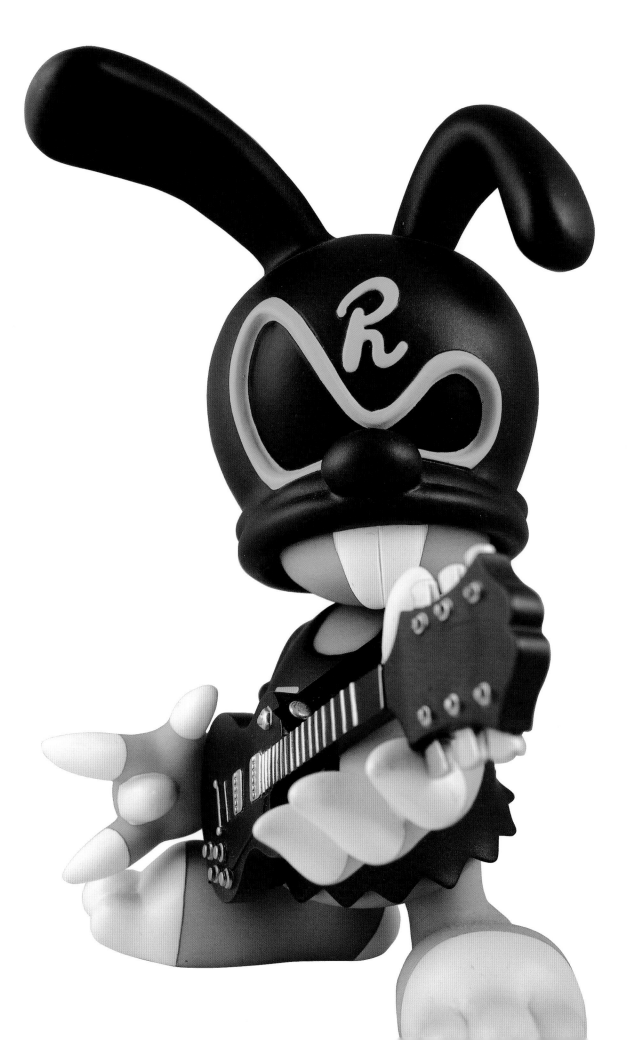

1–3

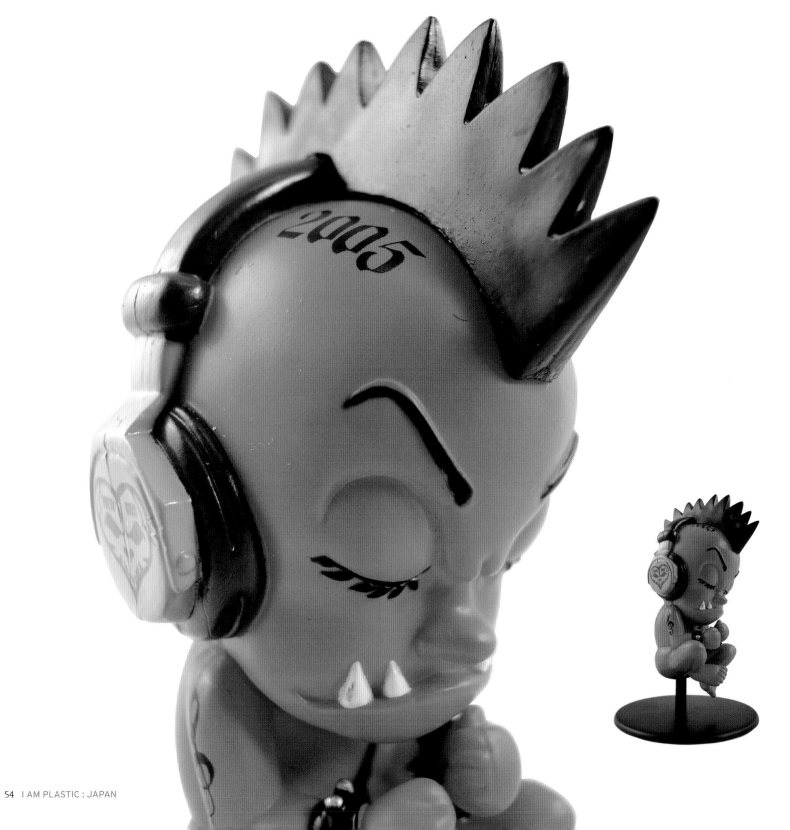

4–5

CUBE WORKS

Designers: Various (Uncle Ryohei, Takashi
Kazaki, Masashi Ichifuru, Cube Works)
Nationality: Japanese
Based in: Tokyo, Japan
Website: cube-works.co.jp
Manufacturer: Cube Co., Ltd.

By Uncle Ryohei:
6–8. Uncle Ryohei
Wooden Toy (Dorobo 2,
Maline 2, Soccer 2),
Uncle Ryohei Wooden Toy,
2003

By Takashi Kazaki:
9–10. Aflo Zamurai
(Figure, Ring), *Aflo
Zamurai*, 2000

11. Kappa Maki (Stuffed
Toy), *Kappa Maki*, 2003

6–8

9–11

By Masashi Ichifuru:
1–4. CAM-10 (Pink, Blue),
CAM-10, 2003 **5.** CAM-08
(White), CAM-08, 2000

1–3

4–5

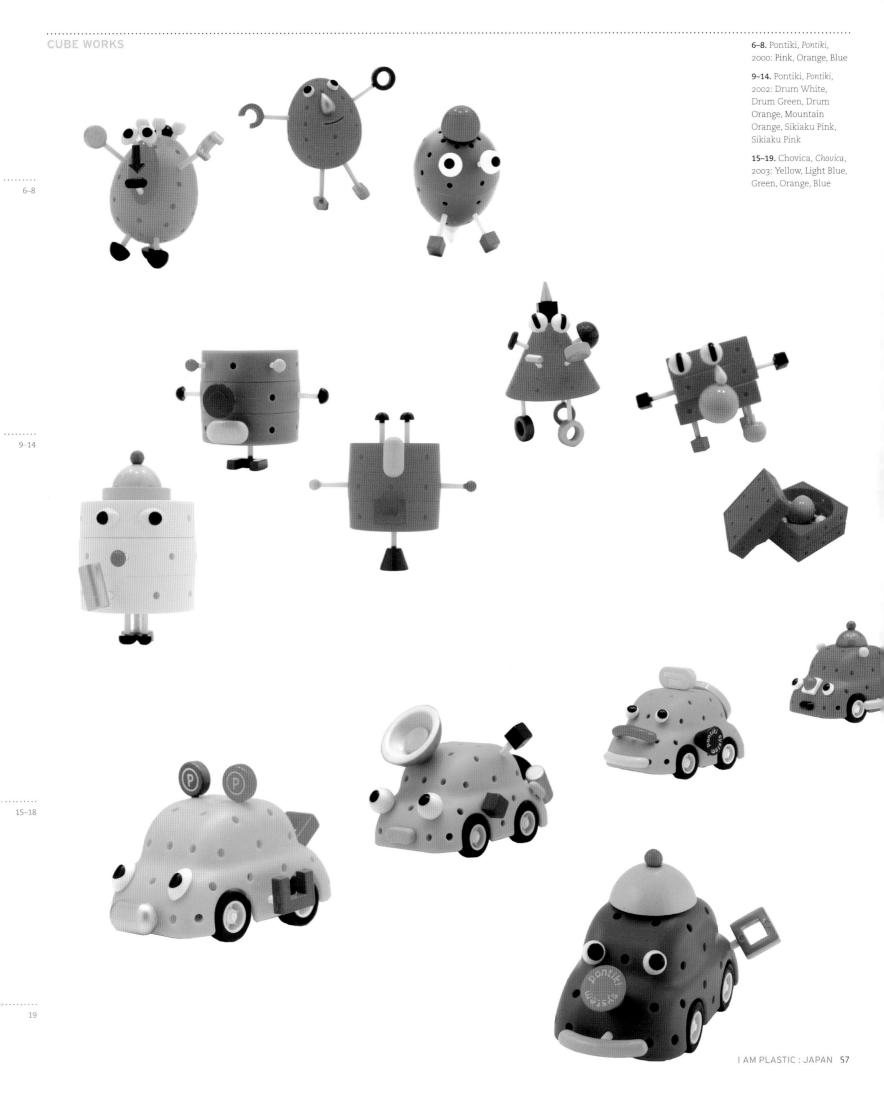

6–8. Pontiki, *Pontiki*, 2000: Pink, Orange, Blue

9–14. Pontiki, *Pontiki*, 2002: Drum White, Drum Green, Drum Orange, Mountain Orange, Sikiaku Pink, Sikiaku Pink

15–19. Chovica, *Chovica*, 2003: Yellow, Light Blue, Green, Orange, Blue

6–8

9–14

15–18

19

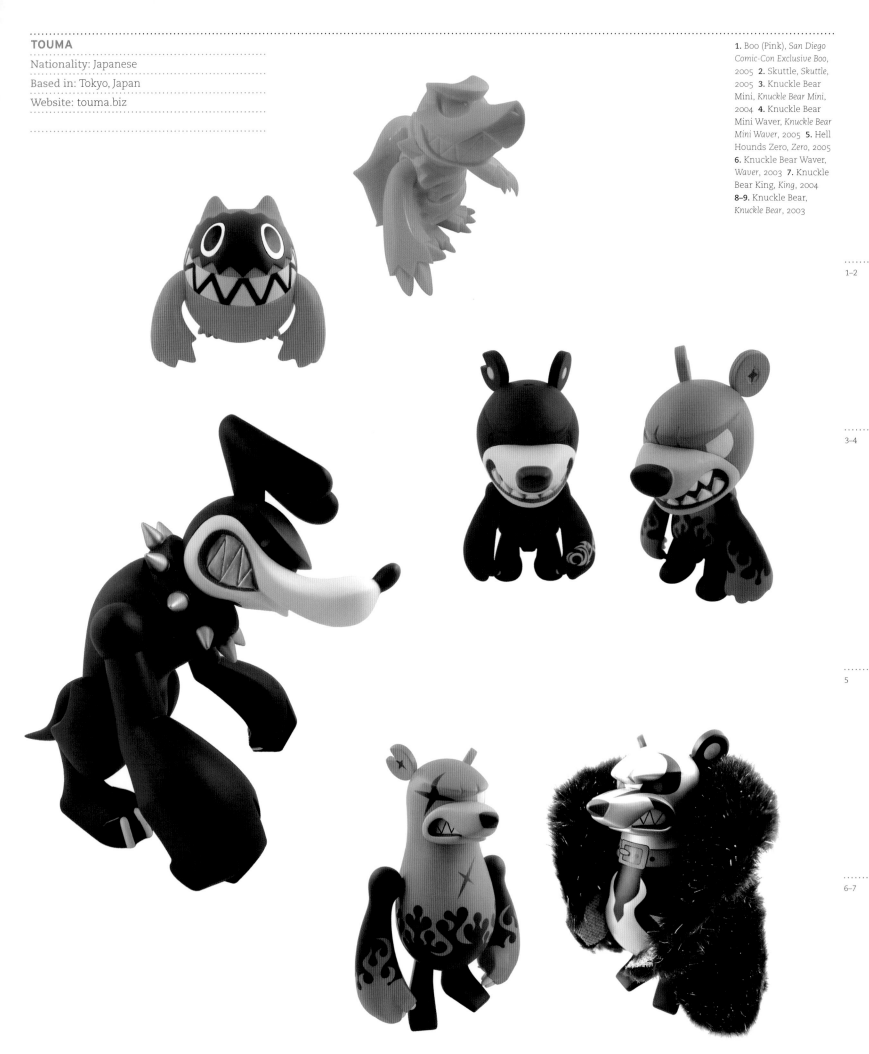

TOUMA

Nationality: Japanese

Based in: Tokyo, Japan

Website: touma.biz

1. Boo (Pink), *San Diego Comic-Con Exclusive Boo*, 2005 2. Skuttle, *Skuttle*, 2005 3. Knuckle Bear Mini, *Knuckle Bear Mini*, 2004 4. Knuckle Bear Mini Waver, *Knuckle Bear Mini Waver*, 2005 5. Hell Hounds Zero, *Zero*, 2005 6. Knuckle Bear Waver, *Waver*, 2003 7. Knuckle Bear King, *King*, 2004 8–9. Knuckle Bear, *Knuckle Bear*, 2003

1–2

3–4

5

6–7

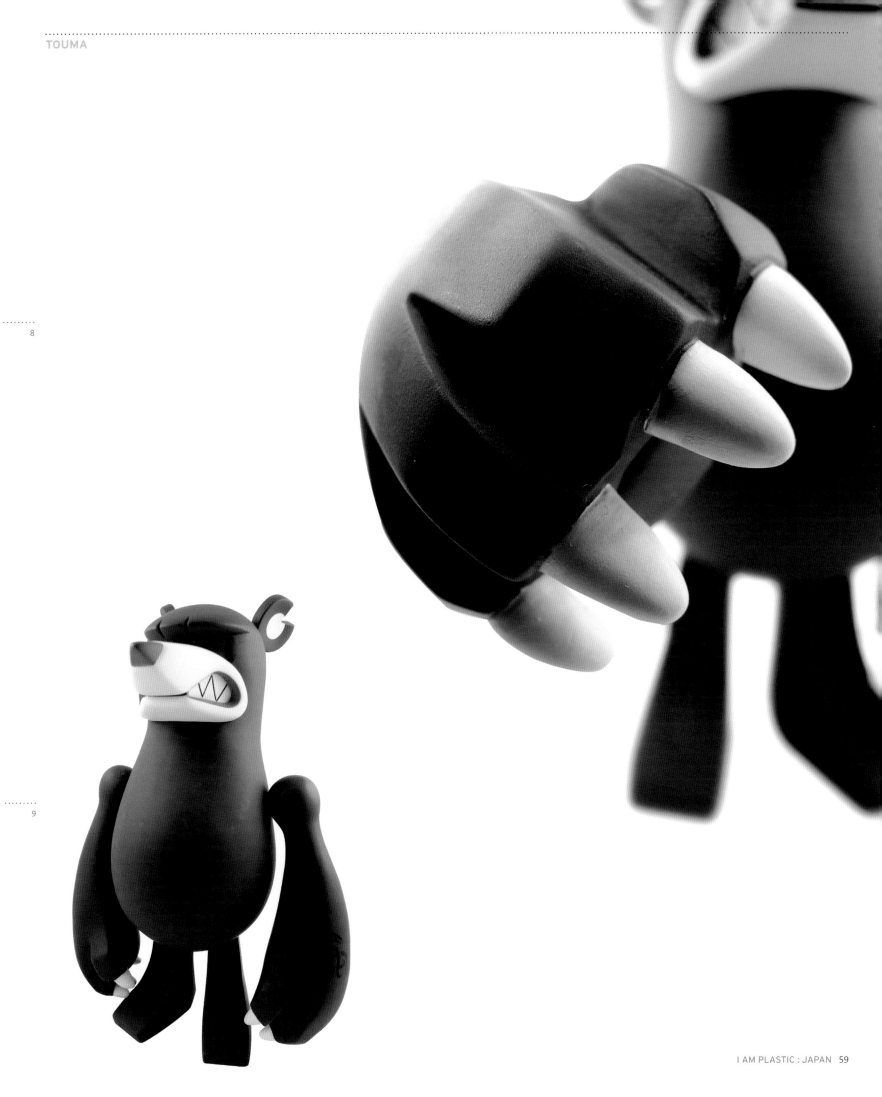

8

9

SNOUT, 2005:
1–2. Taipei Toy Festival
Limited Edition
3. Spanky Limited
Edition **4.** Playlounge
Limited Edition
5. Headlock Studio
Limited Edition

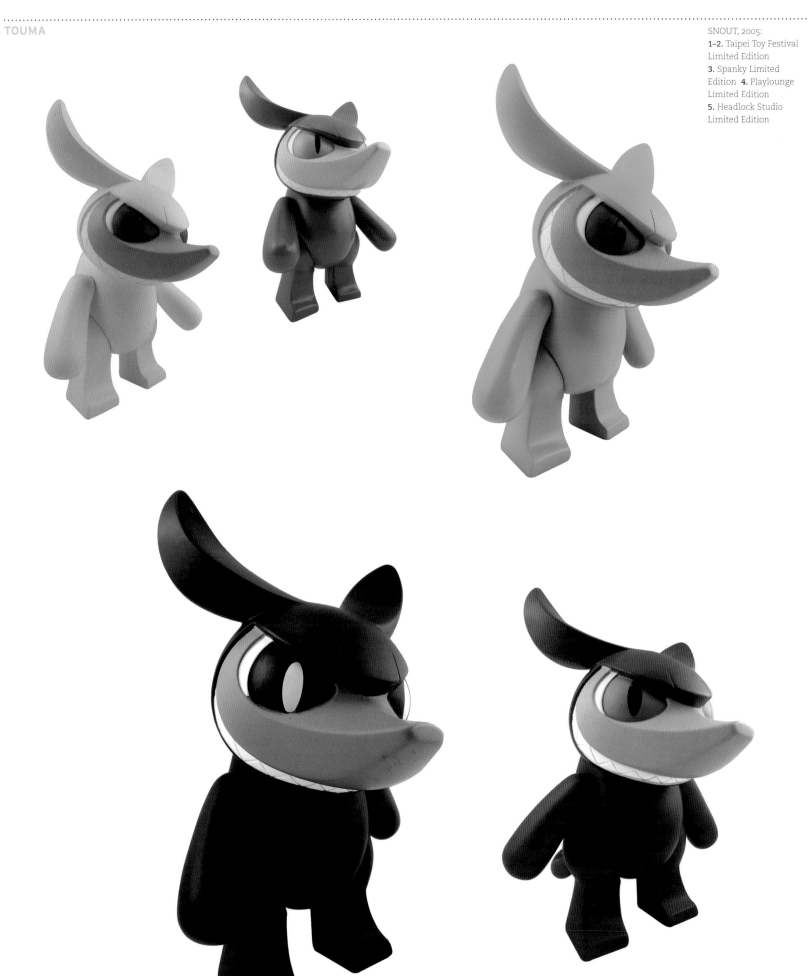

1–3

4–5

TALONS, 2004:
6. Headlock Studio
Limited Edition
7. Spanky Limited
Edition **8.** Figure
King Limited Edition
9. STRANGEco Limited
Edition **10.** Playlounge
Limited Edition

6–7

8–10

MORI CHACK

Nationality: Japanese

Based in: Tokyo, Japan

Websites: gloomybear.net; chax.net

1. Small Nui-Gloomy (Pink), 2003 2. Small Nui-Gloomy (Yellow), 2003 3. Instinctive Nui-Gloomy (Small), 2003 4. Pandatone Nui-Gloomy (Plush), 2004 5. Stand-Up Nui Gloomy (Chax Colony Edition), 2003

1–2

3

4–5

6. Gloomy Vinyl Figure
(Chax Colony Edition),
2004 7. Leather Nui-
Gloomy G5 Limited
Edition, 2005

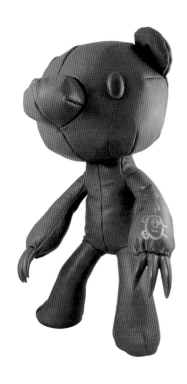

From the set *Puran Pran Key Chain Vol. 3*, 2004:
1. Gloomy Bear (Baby Pink) **2.** Gloomy Bear (Baby Blue) **3.** Gloomy Bear (Baby Yellow)

From the set *Puran Pran Key Chain Vol. 1.5*, 2004:
4. Gloomy Bear (Sky Blue)
5. Gloomy Bear (Pink)

1–5

6–8

9–10

From the set *Chax Figure Collection Vol. 1*, 2004:
6. Gloomy and Mori Chack (Super Secret)
7. Gloomy Bear (Exercise After the Meal)
8. Gloomy and Pity (The First Attack) **9.** Pity and Baby Gloomy (Secret)
10. Gloomy and Pity (Meutsuri – Which One Shall I Have?)

From the set *Puran Pran Key Chain Vol. 3*, 2004:
11. Gloomy Bear (Purple)
12. Podolly (Secret)
13. Pity (Zyanose)

From the set *Chax Figure Collection Vol. 2*, 2005:
14. Gloomy and Pity (Knee Kick) **15.** Pity and Baby Gloomy (Secret) **16.** Gloomy and Pity (Mother's Love)
17. Gloomy and Pity (Dokkoi Hammer)

11–13

14–15

16–17

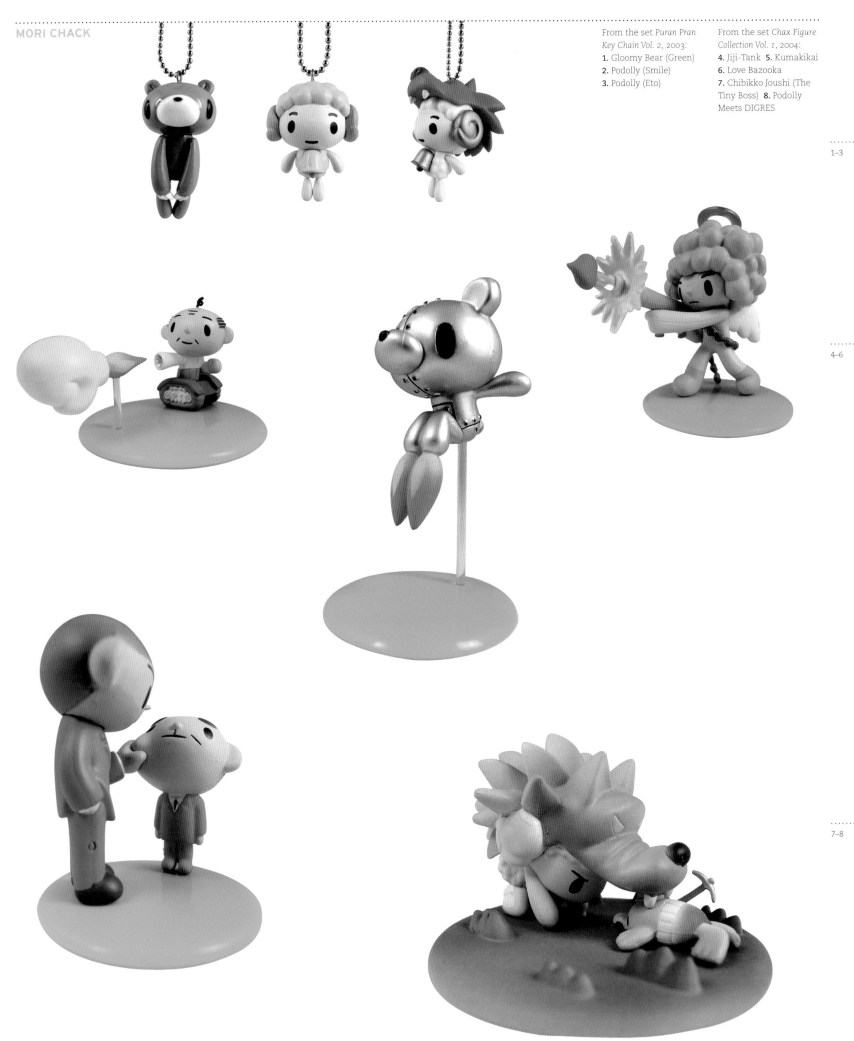

From the set *Puran Pran Key Chain Vol. 2*, 2003:
1. Gloomy Bear (Green)
2. Podolly (Smile)
3. Podolly (Eto)

From the set *Chax Figure Collection Vol. 1*, 2004:
4. Jiji-Tank **5.** Kumakikai
6. Love Bazooka
7. Chibikko Joushi (The Tiny Boss) **8.** Podolly Meets DIGRES

1–3

4–6

7–8

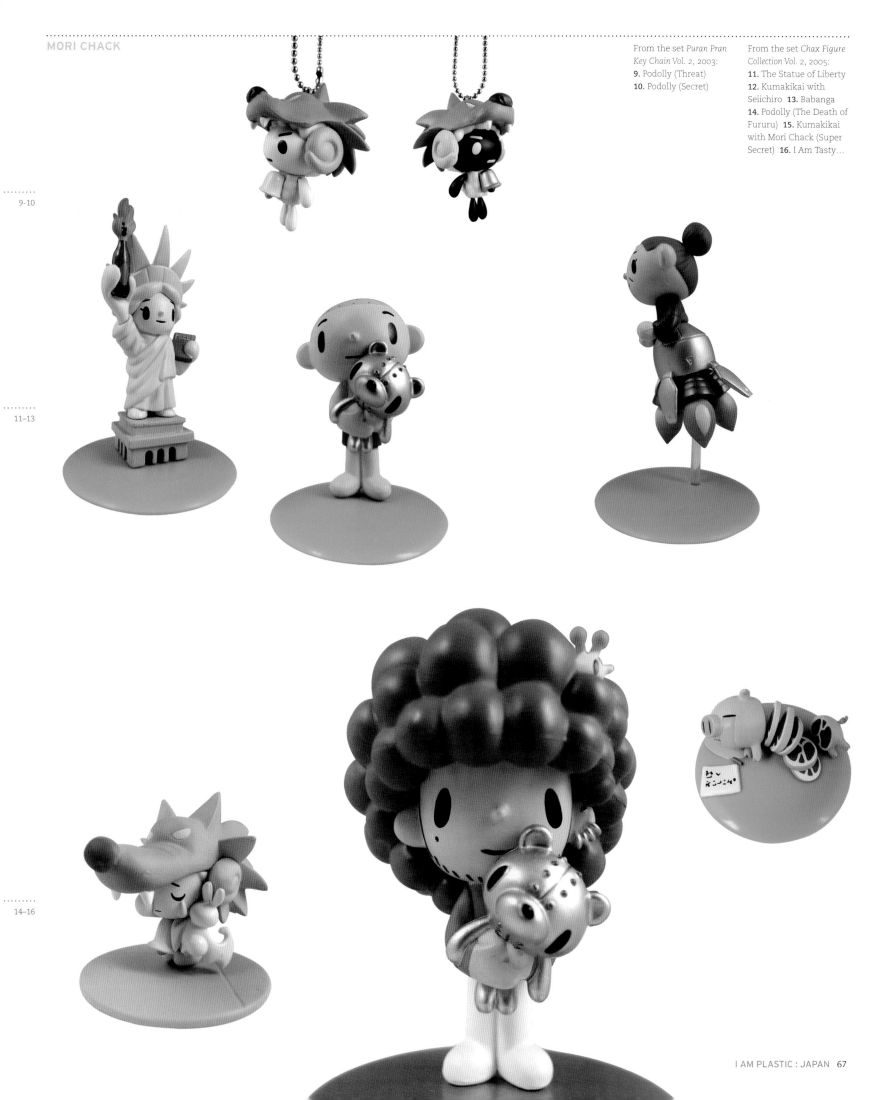

From the set *Puran Pran Key Chain Vol. 2*, 2003:
9. Podolly (Threat)
10. Podolly (Secret)

From the set *Chax Figure Collection Vol. 2*, 2005:
11. The Statue of Liberty
12. Kumakikai with Seiichiro **13.** Babanga
14. Podolly (The Death of Fururu) **15.** Kumakikai with Mori Chack (Super Secret) **16.** I Am Tasty…

9–10

11–13

14–16

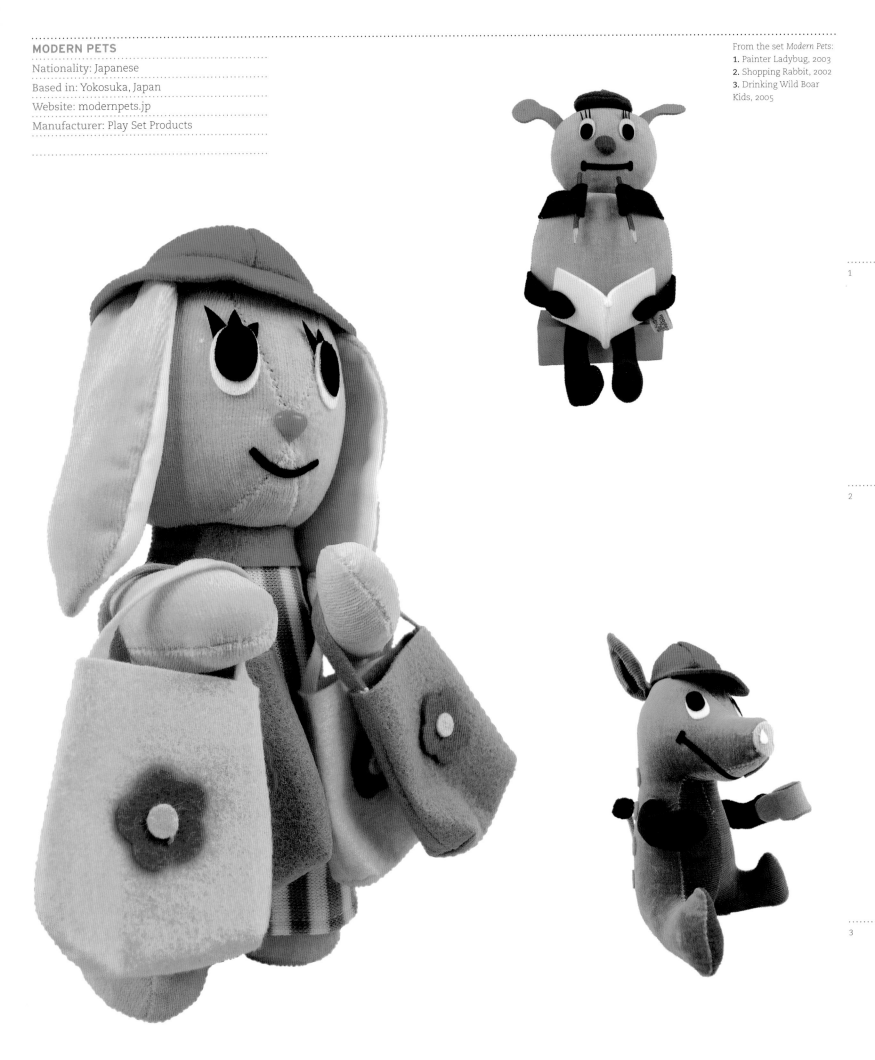

MODERN PETS

Nationality: Japanese

Based in: Yokosuka, Japan

Website: modernpets.jp

Manufacturer: Play Set Products

From the set *Modern Pets*:
1. Painter Ladybug, 2003
2. Shopping Rabbit, 2002
3. Drinking Wild Boar
Kids, 2005

1

2

3

From the set *Modern Pets*:
4–5. Dreaming Bear Dogs,
2002 **6.** Cool Cat, 2004
7. Baton Poodle, 2004
8. Baton Poodle, 2003
9. Shopping Rabbit, 2004
10. Read Elephant, 2004

4–5

6–8

9–10

KOW YOKOYAMA

Nationality: Japanese

Based in: Tokyo, Japan

Websites: homepage3.nifty.com/kow/;

maschinenkrieger.com

Manufacturer: Nitto

From the set *Maschinen Krieger:* **1.** 1/16 Snake-Eye, 2003 **2.** 1/16 Fireball SG, 2004 **3.** Makub Series Snake-Eye, 2004 **4.** Makub Series Rapter, 2004 **5.** 1/20 S.A.F.S. Mk.III Rapter, 2003 **6.** 1/20 S.A.F.S., 2003

1–2

3–5

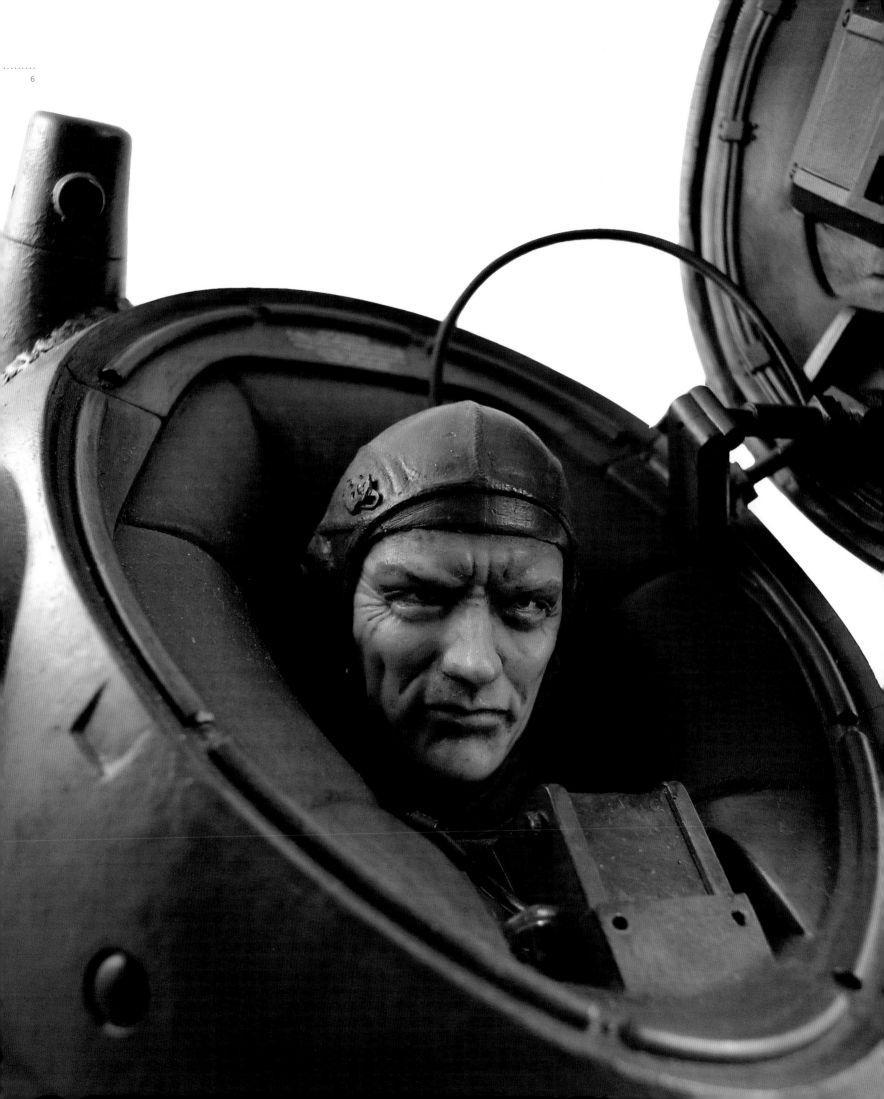

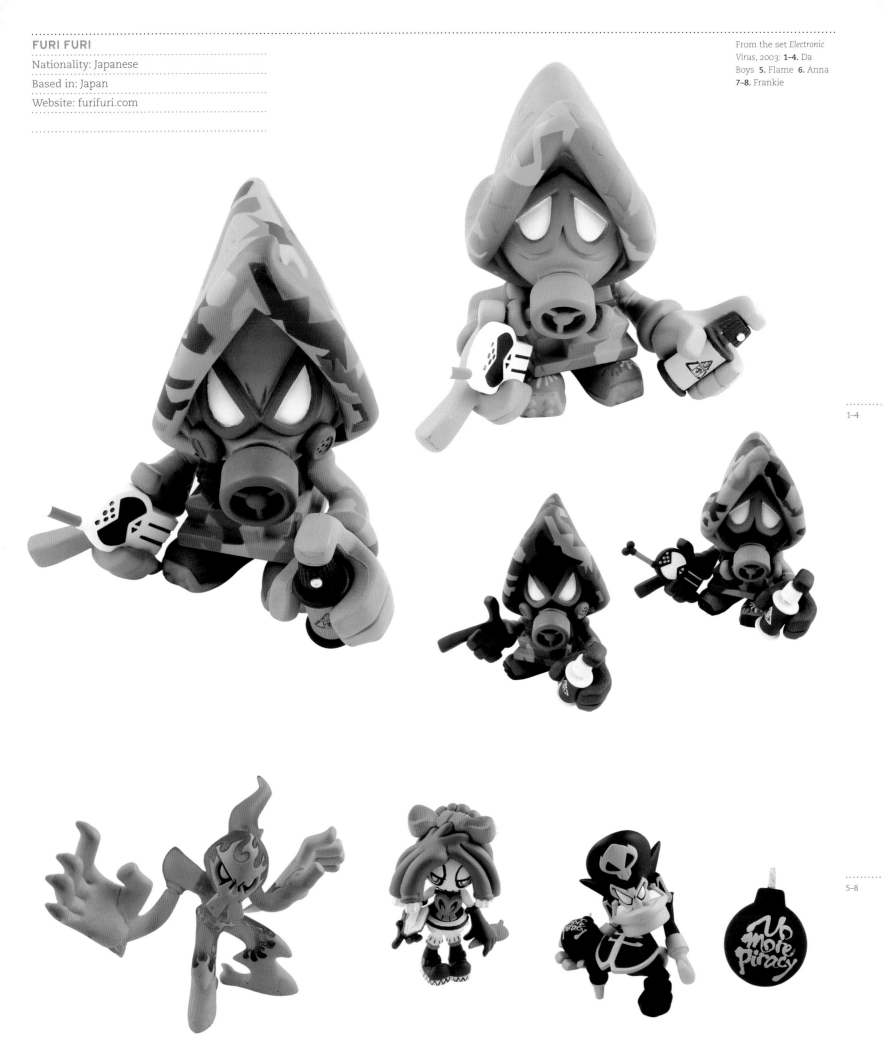

From the set *Electronic Virus*, 2003: **1–4.** Da Boys **5.** Flame **6.** Anna **7–8.** Frankie

1–4

5–8

9. Yoshida-kun Stuffed Doll, 1999 **10–11.** Pinky-chan & Furi Furi-kun Stuffed Doll, 1999 **12.** Mummy the Rabbit, 2003

From the set BUTAZUKA, 2003: **13.** Shimofuri Soldier **14–15.** Queen Buta **16.** Komori Buta **17.** Hataraki Buta **18.** Cook Buta

19. Bash 04, *Bash9*, 2003 **20.** Bash 08, *Bash9*, 2003 **21–22.** Elvis WA-LOHA, 2003

9–12

13–18

19–23

HEADLOCK STUDIO

Nationality: Japanese

Based in: Nagoya, Japan

Websites: headlockstudio.com; spanky.co.jp

Manufacturer: Spanky

1. Sick Boy Billy, 2003
2. Sick Boy Billy, *Super Festival Limited Edition*, 2003

1

2

3

4

1–2. Cherry & Mash (design by PEP), 2004 **3.** SPUMPKIN (Super Festival Limited Edition), 2002 **4.** RAY, 2002 **5–6.** RAY, *Hong Kong Toycon Limited Edition*, 2002

1–3

4–6

7–8

9–11

From the set *Wonderful Men*, 2004 (design by Wonderful Design Works):
1. Wonderfulman BANG-CHO **2.** Wonderfulman SUBURO

3–5. Mini Spanky, 2003 *Christmas Limited Edition Box*, 2003

1–2

3–5

From the set *Wonderful Men*, 2004 (design by Wonderful Design Works):
6. Wonderfulman JIRO Beams-T Limited Edition
7. Wonderfulman BANG-CHO Beams-T Limited Edition

8–10. Mini Spanky, 2003 *Christmas Limited Edition Box*, 2003

6–7

8–10

1–3. Captain Porno
Popeye Magazine
Limited Edition, 2004

1

2–3

4–6. Large Kobito (Purple, Yellow, Green), 2005 **7–9.** Kamebito (Northfield, Adamski, Coolrocker), 2004 **10–11.** King Hoo Snack, 2003 **12.** King Hoo, 2003

4–6

7–9

10

11–12

MAYWA DENKI

Designer: Nobumichi Tosa

Nationality: Japanese

Based in: Tokyo, Japan

Websites: maywadenki.com;
knockman.net; cube-works.co.jp

Manufacturer: Cube Co., Ltd.

From the set *KnockMan Family*: **1.** Knockman (White & Black), 2004 **2.** Pororon (White & Black), 2004 **3.** Kero-tama (White & Black), 2004 **4.** Chacha (White & Black), 2003

1

2–4

From the set *KnockMan Planet Volume 1*, 2005:
5–7. KnockMan Planet (Rocker, Chair, Cart)
8–11. KnockMan Planet (Pet, King, Flower, Pierrot)

5–7

8–11

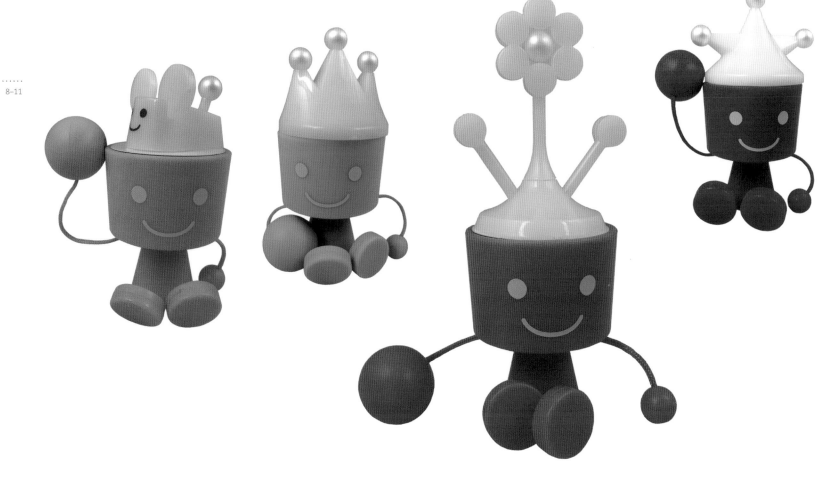

TGB DESIGN

Designer: Ishiura Masaru

Nationality: Japanese

Based in: Tokyo, Japan

Website: tgbdesign.com

From the set *Relax Boy*:
1. DJ90R **2.** Garage Kid
3. Relax Boy **4.** Tsuka-
moto Ichitaro **5.** Relax
Boy **6.** Band-Chan
7. Yoneda Ryota **8.** Neil
Nakamura

1–2

3–4

5–8

9–11

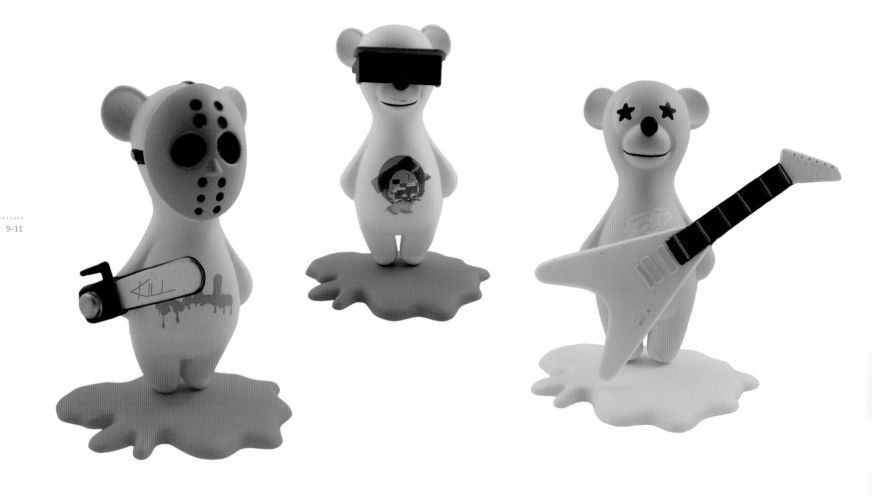

12–13

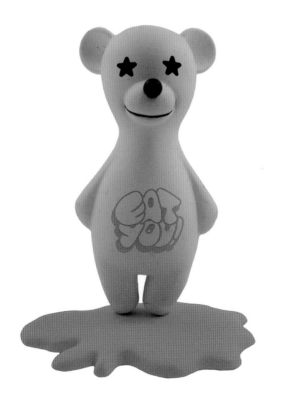

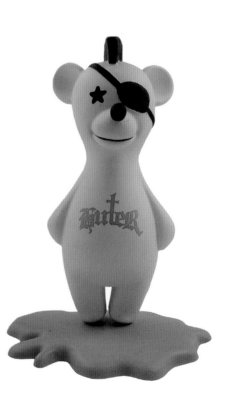

I AM PLASTIC : CHINA

HOT TOYS

Designers: Brothersfree (Winson Ma,
William Tsang, Kenny Wong)
Nationality: Chinese
Based in: Hong Kong
Websites: brothersfree.com; hottoys.com.hk

2

IWCA
offical identification

International
War Correspondent
Association

1

2

3

4–5

JASON SIU

Nationality: Chinese

Based in: Hong Kong

Website: jasonsiu.com

From the *Sound Speaker*
Series: **1.** Spearhead
(Summer Cool Version),
2003 **2.** Spearhead
(Kidrobot Version)

1

2

From the *Sound Speaker Series*: **3.** Spearhead (Kill Billy Version 2), 2004 **4.** Spearhead (Kidrobot Version) **5.** Sound Speaker (Special Edition), 2002 **6–7.** Woogie (Grey), 2005 **8.** N-3B (Orange Camo), 2004

3–5

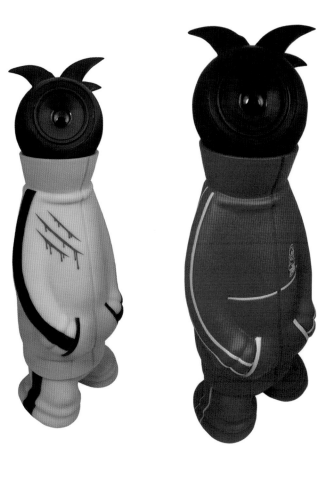
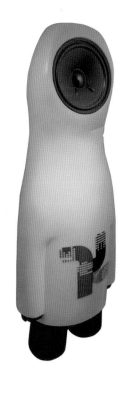

6–8

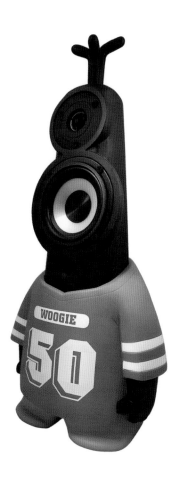
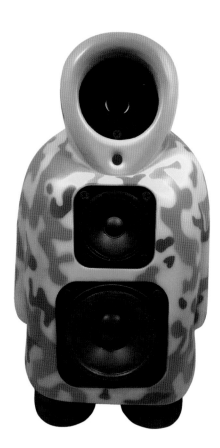

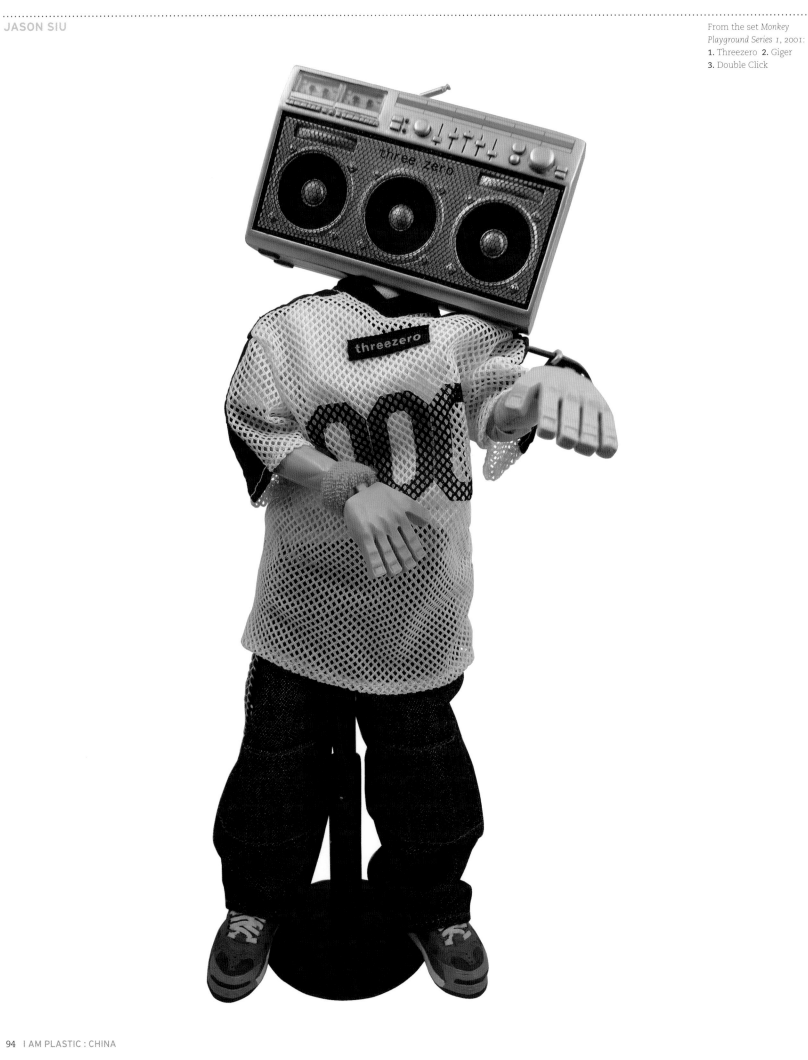

1

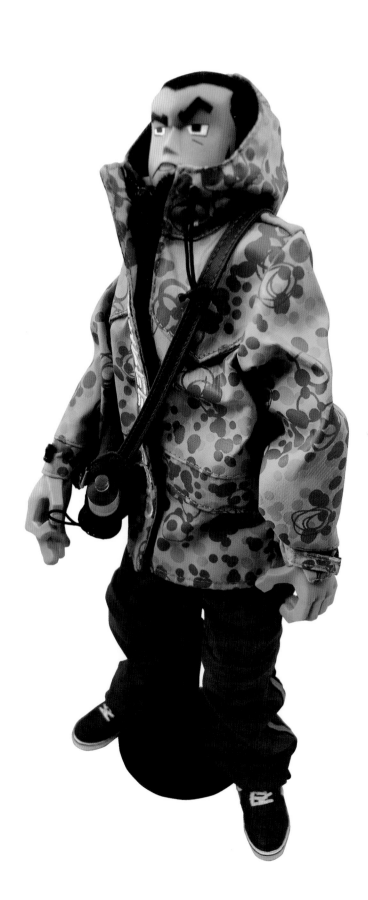

3

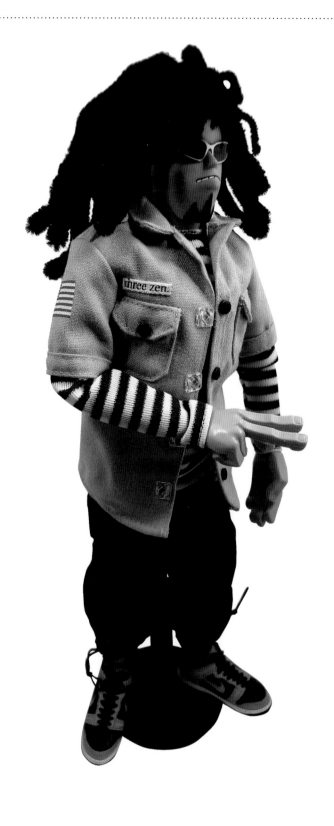

From the set *Gangster Paradise Series 1*, 2002:
1. Karl **2.** DJ Pete

3–5. Wooven Brothers, *Gangster Paradise*, 2002

1–2

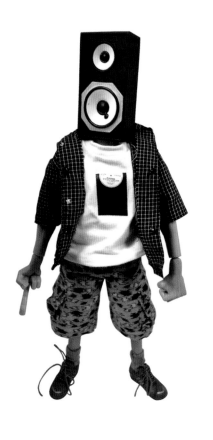

3–5

From the set *Monkey Playground Series 2*, 2002: **6.** Rapper Kurt **7.** Dada **8.** DJ Base

From the set *Monkey Playground 7-inch Vinyl Figure*, 2005: **9.** Golden Eagle

6–7

8–9

From the set *Dancing
with Gravity*, 2002:
1. DJ Dom (DJ Battle
Version) **2.** DJ Jammie
(DJ Battle Version)
3. Wooven **4.** Big Mac
5. Kurt **6.** Tappy

1–2

3

4–5

6

7–9

10–11

Nationality: Chinese

Based in: Hong Kong

1

2–3

4–7

8–11

1. CiBoys Deri, *Original Series*, 2002

1

CiBoys from the *Original
Series*, 2002: **2.** Deri
3. Go **4.** Hiro **5.** Migu
6. Nomi **7.** Poka **8.** To-7
9. X-Cite

2–3

4–6

7–9

CiBoys from the set
CiBoys Warrior, 2005:
1. General Migu
2. Warrior Deri
3. Warrior Deri Special
Edition

CiBoys from the set
CiBoys Games Master,
2005: **4.** Migu **5.** Poka
6. Go **7.** Nomi **8.** Hiro
9. Deri **10.** To-7

CiBoys from the set
CiBoys Star Wash, 2005:
11. To-7 "Sh-it" **12.** Nomi
"Soapie" **13.** "Robo Go"
14. Go "W.C30" **15.** Migu
"Washer Master"
16. Nomi "Dark Vapor"
17. Poka "Skywasher"

4–8

11–13

18–22

29–31

CiBoys from the set *CiBoys Super Hero*, 2004: **18.** Spider Deri **19.** Ranger Go! **20.** Ultra To-7 **21.** Super Deri **22.** X-Deri **23.** Masked Nomi **24.** Invisible Deri **25.** Captain Poka **26.** Hiro the Flash **27.** Bulk Migu **28.** Deri-Bat

CiBoys from the set *CiBoys Cowboy*, 2004: **29.** Go Purple Chief **30.** Poka Tear Bandit **31.** To-7 Red Chief **32.** Nomi Black Cowboy **33.** Hiro Sweat Bandit **34.** Deri White Cowboy **35.** Migu Patrol

1–3

9–10

14–17

23–28

32–35

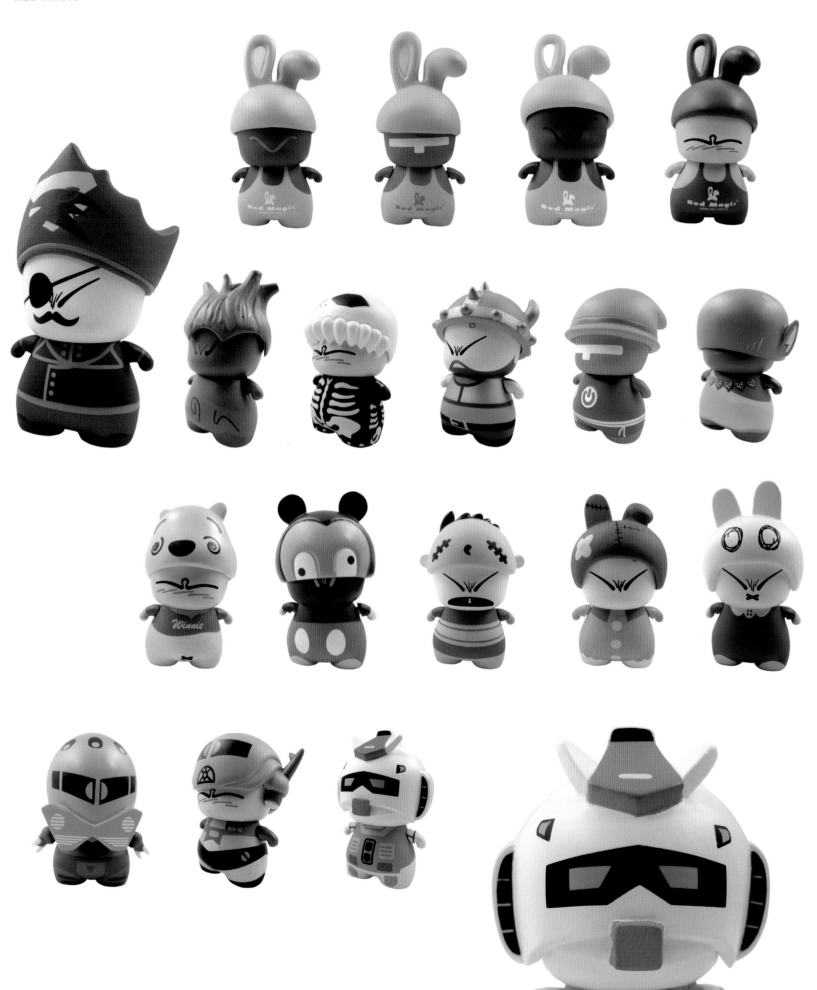

1–4

8–13

19–23

30–33

CiBoys from the set *CiBoys Red Magic Series* 2, 2005: **1.** Go **2.** To-7 **3.** Hiro **4.** Migu **5.** Poka **6.** Deri **7.** Nomi

CiBoys from the set *CiBoys Dark Age*, 2004: **8.** Deri "Pirate" **9.** Nomi "Treeman" **10.** Migu "Skull" **11.** Deri "Dwarf" **12.** To-7 "Wizard" **13.** Go "Flying Elf" **14.** Nomi "Army of Darkness" **15.** Poka "Knight" **16.** Deri "Devil Knight" **17.** Deri "Werewolf" **18.** Deri "Elf"

CiBoys from the set *CiBoys Crazy Cutie*, 2005: **19.** Migu "Winnie the Bear" **20.** Nomi "Mickey the Rat" **21.** Deri "Big Mouth Boy" **22.** Deri "Melo" **23.** Deri "Mif" **24.** Hiro "Gar Fei Cat" **25.** To-7 "Killer B" **26.** Deri "Yo! Kitty" **27.** Deri "Snooze-py" **28.** Go "Ding Ding Dong Dong" **29.** Poka "Ronald Duck"

CiBoys from the set *CiBoys x Gundam*, 2005: **30.** To-7 Z'Gok **31.** Migu Zeong **32–33.** Deri Gundam **34.** Poka Zaku **35.** Go Gyan **36.** Hiro Gouf **37.** Nomi Dom

5–7

14–18

24–29

34–37

From the set *Super Animal Machine (Sam) (World Attack Series)*, 2005: **1.** Sam "America" **2.** Sam "Italy" **3.** Sam "Egypt" **4.** Sam "France" **5.** Sam "China" **6.** Sam "England"

1

2–3

4–6

From the set *LaLa Couple 2* (*LaLa Outfit*), 2004: **7.** LaLa Couple "Cabin Crew" **8.** LaLa Couple "Fire Fighter" **9.** LaLa Couple "Space Explorer" **10.** LaLa Couple "Fairy Tale" **11–12.** LaLa Couple "Clinic Couple"

7

8–10

11–12

DA JOINT

Designer: Jet Yin (aka Ah Yin, Yung Kwok Yin)

Nationality: Chinese

Based in: Hong Kong

Website: dajoint.com.hk

1–2

3

1. ZMDC Brown Camo
Edition **2.** ZMDC Grey
Camo Edition **3.** ZMDC
K.U.S.A. Master Nova
Trooper **4.** ZMDC Metal
Edition

1

2

3–4

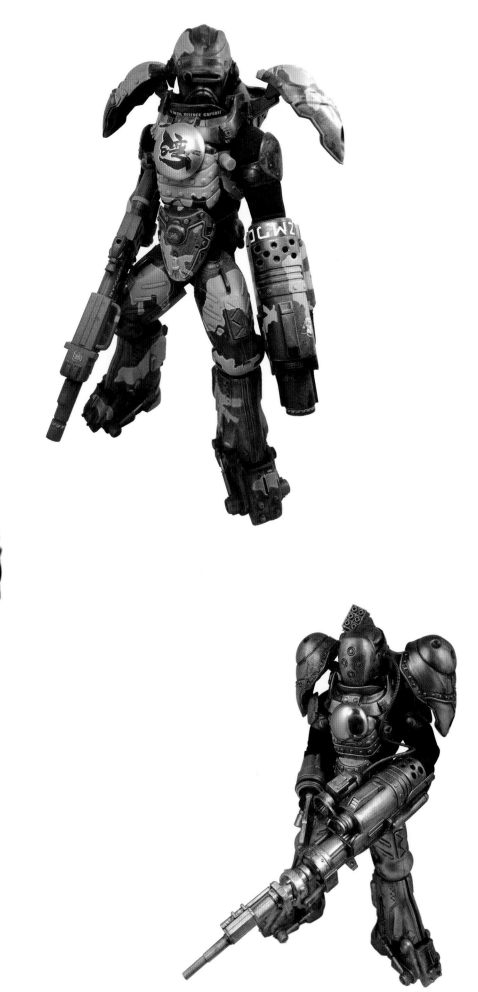

COVERT

Designer: Alex Lau
Nationality: Canadian
Based in: Hong Kong/Vancouver, Canada
Website: covertagent.com

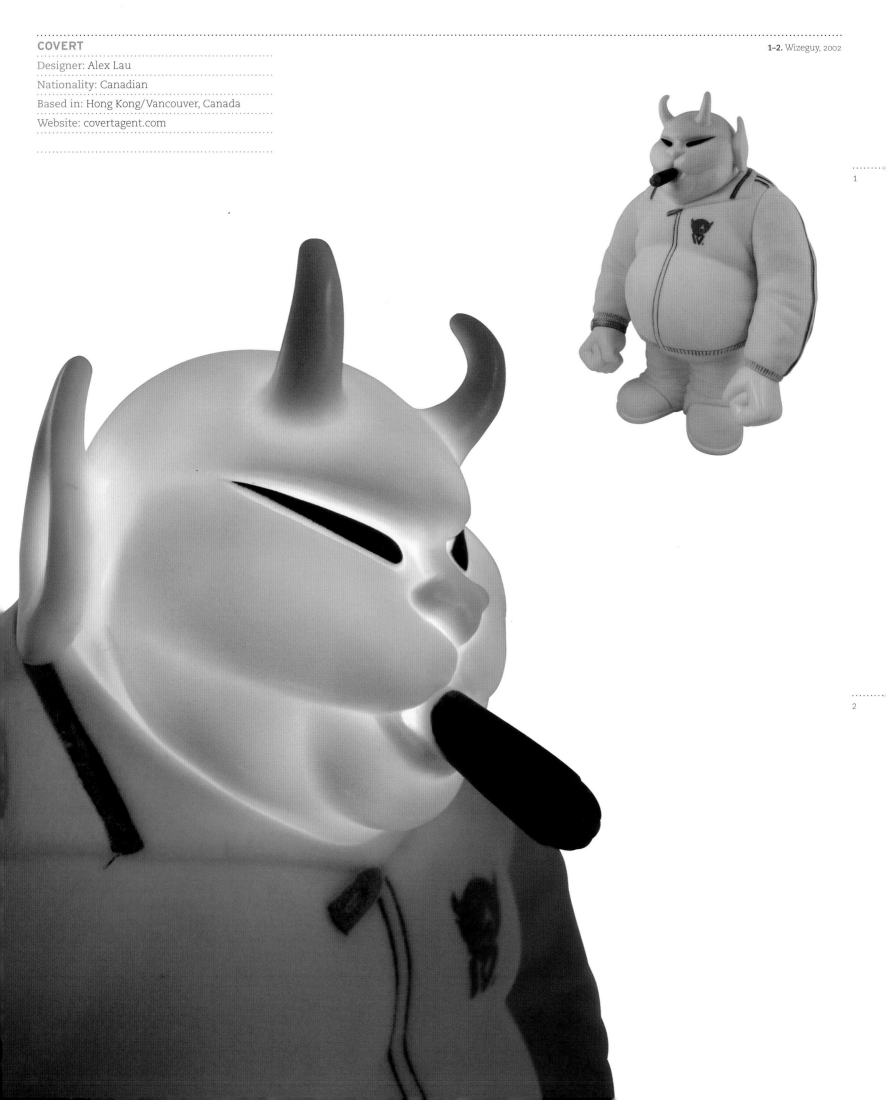

1

2

3–4

5–6

7–10

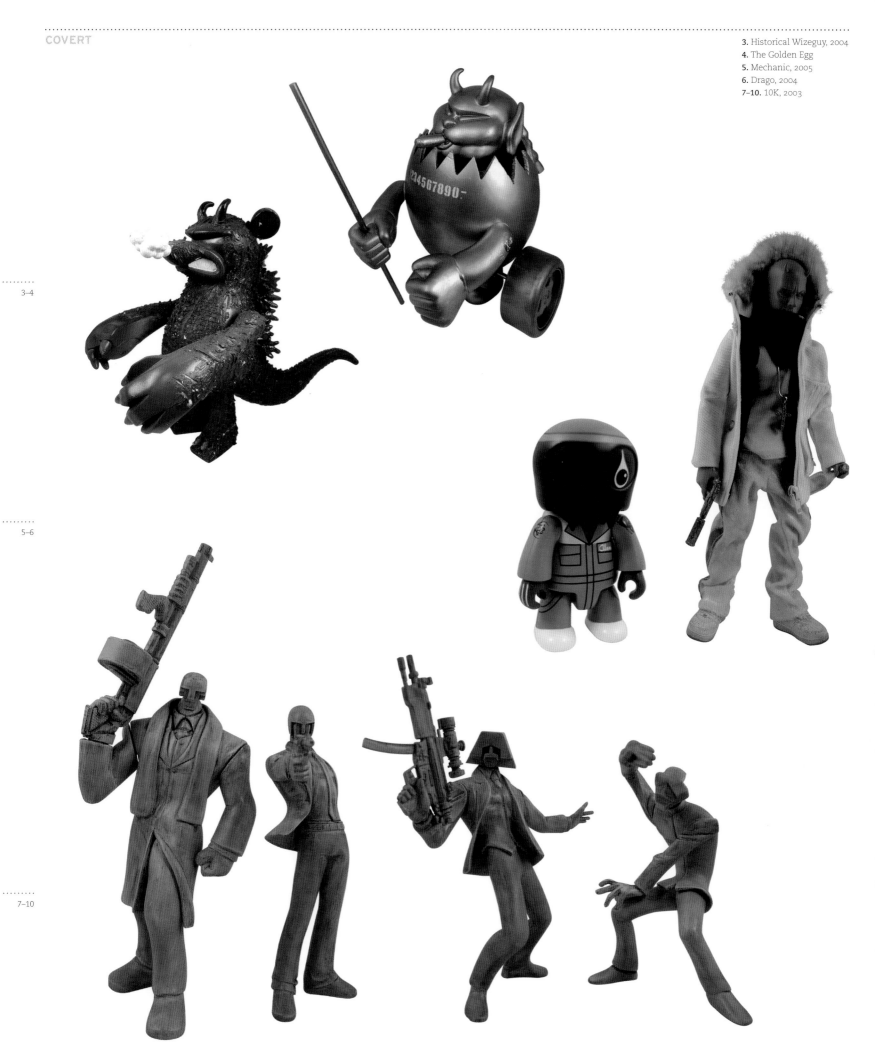

By Steve Lee:
1. Toyer (Black), 1998
2–3. Boyer, *Devil Toyer*,
2002 **4.** Toyer Bobbing
Head (White and Black
Strap), 2003 **5.** Toyer
Bobbing Head (White
and Red Bone), 2003
6–8. Toyer (Green), 1999

2–3

4–5

6–8

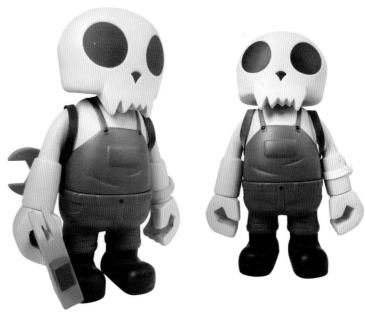

From the set *GalleColle*
03 – Banded Blaze, 2005:
1. Tygun (Pink)
2. Tygun (Green)
3. Tygun (Black)
4–5. Tygun (White)
6. Tygun (Green)
7. Tygun (Gold)

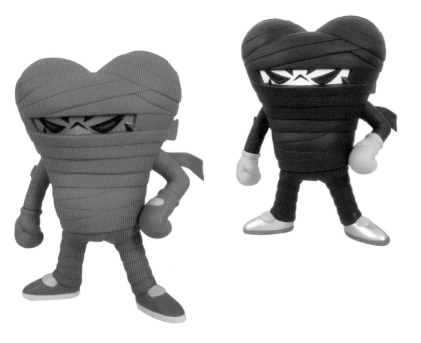

1–2

3

4–5

6–7

By Rolito (aka Semper Fi):

8. Rolitoboy, *Yoyamart Version*, 2005 **9.** Rolito-boy, *Oxop Version*, 2005 **10–11.** Rolitoboy, *Devil-robot Version*, 2005 **12–13.** Nedzed Rabbit (Artoyz Version), *Spicy Henry Twin*, 2006 **14–16.** Nedzed Rabbit (Pink), 2005 **17–18.** Nedzed Rabbit, *Blue Colette Version*, 2006

From the set *Rolitoland Safari Mini*, 2006: **19–20.** Lord Hunter (aka Dr. Von Jager) & Little Sarah **21–22.** Spicy Henry & Green T **23–24.** Ned Junior Jean Paul & Jean Pierre

8–11

12–14

15–18

19–23

1–2

3

4

5

1. Meomi Cat Qee, *2.5-inch Qee*, 2006

From the set *8-inch Qee*:
2. Zulu Cat Qee, 2003
3. Wrecker Panda Bear Qee by Tim Biskup, 2005
4–5. Deco Virus Bear Qee & Deco Plague Cat Qee (Comic-con Version) by Tim Biskup, 2005
6–7. Deco Virus Bear Qee by Tim Biskup, 2004

1–3

4–5

6–7

From the set *8-inch Qee*:
8. Gary Baseman Bear Qee, 2004 **9–10.** Deco Plague Cat Qee by Tim Biskup, 2003 **11–12.** The Buckingham Forest Bear Qee (Letter D) by Gary Baseman, 2005 **13–14.** Nervous Cosmonaut Bear Qee (Letter K) by Frank Kozik, 2005 **15–16.** Town Crier Bear Qee (Letter N) by Tim Biskup, 2005 **17–18.** Man Made Bear Qee (Letter Y) by David Horvath, 2005

8–10

11–14

15–18

From the set *2.5-inch Qee*:

V.S.O.P Version, 2005:
1. Henne Bear Qee
2. Nessy Bear Qee

Lane Crawford Version,
2005: **3.** Star Bear Qee
4. Moon Bear Qee **5.** Sun
Bear Qee

6. Lane Bear Qee, 2005
7. Crawford Bear Qee,
2005 **8–10.** Shogun Mon
Qee, 2004 **11.** PSP Bear
Qee, 2004

Sony Style Version, 2005:
12. Al Bear Qee **13.** Sony
Style Bear

1–2

3–7

8–10

11–13

14–17

18–21

22–25

26–29

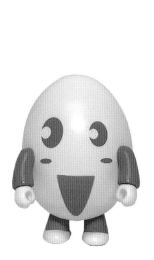
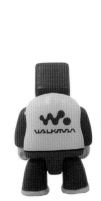

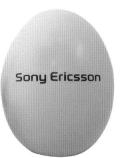

1–4

5–7

8–10

11. Evil Pinky, *Evil Kingdom Set*, 2004
12–14. *Evil Kingdom (Snorty Set)*, 2004
15–19. *Patchwork Pudgy*, 2005

From the set *Snorty & Friends*: 20. Snorty
21. Carbot (Exhibition Sample), 2005 22. Moo
23. Sweety, 2003

11–14

15–19

20–23

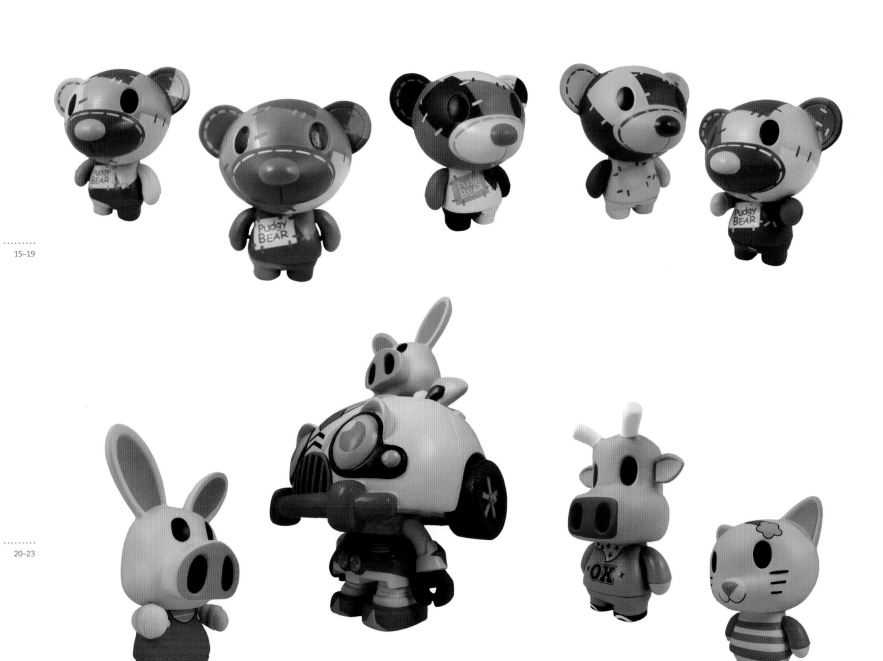

ADFUNTURE

Designers: Various

Nationality: Chinese

Based in: Shanghai, China

Website: adfuntureworkshop.com

By *Dave Silva*:
1. Fling (Colette Edition), 2004 **2.** Devilrobots Fling (Monkey-Robo), 2004 **3.** Fling (Customized by Dave Silva), 2003

4. D'Dog by D'Face, 2005

5. JAKe Ape (Regular Edition) by JAKe, 2004

1–3

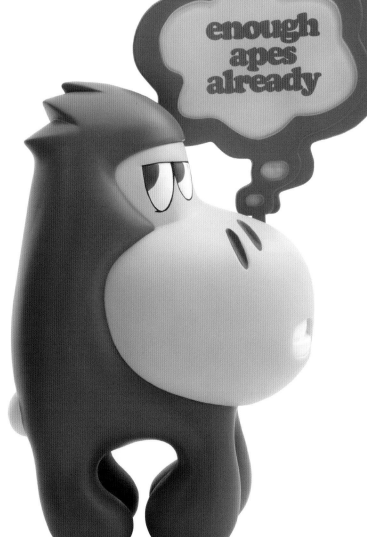

4–5

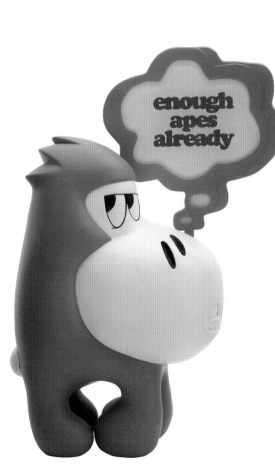

6–8

9–11

12–14

1

2–3

4–5

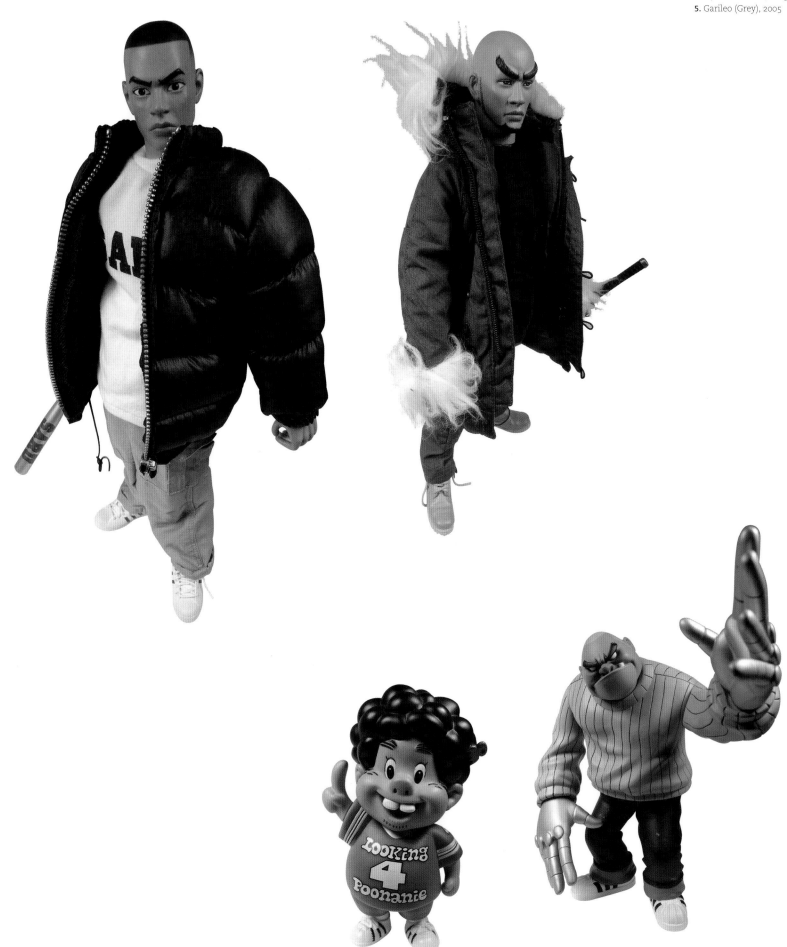

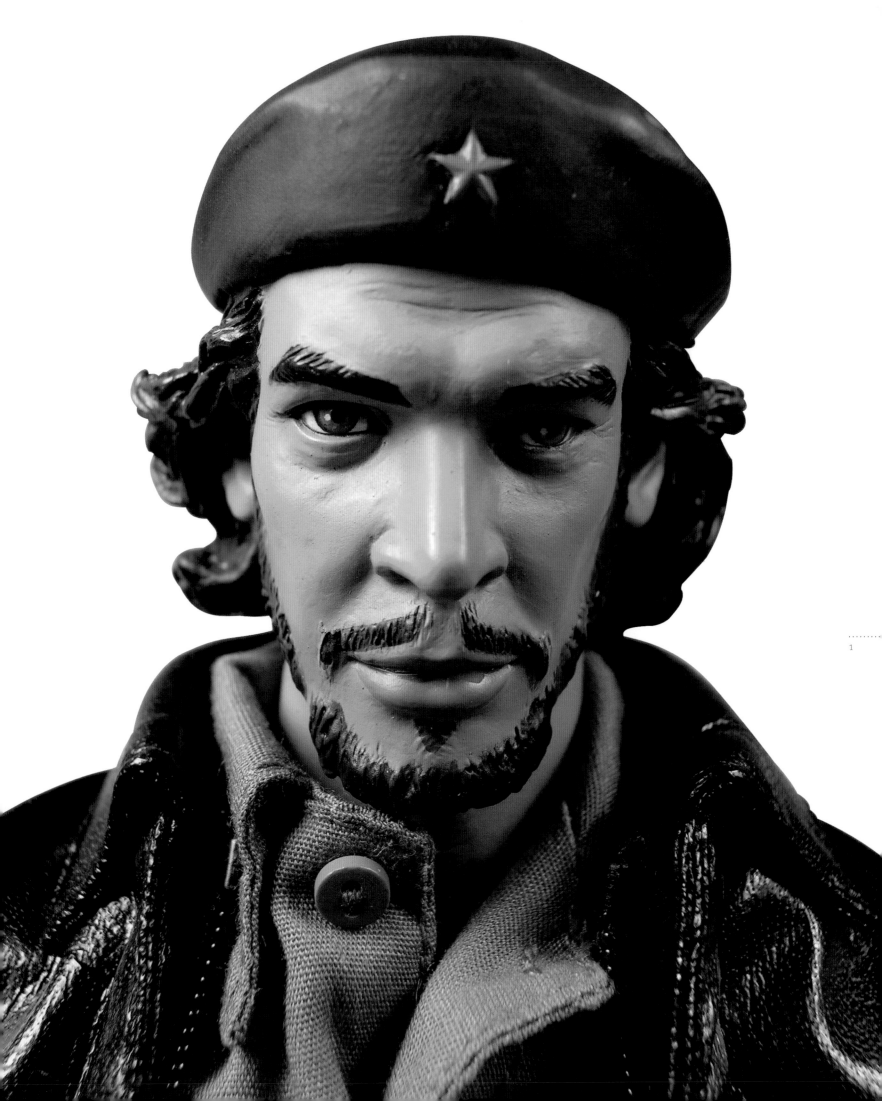

2

3–5

From the set *Full Time eBayer*, 2002: **1.** KFL
2–4. So Full Sam

1

2–3

Nationality: Chinese

Based in: Hong Kong

Website: everylittlethings.com

1. Dangerous Sperm, *Sex Exhibition*, 2005 **2.** Jeff, *Giveme5 – Levi's Original Watch Model*, 2005 **3.** Jasper, *Giveme5 – Milk Magazine Version*, 2002 **4.** Jasper, *Giveme5 – Premium Version*, 2003

1

2–4

5–7

8–9

1–2

3

4

5–7

8

Designers: Wendy Mak and Kevin Mak

Nationality: Chinese

Based in: Hong Kong

Websites: 2da6.com; d852interactive.com

Manufacturer: d852 Interactive Ltd.

1–2. Propane Gas Carrier
(Gulf), 2002

1

2

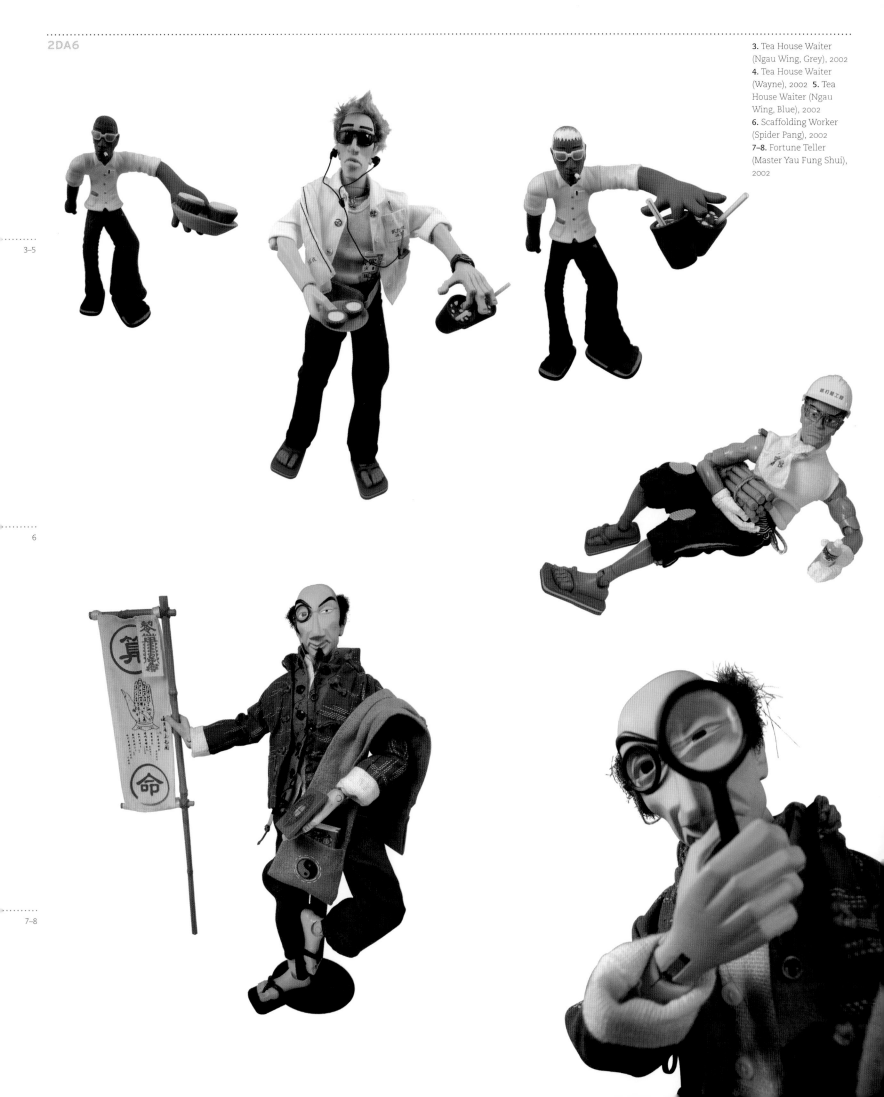

3. Tea House Waiter (Ngau Wing, Grey), 2002
4. Tea House Waiter (Wayne), 2002 **5.** Tea House Waiter (Ngau Wing, Blue), 2002
6. Scaffolding Worker (Spider Pang), 2002
7–8. Fortune Teller (Master Yau Fung Shui), 2002

1. Wanton, *Handmade 12-inch Action Figure (Friend Series),* 2002

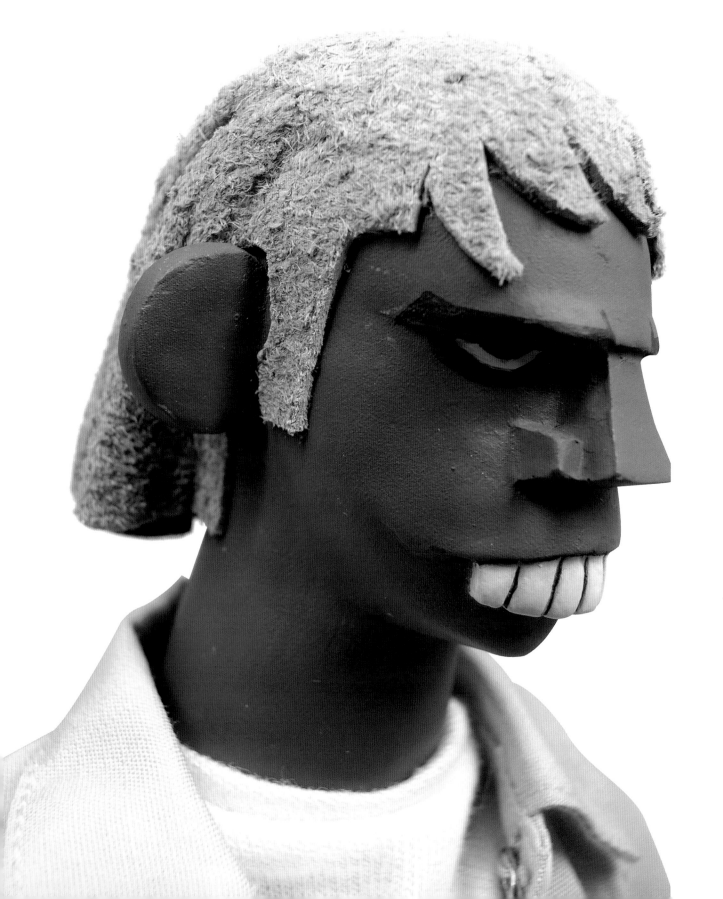

2. Gowster Bust, 2005
3. Gowster Kid, 2003
4. Gowster, *Toys Airmail Version (Japan)*, 2002

From the set *Handmade 12-inch Action Figure (Friend Series)*, 2001:
5. GI2L 6. Howie
7. Gabe 8–9. Kawo
10. James Jay

2–4

5–8

9–10

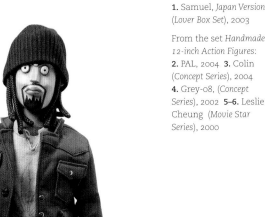

1. Samuel, *Japan Version*
(*Lover Box Set*), 2003

From the set *Handmade
12-inch Action Figures*:
2. PAL, 2004 3. Colin
(*Concept Series*), 2004
4. Grey-08, (*Concept
Series*), 2002 5–6. Leslie
Cheung (*Movie Star
Series*), 2000

1–3

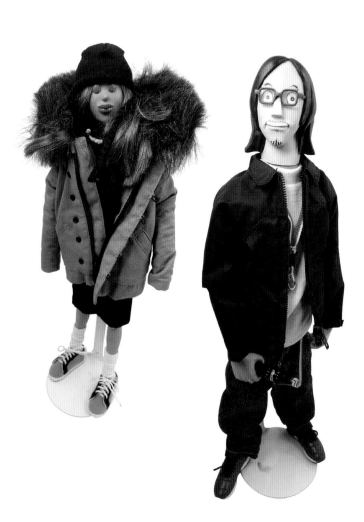

7–8

9–10

ESPERANTO DESIGN WORKSHOP

Designer: Colan Ho

Nationality: Chinese

Based in: Hong Kong

1. I Am Mustard Yellow, 2002 **2.** Space-R, 2002

From the set *United Planet-Mars Gunners*, 2004: **3.** Mini Mars Gunners by Colan Ho & Siu Fung **4–5.** Mars Gunners by Colan Ho & Siu Fung

1–2

3

4–5

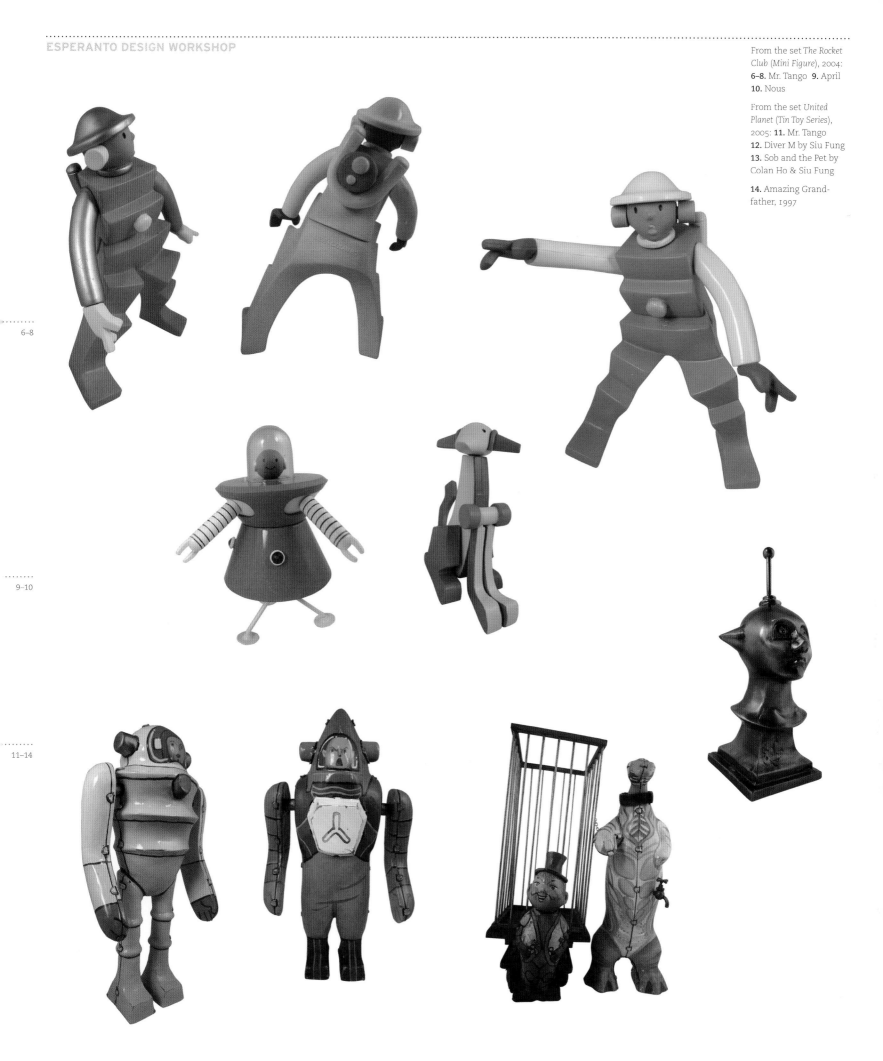

From the set *The Rocket Club (Mini Figure)*, 2004: **6–8.** Mr. Tango **9.** April **10.** Nous

From the set *United Planet (Tin Toy Series)*, 2005: **11.** Mr. Tango **12.** Diver M by Siu Fung **13.** Sob and the Pet by Colan Ho & Siu Fung

14. Amazing Grandfather, 1997

6–8

9–10

11–14

DA TEAMBRONX

Designer: Tim Tsui

Nationality: Chinese

Based in: Hong Kong

Website: teamzero.com.hk

1

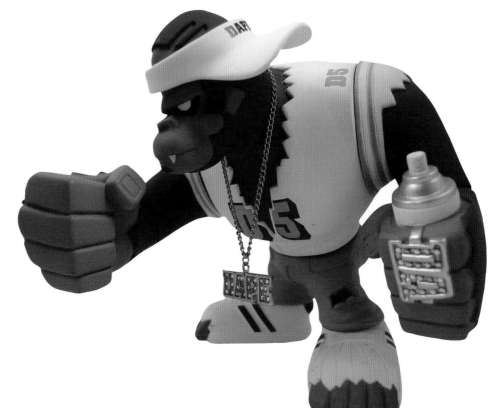

1–2. King (Royal Elastics Version), *Da TeamBronx*, 2003

From the set *Da Team-Bronx* (Handmade 12-inch): 3. King, 2002
4. Kevin, 2003 5. Simon, 2003 6. Mr. One, 2003
7. Zero, 2002 8. Kato, 2002

1–4

5–8

9

10–11

I AM PLASTIC : **EUROPE**

PETE FOWLER

Nationality: British

Based in: London, United Kingdom

Websites: monsterism.net; playbeast.com

Manufacturer: Playbeast

1. Boris (Original), 2002

From the set *Coin Bank*,
2003: **2.** Bone Bank
3. Worm Bank (Blue)
4–5. Squid Bank
6. Worm Bank

1–2

3–6

From the set *Monstrooper
7-inch Vinyl:* **1.** Artic
Monstrooper, 2002
2. Monstrooper (Black),
2002 **3.** Monstrooper
(Red), 2001 **4.** Original
Monstrooper (Green),
2001

1–2

3–4

From the set *Cam-Guin*,
2004: **5.** Cam-Guin
(Brown) **6.** Cam-Guin
(Snow) **7.** Cam-Guin
(Red)

8–9. Janitor, 2003
10. Janitor (Brown), 2003

5–7

8–9

10

1–2

3

4–5

6–8

9–12

1. Martin, 1998
2. King Ken III, 2005

1

From the set *In-Crowd: Zombies*, 2003:
1. "Dangerous" Dave
2. Helen **3.** Steve
4. Rhonda **5.** Rusty
6. Nancy

From the set *In-Crowd: Forever Sensible Motorcycle Club*, 2003:
7. Red **8.** Kathleen
9. Astrid **10.** Eric
11. Alison **12.** Mongo

.......... 1–6

.......... 7–8

.......... 9–12

From the set *In-Crowd:
Ages of Metal*, 2003:
13. William **14.** Ian
15. Magnus **16.** John
17. Terry **18.** Vincent

From the set *In-Crowd:
House of Horror*, 2003:
19. Wolfo **20.** Monzstro
21. Mumbo **22.** Szimon
23. Szofia **24.** Monszstra

13–15

16–18

19–24

From the set *In-Crowd: Punk Is Not Dead*, 2004:
1. Nige **2.** "Lieutenant" Les **3.** Jean Paul
4. Ferg **5.** "New Wave" Dave **6.** Bunty

1–3

4–6

From the set *In-Crowd:
Young Ruffians*, 2004:
7. Josh **8.** Ezra **9.** Snake
10. Caleb **11.** Bam Bam
12. Caution

From the set *In-Crowd:
Major Moulty's Amazing
Magical Plastic Band*,
2005: **13.** Moulty
14. Algernoon **15.** Chas
16. Basildon **17.** Neil
18. Desmond

7–12

13–15

16–18

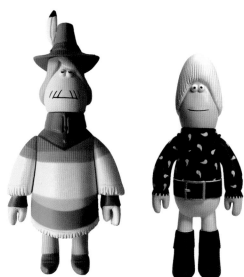
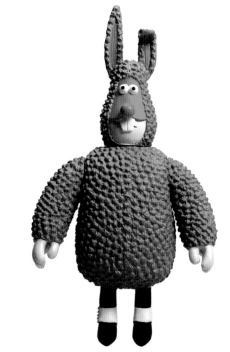

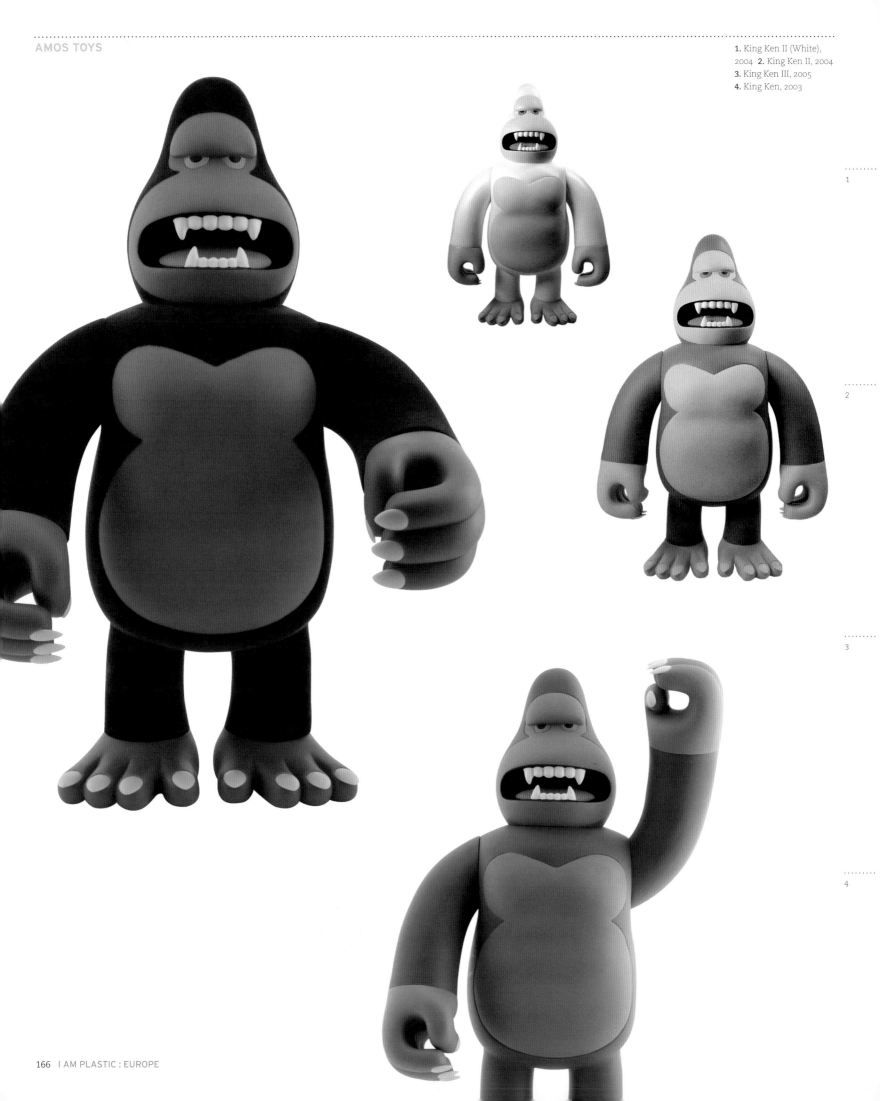

1. King Ken II (White), 2004 **2.** King Ken II, 2004 **3.** King Ken III, 2005 **4.** King Ken, 2003

1

2

3

4

5–6. Mr. Vortigern,
Vortigern's Machine, 2005

From the set *In-Crowd:
ICWF*, 2005: **7.** "Hairy"
Hans Nation **8.** Mahobin
9. El Viejo **10.** Man Love
11. Lord Humungous
12. Boner **13.** Ken Jr.

5–6

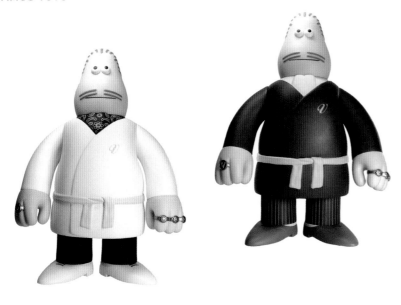

7–9

10–13

1. Helmut the Hot
Dog Man (design by
Will Sweeney), *Tales
from Greenfuzz*, 2005
2–3. Harvey and Jubs,
Vortigern's Machine, 2005
3. Wiggins, *In-Crowd: The
Thin Blue Line*, 2004

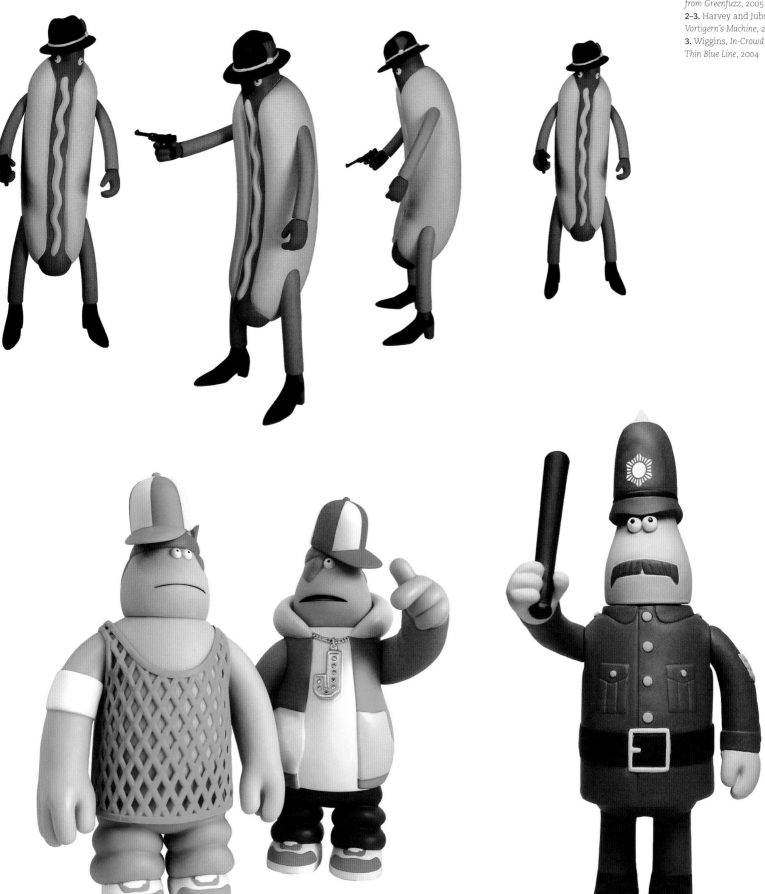

1

2–4

From the set *In-Crowd: The Old Guard*, 2004: **5.** Paula **6.** Hengist **7.** Ebi-chan **8.** Strong Running River **9.** Tony **10.** Misha

5–7

8–10

JAMIE HEWLETT

Nationality: British

Based in: London, United Kingdom

Websites: gorillaz.com; kidrobot.com

Manufacturer: Kidrobot

From the set *Gorillaz*:
1. Russel (Red)
2. Noodle (Red)

1

2

3–5

6–7

TOKYOPLASTIC

Designers: Andrew Cope and Sam Lanyon Jones

Nationality: British

Based in: London, United Kingdom

Websites: tokyoplastic.com; flying-cat.com

Manufacturer: Flying Cat

1–2

3–4

MIST

Nationality: French

Based in: Paris, France

Website: go2mist.com

Manufacturer: BonusToyz

5

6

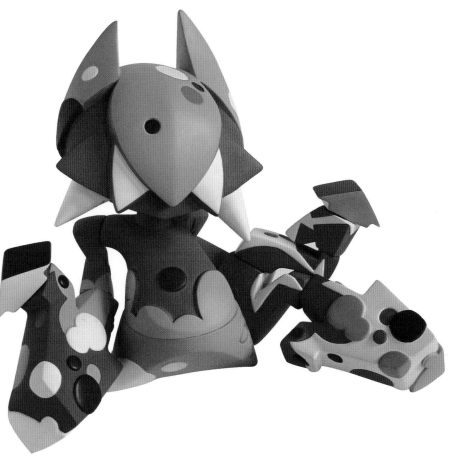

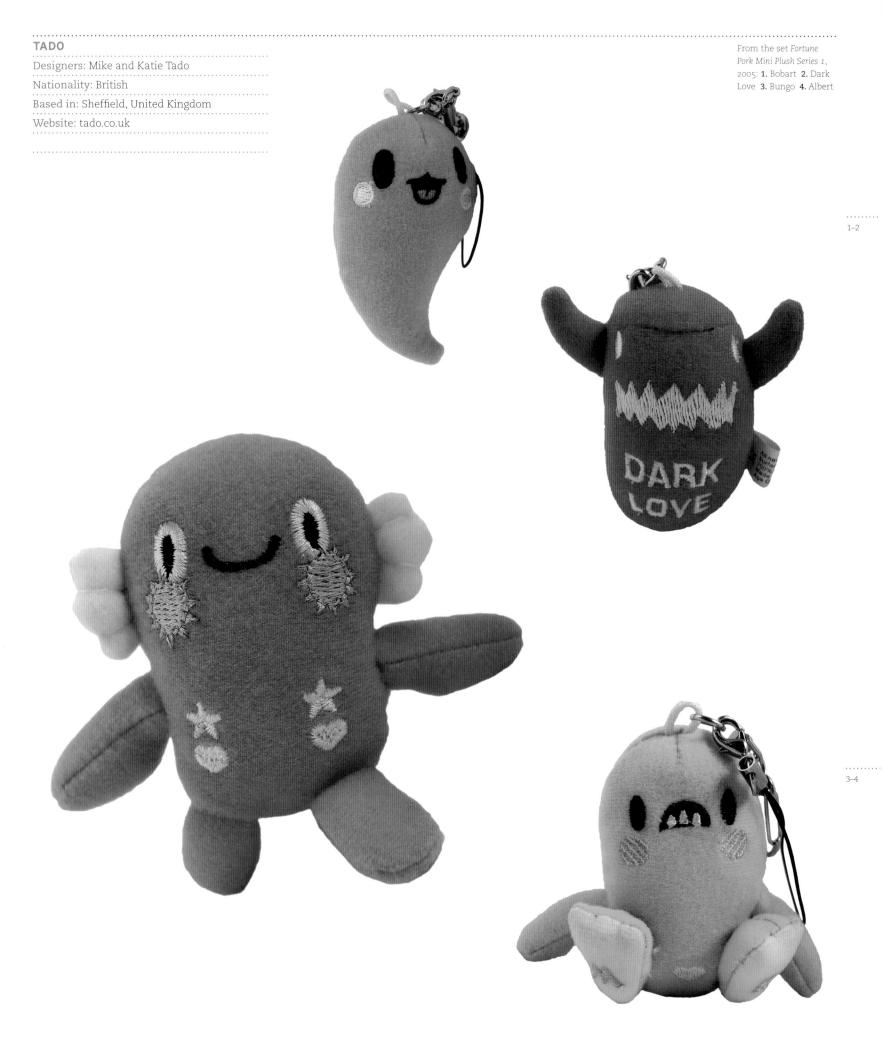

TADO

Designers: Mike and Katie Tado

Nationality: British

Based in: Sheffield, United Kingdom

Website: tado.co.uk

From the set *Fortune Pork Mini Plush Series 1*, 2005: **1.** Bobart **2.** Dark Love **3.** Bungo **4.** Albert

1–2

3–4

DARK LOVE

5–7

8

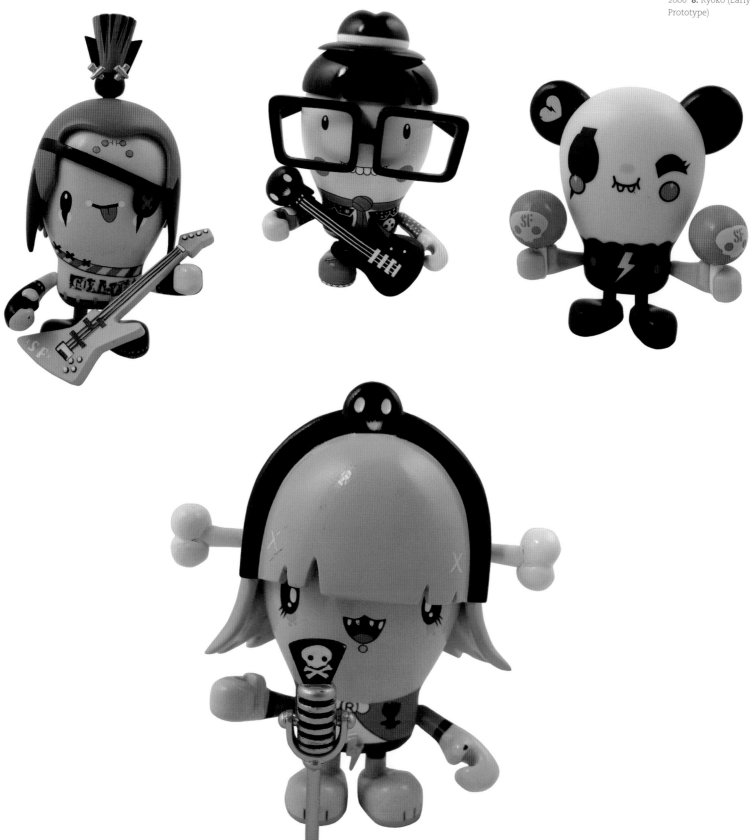

MARK JAMES

Nationality: British

Based in: London, United Kingdom

Websites: akamushi.com; cardboy.tv

Manufacturer: Playbeast

1

2

3–4

5–6

7–8

1–2

3–7

8–10

From the set *Stereotype 3: From Outer Space*, 2005:
1. Dirt **2.** Fez **3.** Beca
4. Kuku **5.** Pico **6.** Scien
7. Nami **8.** Simon **9.** Kiki
10. Boo

11–12. Be My Slave Dunny, 2005

11–12

1. Flake and Fluid, *Switch Coarsetoys (First Release)*, 2004 2. Flake and Fluid, *Cream Coarsetoys (First Release)*, 2004 3. Rowley, *Coarsetoys (Second Release)*, 2006 4. Cream Float 5. Fluid, *Cream Coarsetoys (First Release)*, 2004

1. Kubrick (Prototype)
2. André Plush Figure

1

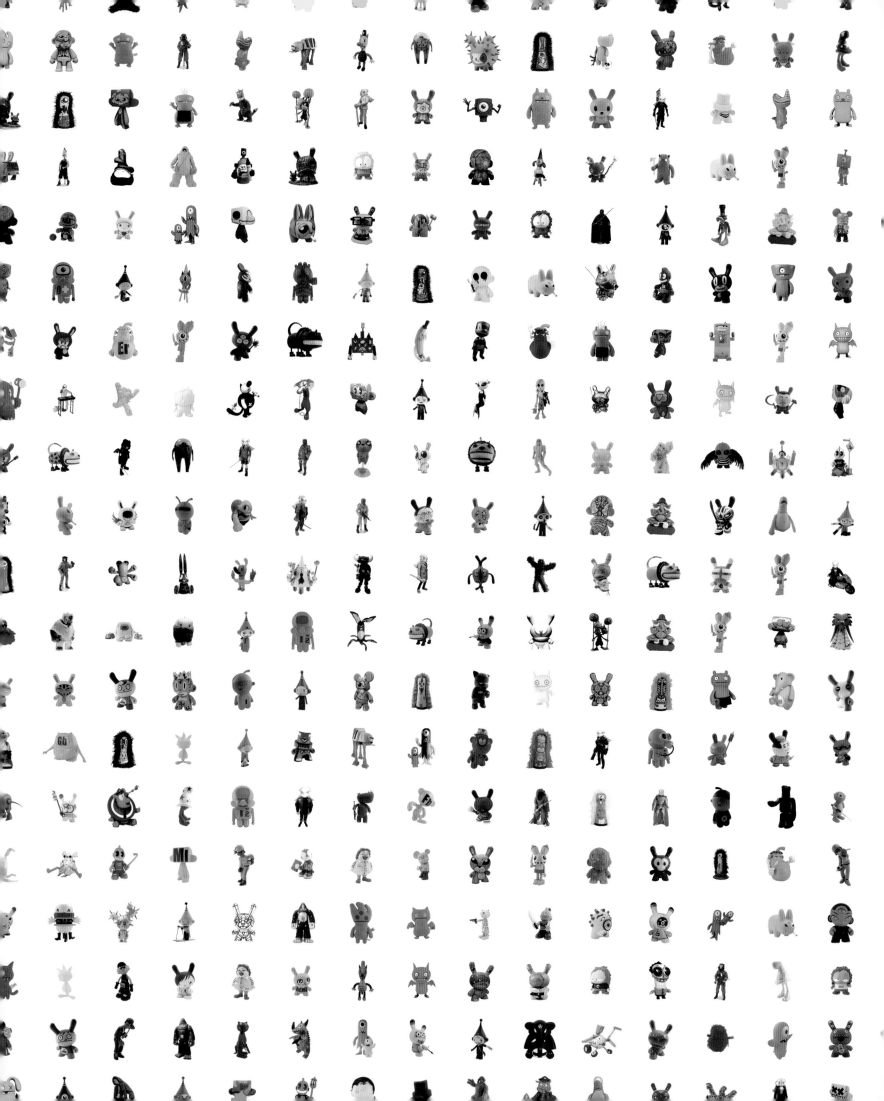

I AM PLASTIC : **UNITED STATES**

1

2

1–3

4–7

From the set *Baseman's Dunces Vanimal Zoo*, 2003:
8. Fib **9.** ReTardy
10. Goody 2 Shoes
11. Ditch **12.** Lil Copy Cat

13. JP (White), *Fire Water Bunnies*, 2004

8

9–11

12–13

1

5

6

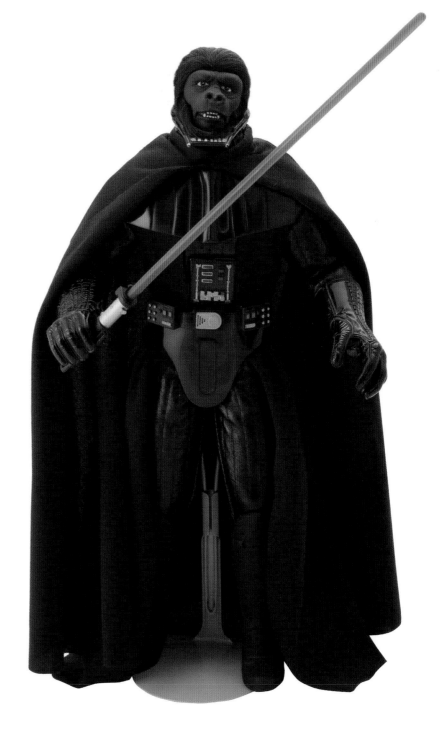

From the set *Guerillas in the Midst…*, 1996:
1. Sniper **2.** Pilot
3. Desert

From the set *Guerillas in the Midst…*, 1998:
4. Austrailian **5.** Tanker
6. WW2

1–3

4–6

7. Che Guevara (Proto-
type), *Handmade*, 1996
8. Baseball Furies, *Hand-
made*, 1997 9. Baseball
Furies (Warriors), *Hand-
made*, 1997 10–11. Be@r-
brick, *Inflatable Lover
with Deep Throat*, 2003

From the set *Caviar
Cartel*, 2003: 12. Zayitz
13. Volk

7–9

10–13

DALEK

Designer: James Marshall
Nationality: American
Based in: Brooklyn, New York
Website: dalekart.com

1–3

4–7

8–10

11. Diver Dunny (Green), 2005 12. Diver Dunny (Blue), unreleased 13. Diver Dunny (Yellow), 2005 14. Diver Dunny (White), 2005 15–16. Diver Dunny (Pink), 2005

11–12

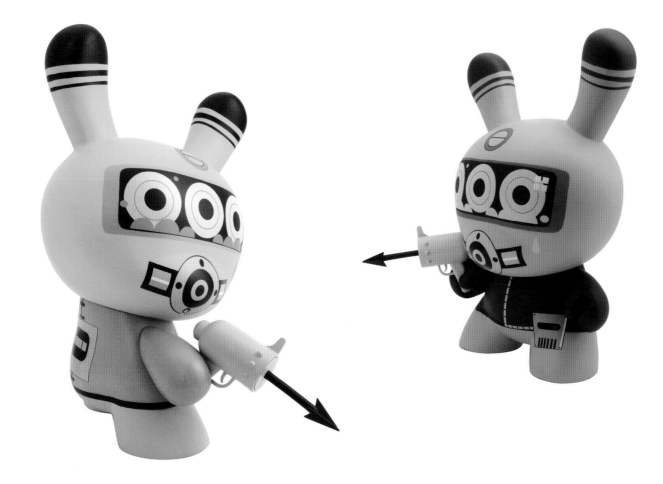

13–16

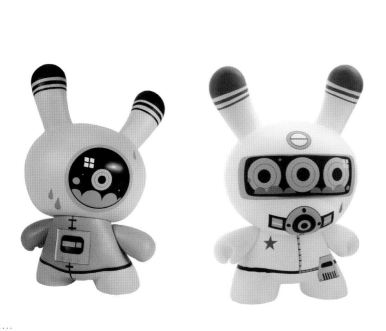

Designer: Osamu Koyama

Nationality: Japanese

Based in: Brooklyn, New York

Website: completetechnique.com

1. Custom Speaker
Medallion, CP002-SP,
2005 **2.** Custom Munny,
The Munny Show, 2005
3–4. ARION, 2005
5–7. Bottoms, 2004

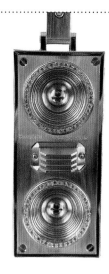

1

2–4

5–7

FRIENDS WITH YOU

Designers: Sam Borkson and Arturo Sandoval III

Nationality: SUPER

Based in: Miami, Florida

Website: friendswithyou.com

8

9–10

11–13

14–15

8. Mr. TTT, *Prototype*, 2002

From the set *Friends With You*, 2002: **9–10.** Poppings **11.** Albino Squid **12.** King Albino **13.** Barby with Spirit Suit **14.** Xuxa **15.** Shoe Baca

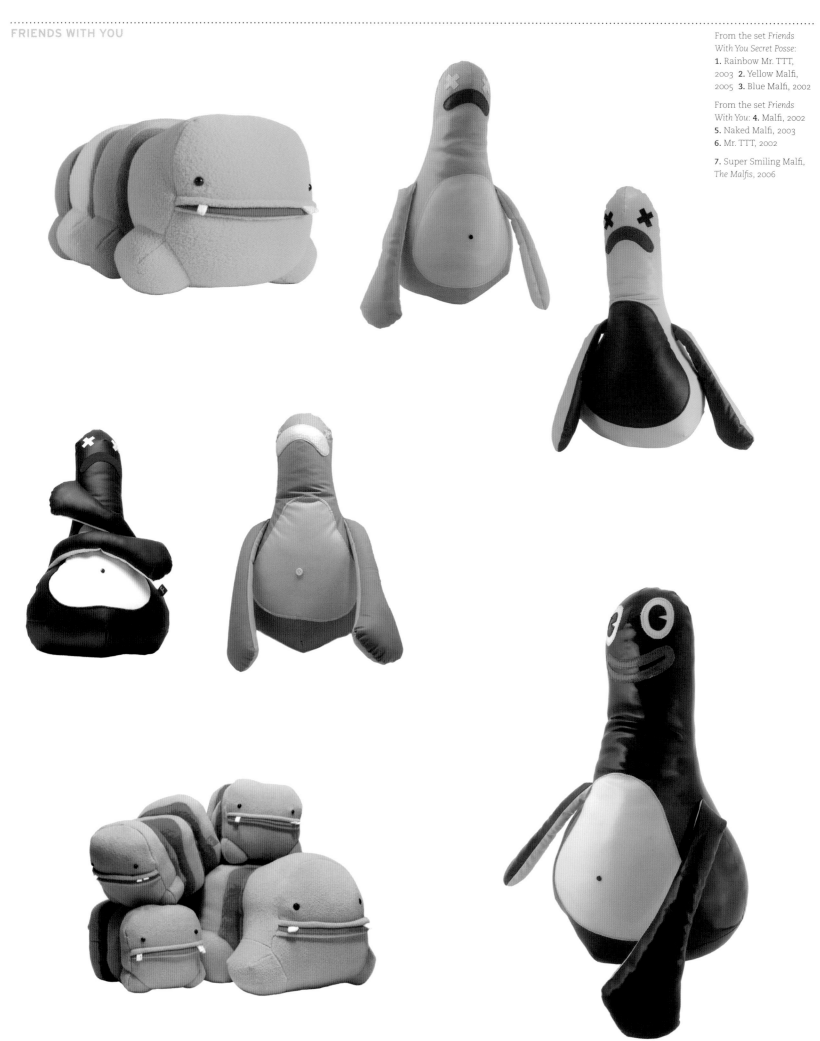

From the set *Friends With You Secret Posse:*
1. Rainbow Mr. TTT, 2003 **2.** Yellow Malfi, 2005 **3.** Blue Malfi, 2002

From the set *Friends With You:* **4.** Malfi, 2002 **5.** Naked Malfi, 2003 **6.** Mr. TTT, 2002

7. Super Smiling Malfi, *The Malfis,* 2006

1–3

4–5

6–7

8–10

11–13

14–16

FRANK KOZIK

Nationality: Human/Sol 3

Based in: Pacific Rim

Website: frankkozik.net

Manufacturers: Kidrobot, Toy2R

1–2. Smorkin' Labbit (Pink) 3. Smorkin' Labbit (Orange) 4. Smorkin' Labbit (Blue) 5. Smorkin' Labbit (White) 6. Smorkin' Labbit (Glow in the Dark)

1–2

3

4–6

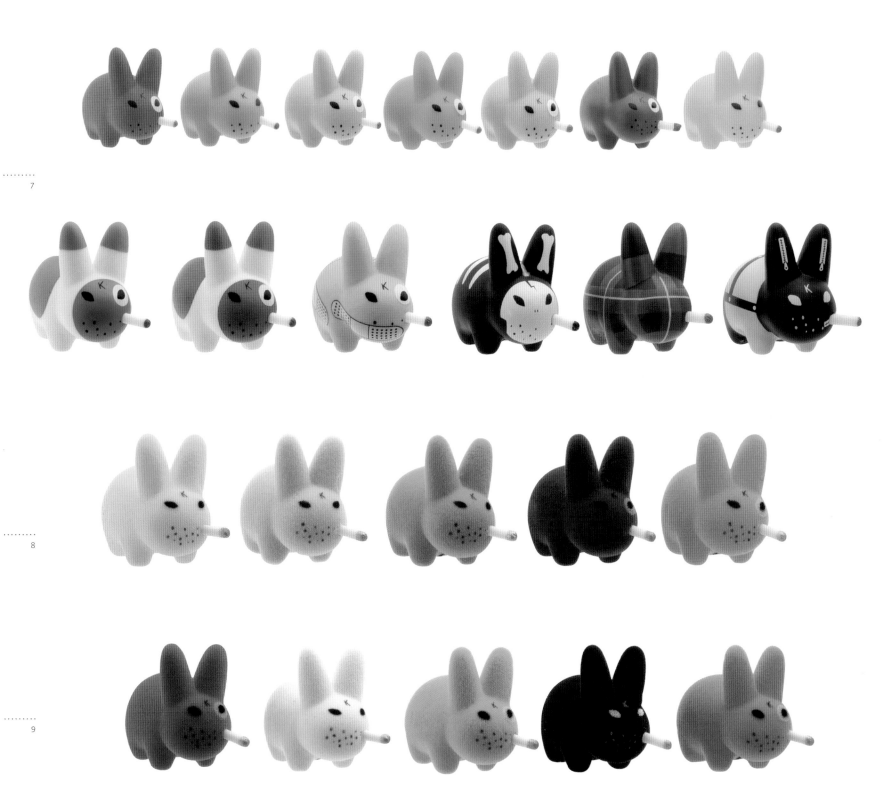

7

8

9

1. Dunny Lenin, *3D Retro
Exclusive Edition*, 2006
2. Dunny Mrs. Mao, 2005
3–4. Dunny Mao Water-
melon Accessory, 2005

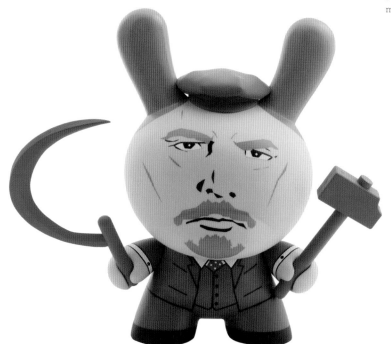

1

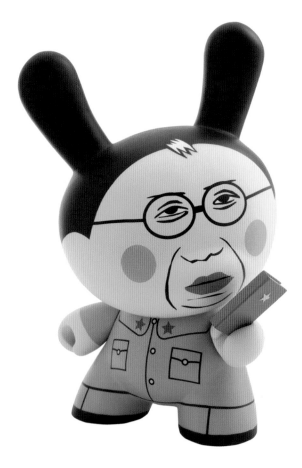

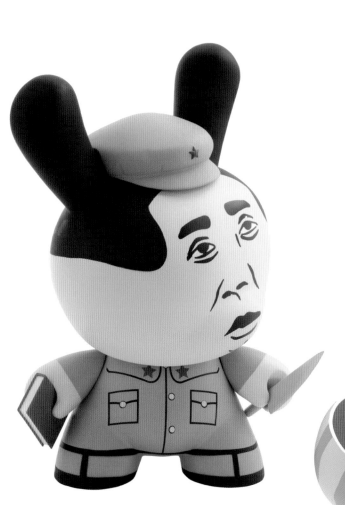

2–4

5–6

7

8–9

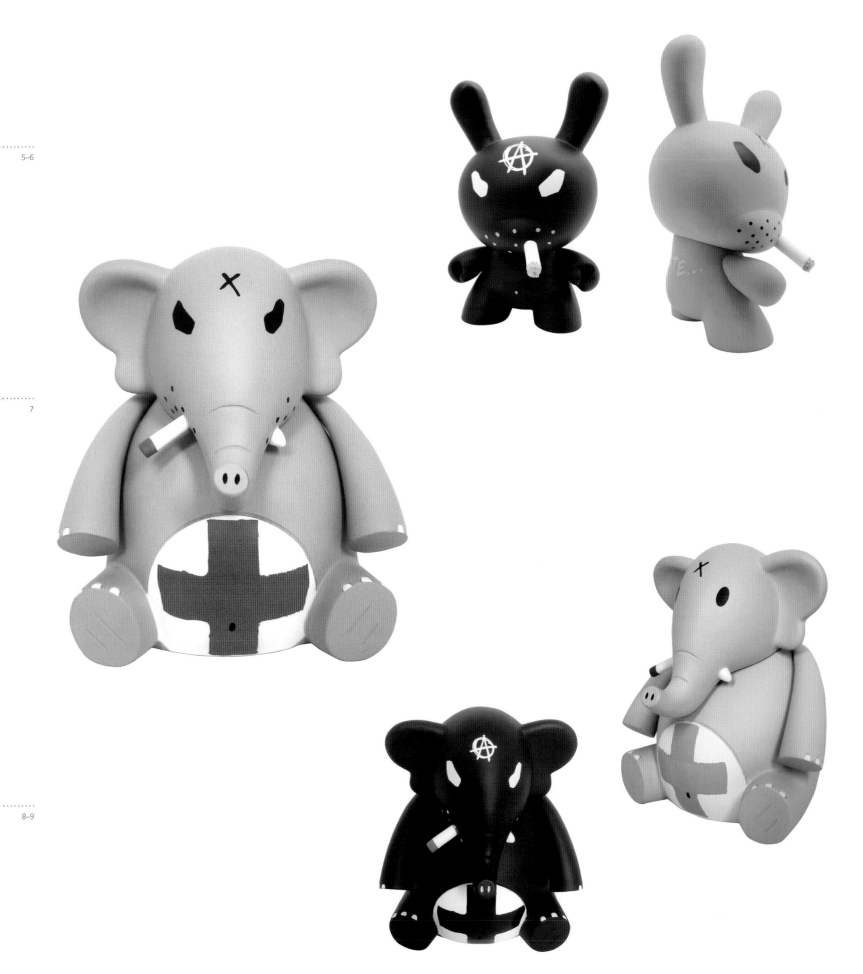

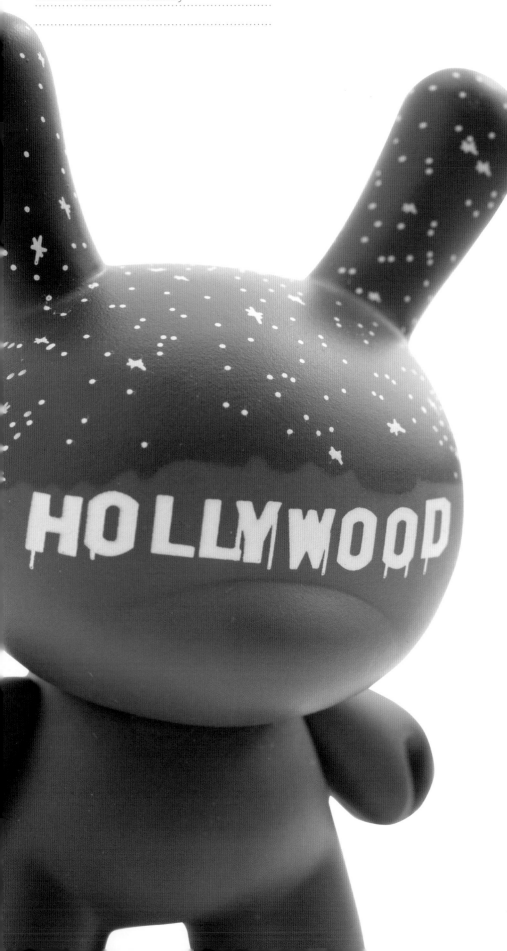

KIDROBOT/DUNNY

Designers: Various

Dunny shape: Tristan Eaton and Paul Budnitz

Nationality: American

Based in: New York, New York

Website: kidrobot.com/dunny

1

2

1. Dunny by Cycle, 2006
2. Dunny by Deph, *Series 2*, 2005

Dunny Secret (Hand Customized), *Series 2*, 2005: **3.** by Dr. Revolt
4. by Sket One **5.** by UPSO **6.** by Cycle
7. by Queen Andrea
8. by Tado

3–5

6–8

Dunny, *Series* 2, 2005:
1. by Dr. Revolt **2.** by Sket One **3.** by Tristan Eaton **4.** by Superdeux **5.** by UPSO **6.** by Tado **7.** by Glenn Barr **8.** by Deph **9.** by Sket One **10.** by Tristan Eaton **11.** by Cycle **12.** by Filth **13.** by Kozik

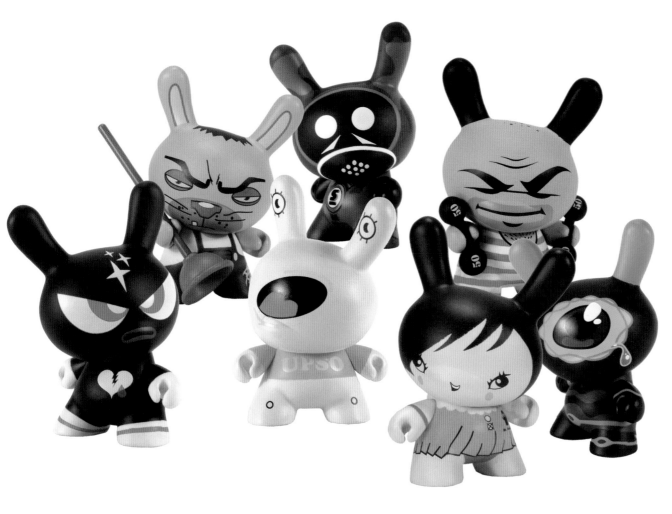

1–3

4–7

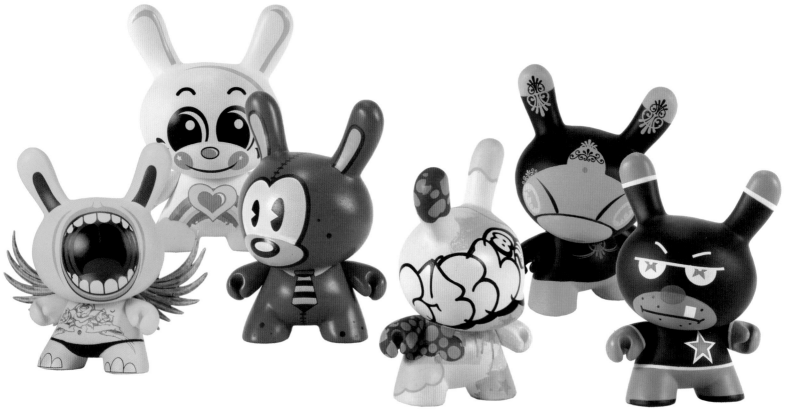

8–13

14–15

16–17

18–21

22

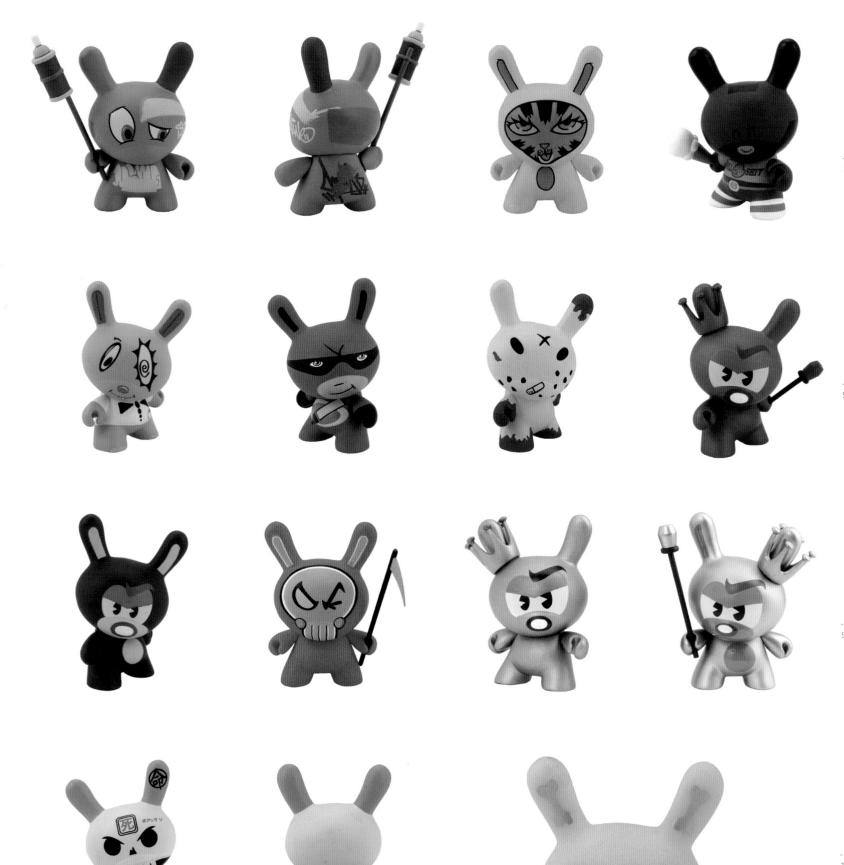

1–4

5–8

9–12

13–15

Dunny, *Series 1*, 2004:
1–2. by Shane Jessup
3. by Persue **4.** by
Superdeux **5.** by Quik
6. by Dr. Revolt **7.** by
Frank Kozik **8–12.** by
Tristan Eaton **13–14.** by
Huck Gee **15.** by Jerry
Abstract

16. Mexican Dunny
Custom by Headquarter,
Mexico, and The Huichol
Indians, 2005

16

1–2

3–5

6–9

10–12

By *Tristan Eaton:*
13. Dunny Voodoo (Black), 2004 **14.** Dunny Vodoo Swamp Edition, 2004 **15–16.** Dunny El Robo Loco, 2004 **17.** Dunny El Robo Loco SDCC Special

By *KOA:*
18. Dunny Flabby
19. Dunny Barbarian
20. Dunny Swamp

By *David Horvath:*
21–22. Dunny Little Inky (Brown), 2004
23–24. Dunny Little Inky (Blue), 2004

13–14

15–17

18–20

21–24

BARNEYS NEW YORK

Designers: Huck Gee (Skullhead figure);
Marc Jacobs, Dries Van Noten, Jil Sander,
Rick Owens, Duckie Brown (clothing)
Based in: New York, New York
Website: barneys.com
Manufacturer: Kidrobot for Barneys New York

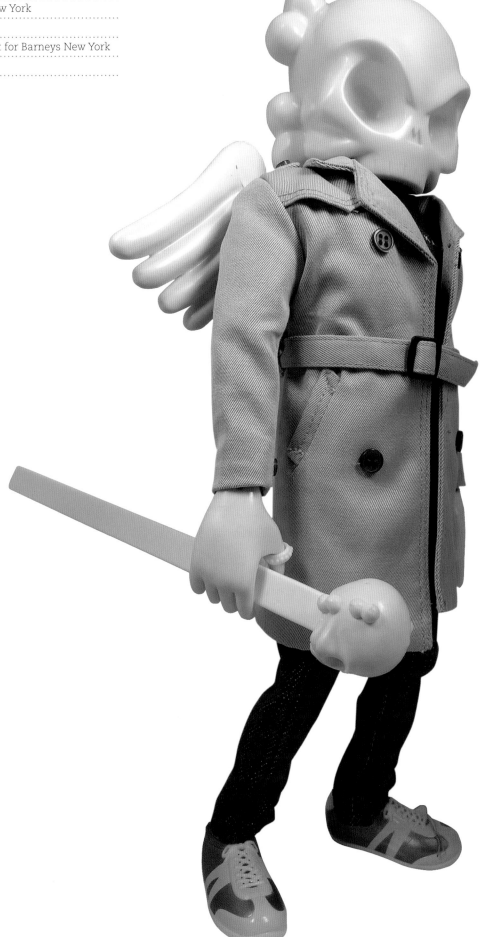

1

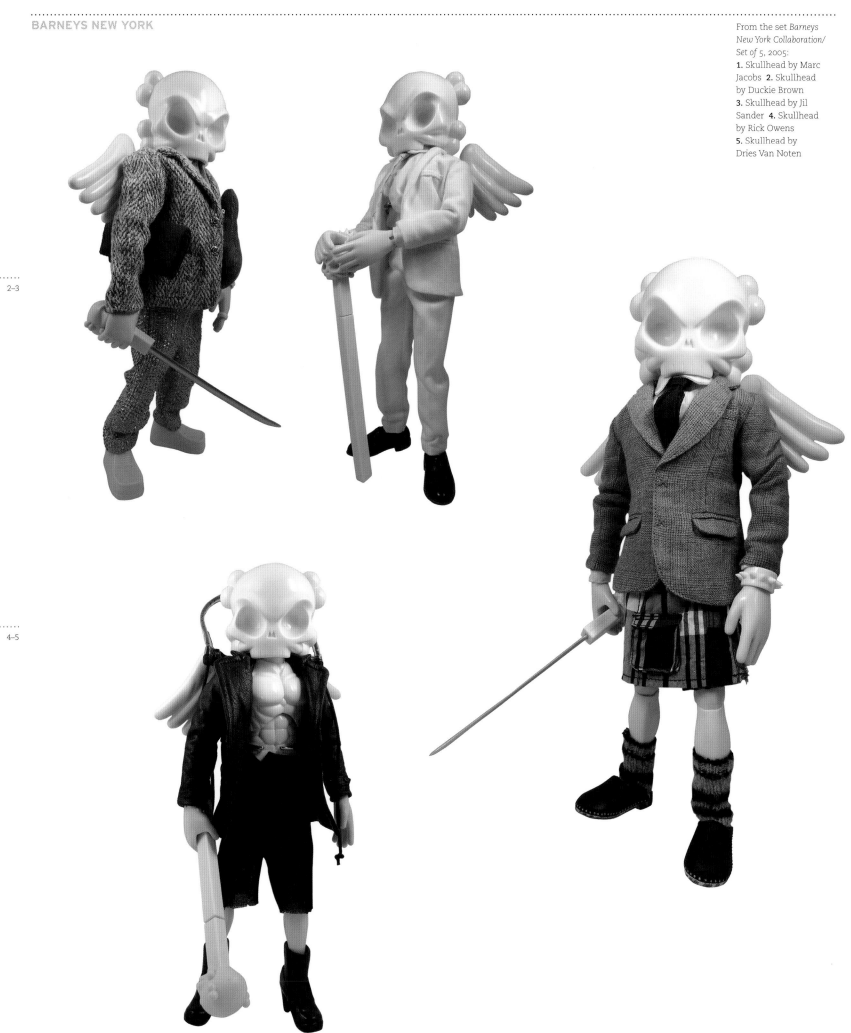

From the set *Barneys New York Collaboration/ Set of 5*, 2005:
1. Skullhead by Marc Jacobs **2.** Skullhead by Duckie Brown **3.** Skullhead by Jil Sander **4.** Skullhead by Rick Owens **5.** Skullhead by Dries Van Noten

2–3

4–5

ALIFE

Designer: Jest (Rob Cristofaro)

Nationality: American

Based in: New York, New York

Website: alifenyc.com

Manufacturer: Medicom

1. ALIFE Kubrick, *Who the Fuck Is Jest*, 2003

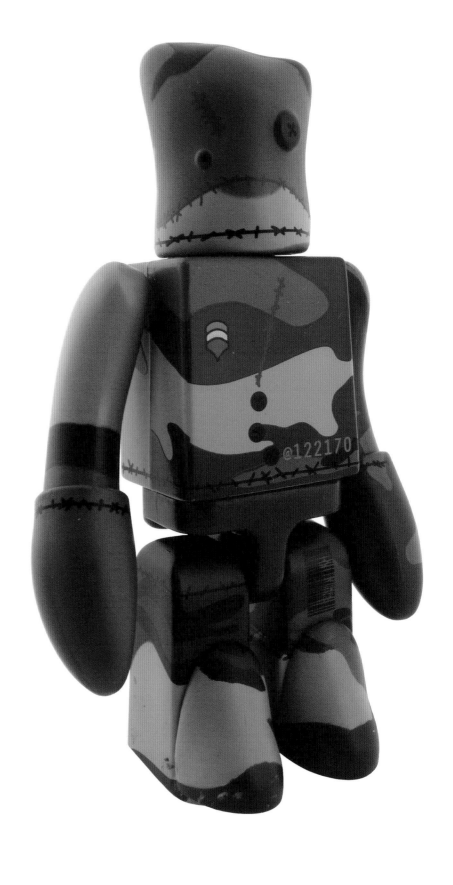

1

TOKION MAGAZINE

Designers: Various (Barry McGee, Margaret
Kilgallen, Stash, Os Gemeos, Shepard Fairey)

Based in: New York, New York

Website: tokion.com

From the set *Tokion
Magazine's Neo Graffiti
3D Project*, 2002:
2. Margaret Kilgallen
3. Stash 4. Os Gemeos
5. Shepard Fairey
6–7. Barry McGee

2–5

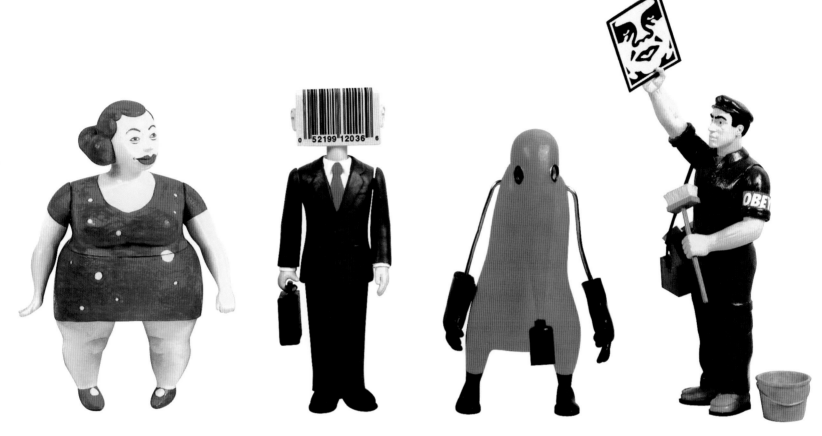

6–7

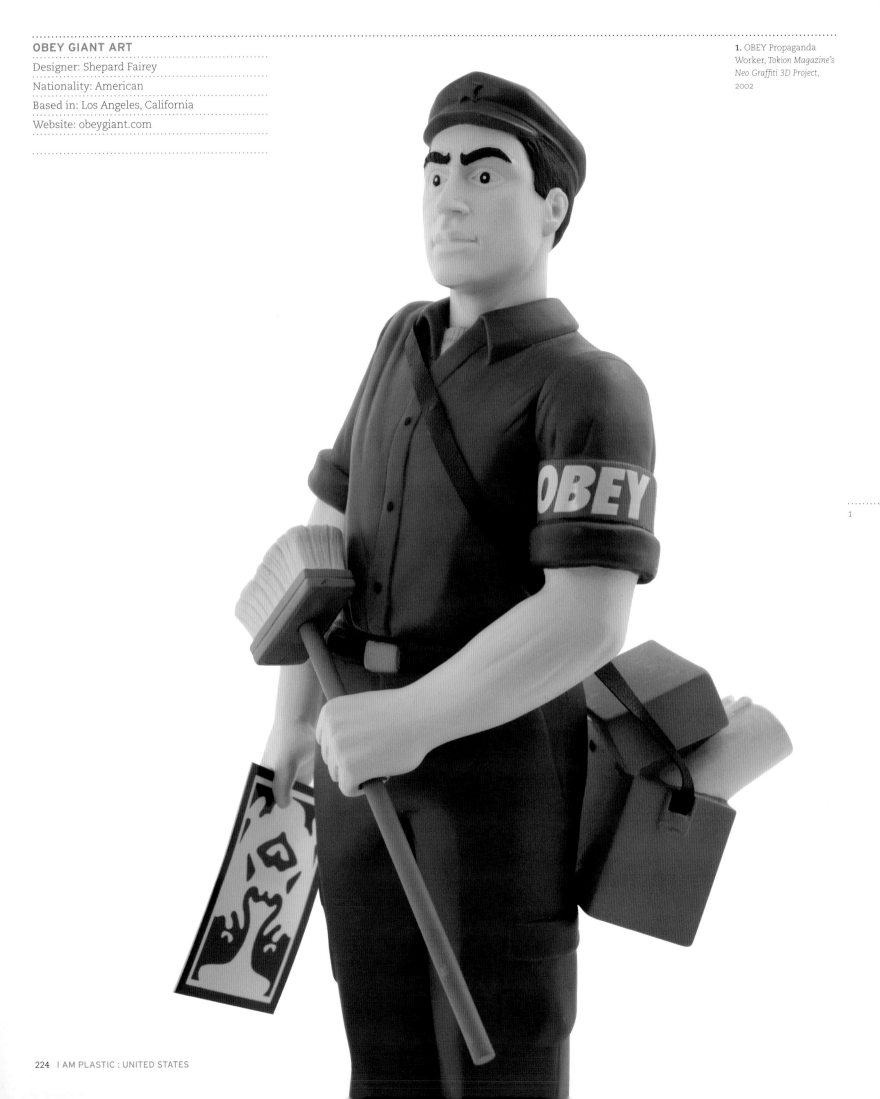

OBEY GIANT ART

Designer: Shepard Fairey

Nationality: American

Based in: Los Angeles, California

Website: obeygiant.com

1

From the set OBEY *Stealth Bomber 8-inch Qee Toy*: **2.** Qee Cat (Sub-Version I), 2004 **3.** Qee Dog (Sub-Version 3), 2005 **4.** Qee Bear (Sub-Version 2), 2004 **5.** Qee Cat (Sub-Version I)

6. Unique Customized 8-inch Qeedrophonic Bear, *Qeedrophonic Exhibition*, 2004

2–4

5

6

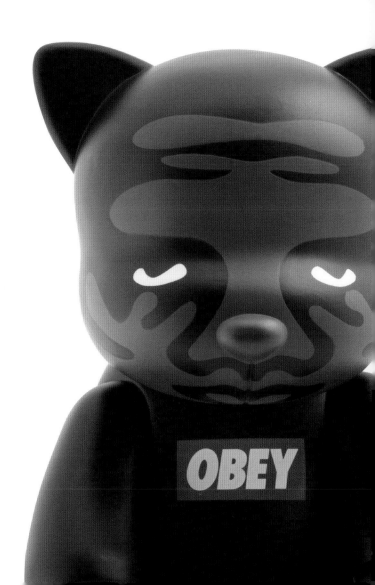

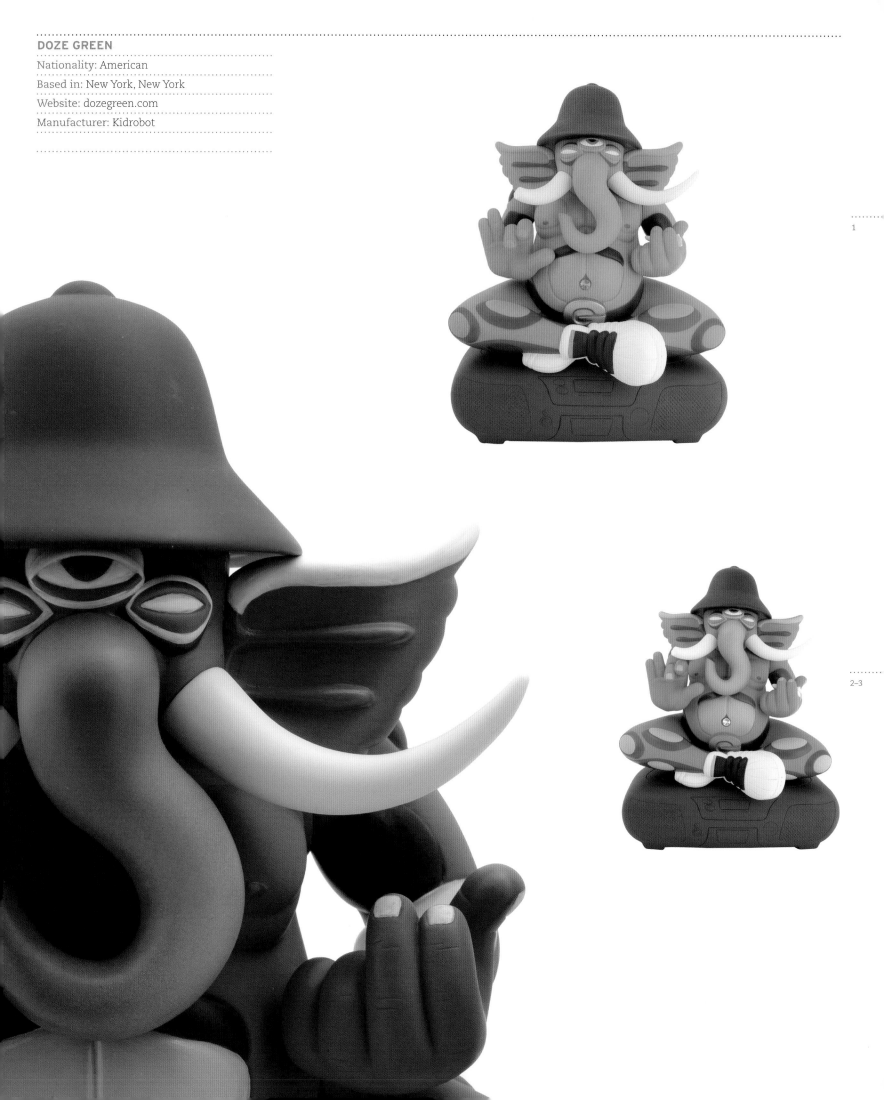

1

2–3

4–5

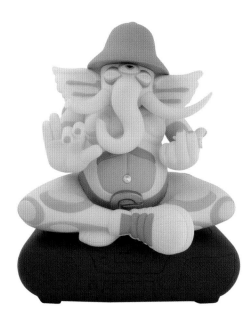

6

GEOFF MCFETRIDGE

Nationality: American

Based in: Glendale, California

Website: kingofmountain.info

Manufacturer: King of Mountain

From the set *Creature: Off My Back by Geoff McFetridge*, 2005: **1.** Bear **2.** Coin **3.** Creature: Off My Back **4.** Chuck **5.** Solitary

1–2

3–4

5

NECESSARIES TOY FOUNDATION

Designers: Various (Daniel Clowes, Pablo,
Todd Schorr); Nathan Cabrera (sculptor)

Nationality: American

Based in: Long Beach/Hollywood, California

Websites: necessariestoyfoundation.com;
spanofsunset.com

Manufacturer: Span of Sunset

6

By Daniel Clowes:
1. Enid HI-FASHION Doll, NTF-001, 2001

By Pablo:
2. Antoinette the Sympathy Girl, MOM and POP Record Stores Only Edition, NTF-002, 2003

By Todd Schorr:
From the set *The Bunny Duck*, NTF-003:
3. Secret Mystic Serpent Bonus Figurine, 2004
4. Bunny Duck, 2003
5. Bunny Duck, Friends and Family limited edition of 57, 2003

1–2

3–5

NATHAN CABRERA

Nationality: American

Based in: Los Angeles, California

Websites: necessariestoyfoundation.com;

spanofsunset.com

Manufacturer: Span of Sunset

6. R2-D4 A.K.A. Span-droid, 2001 **7.** Breakfast at Tiffany's, Starring French Kitty, 2004

From the set *A Roman Dirge Thingy*:
8–11. Halfsies, 2002
12. Beware the Floaty Bear THING!!!, 2004

6–7

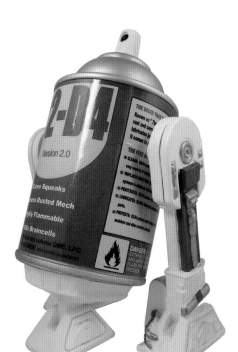

8–12

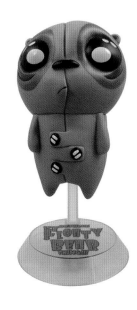

SUSPECT TOYS

Designer: Ramirez

Nationality: American

Based in: Los Angeles, California

Website: skullbrain.org

Manufacturer: Span of Sunset

From the set *Suspect Toys 01*, 2005: **1.** Hunchy **2.** Hunchy "What the CHUCK!" (Skullbrain Exclusive)

1

2

Designers: Mark Davis, Mike Davis, Paul Harding

Nationality: American

Based in: Los Angeles, California

Websites: streetlegendsink.com;

blokhedz.tv; spanofsunset.com

Manufacturer: Span of Sunset

3–4. Carhartt Vulture
with Cuban Link,
Japanese Edition, 2003

3

4

Nationality: American

Based in: New York, New York

Website: billmcmullen.com

Manufacturers: Span of Sunset, SwishToys, Kidrobot

1

2

3–4

5–7

CRITTERBOX

Designers: Various (Dave Cooper;

Tony Millionaire; KAZ; Ron Regé, Jr.)

Nationality: American

Based in: Santa Monica, California

Website: critterbox.com

By Dave Cooper:
1. Eddy Table, 2003
2. PIP + norton, 2003

1

2

By Ron Regé, Jr.:
From the set *Ouch!*
Twins, 2004: **3.** Ouch Boy
4. Ouch Girl **5.** Wizardly
Agitator

By MAAKIE (aka Tony
Millionaire):
6. Drinky Crow Jack-in-
the-Box, 2005

By KAZ:
7. Smoking Cat, 2004

3–5

6–7

KIDROBOT

Designers: Tristan Eaton and Paul Budnitz

Nationality: American

Based in: New York, New York

Website: kidrobot.com

1–3

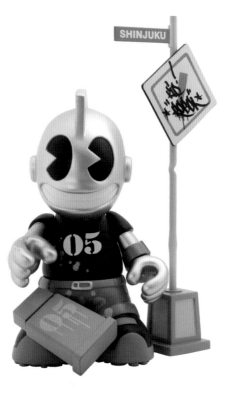
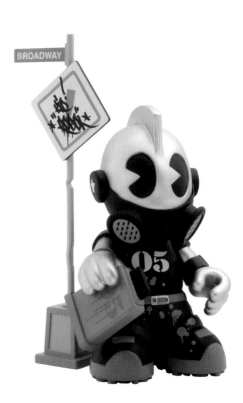

4–6

7–9

10–11

12

BANG!

13–15

ROCKET WORLD

Designer: Patrick Ma

Nationality: American

Based in: San Francisco, California

Website: rocketworld.org

1

2

3

2–4

5–7

Nationality: American

Based in: San Francisco, California

Websites: bigfootone.com; strangeco.com

Manufacturer: STRANGEco/Fifty24SF

1. Bigfoot (Silver and Black), 2004 **2.** Bigfoot (Brown), 2004 **3.** Bigfoot (Green), 2004

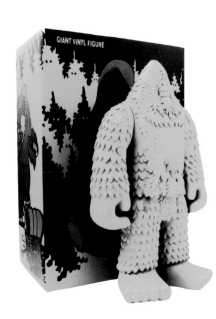

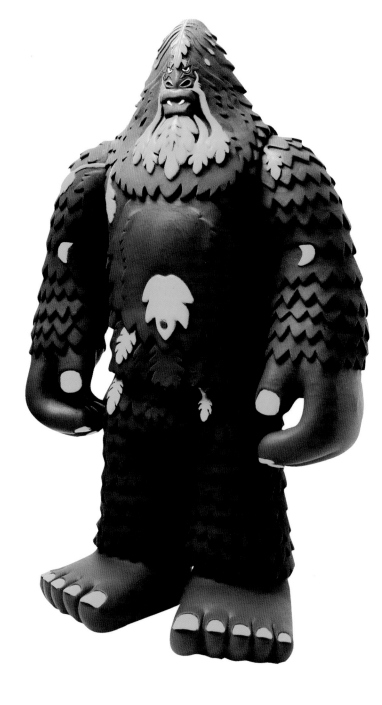

1

2

3

Nationality: American

Based in: San Francisco, California

Website: samflores.com

Manufacturer: STRANGEco

4–6

Nationality: British

Based in: Bay Area, California

Website: huckgee.com

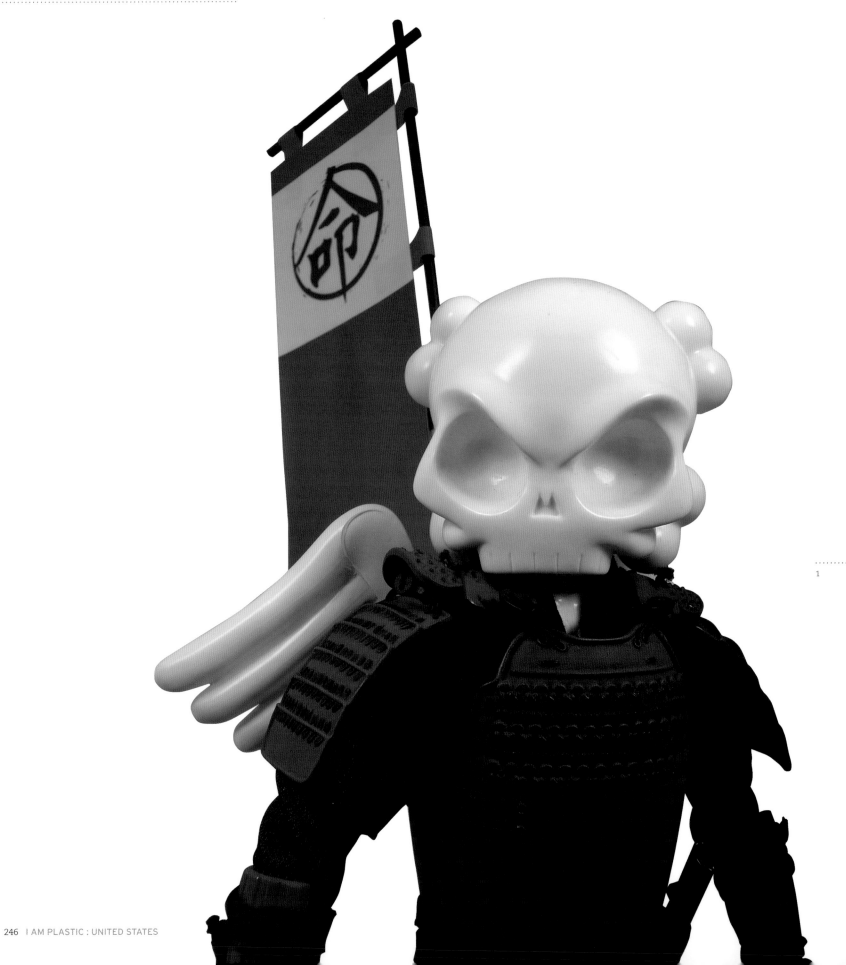

1

2

3

1. Ducati Skullhead,
2005 **2.** Skinhead
Skullhead, 2005
3. Kaneda Skullhead,
2005 **4.** Green Beret
Skullhead, 2005

1

2

3–4

5–7

1–3

4–5

6. Custom Operation
Munny, *Kidrobot Munny*,
2005

SPARE
RIBS

BUCKET
FOOT

BROKEN
HEART

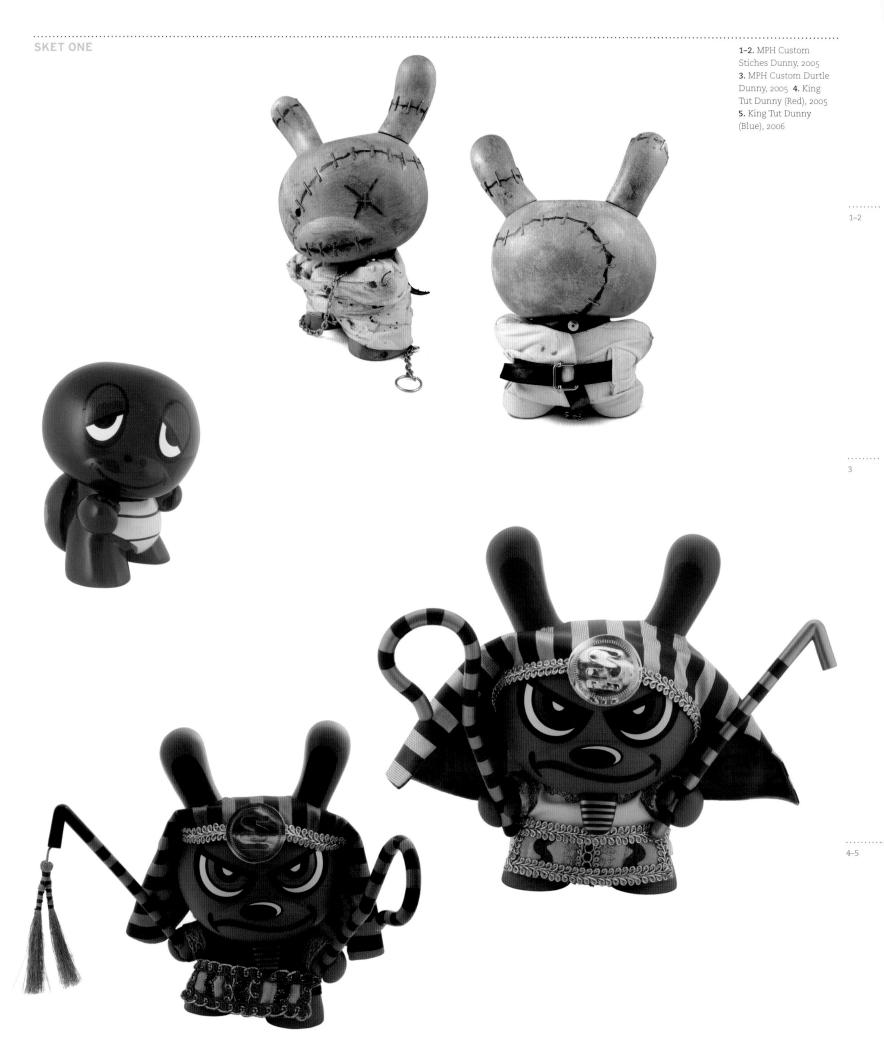

1–2. MPH Custom
Stiches Dunny, 2005
3. MPH Custom Durtle
Dunny, 2005 **4.** King
Tut Dunny (Red), 2005
5. King Tut Dunny
(Blue), 2006

1–2

3

4–5

6–7

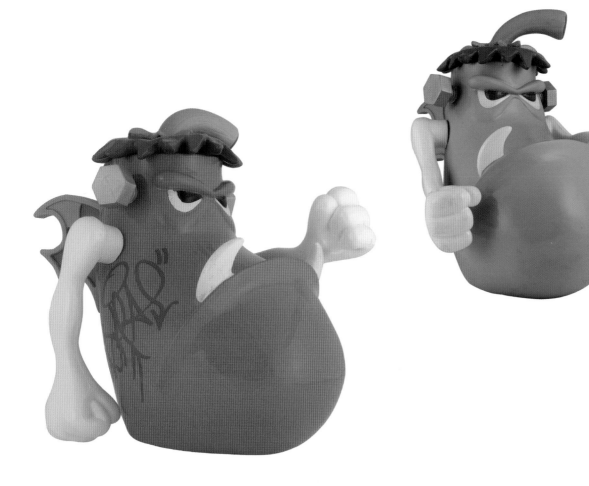

8

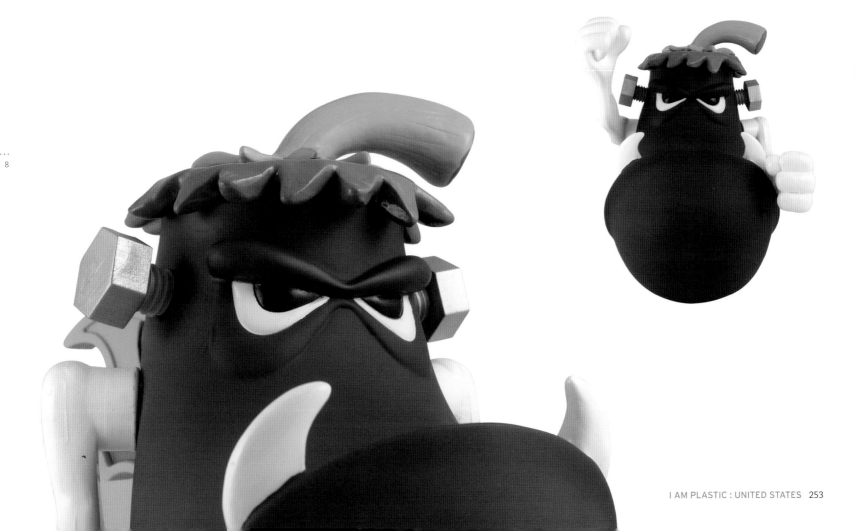

1

053
Fb

124
Ax

2

3. Crossover Custom MAD*L, 2005 **4.** Crossover Custom Groob, 2005 **5.** Crossover Custom Dero, 2005 **6.** Crossover Custom Eggster, 2005

3–4

1312 Mi

072 Gb

5–6

415 Do

RON ENGLISH

Nationality: American

Based in: New York, New York

Website: popaganda.com

1–3. Rabbbit, 2005
4. McCircus Punk, 2005
5. Spot, 2005 6. MC Supersized, 2006
7. MC Supersized (Green), 2006 8. MC Supersized Black and White, 2006

1–3

4

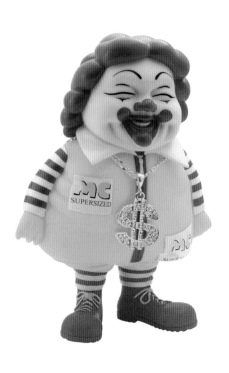

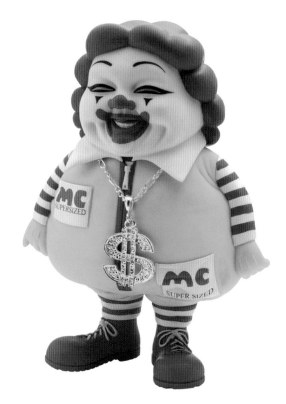

5–7

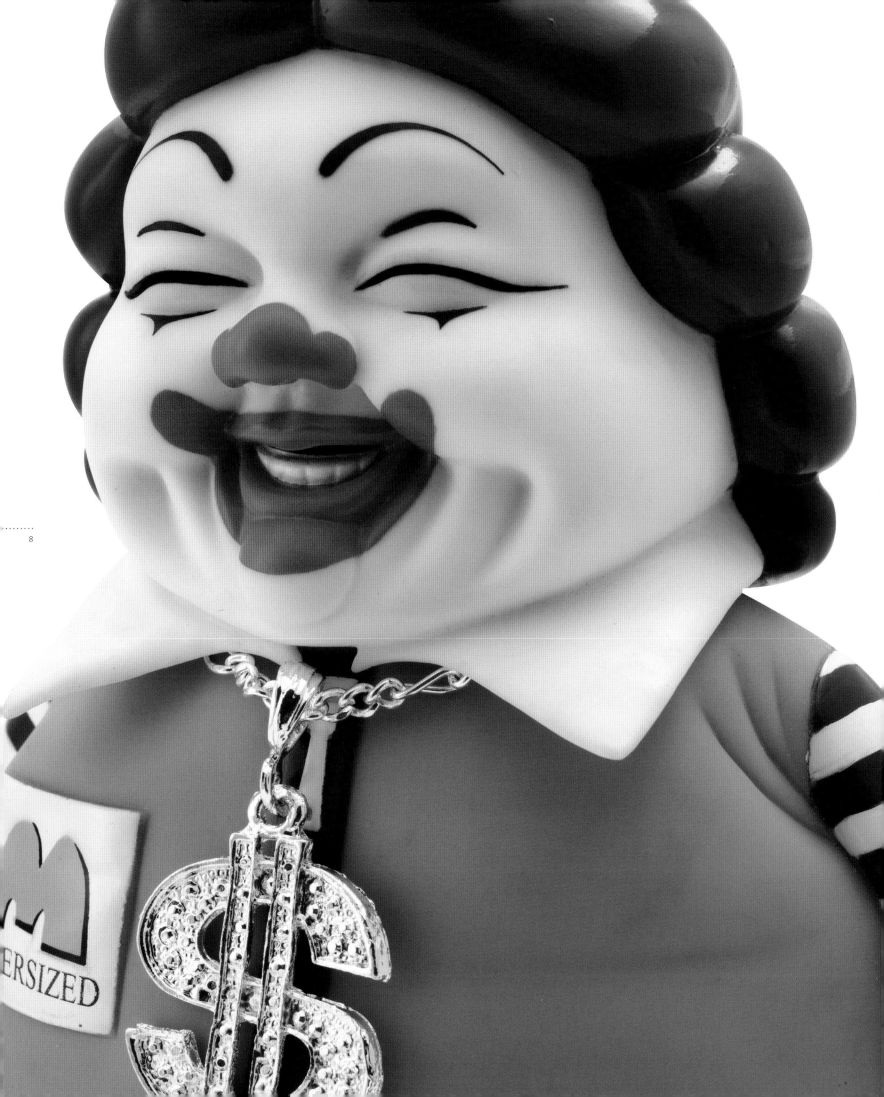

MARS-1

Designer: Mario Martinez

Nationality: American

Based in: San Francisco, California

Websites: mars-1.com; strangeco.com

Manufacturer: STRANGEco

1. MARS-1 Vinyl Figure (Green), 2004
2–4. MARS-1 Vinyl Figure (Green, Blue, and Gray), 2004
5–7. Observer (Gray, Red, Green), 2005

1–4

5–7

8. MARS-1 Vinyl
Figure (Gray), 2004
9–10. MARS-1 Vinyl
Figure (Blue and Gray),
2004 **11–12.** Observer
(Gray and Green),
Invisible Plan, SDCC
Edition, 2005

8–10

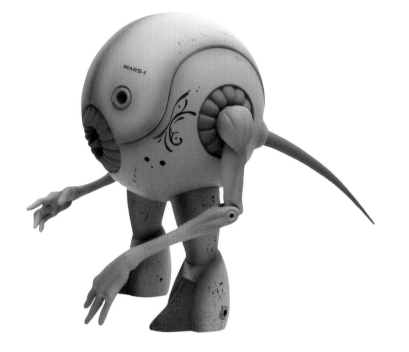

11–12

GREG FOLEY

Nationality: American

Based in: New York, New York

Website: ooco.com

Manufacturer: Kidrobot for Visionaire

Visionaire Toys,
Visionaire 44 and 45,
2004/2005

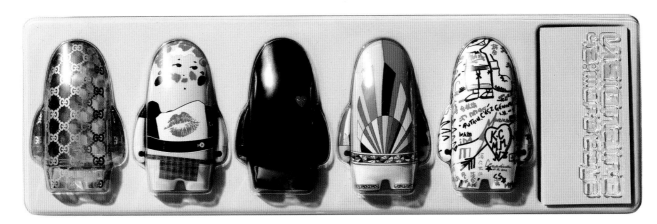

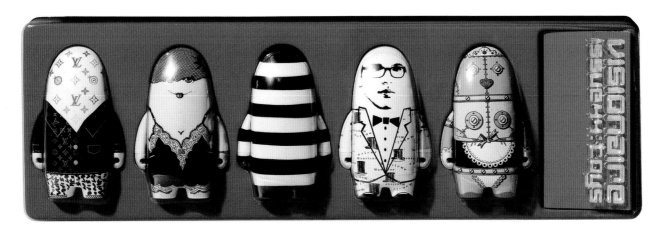

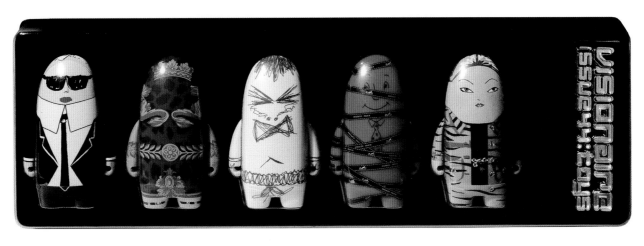

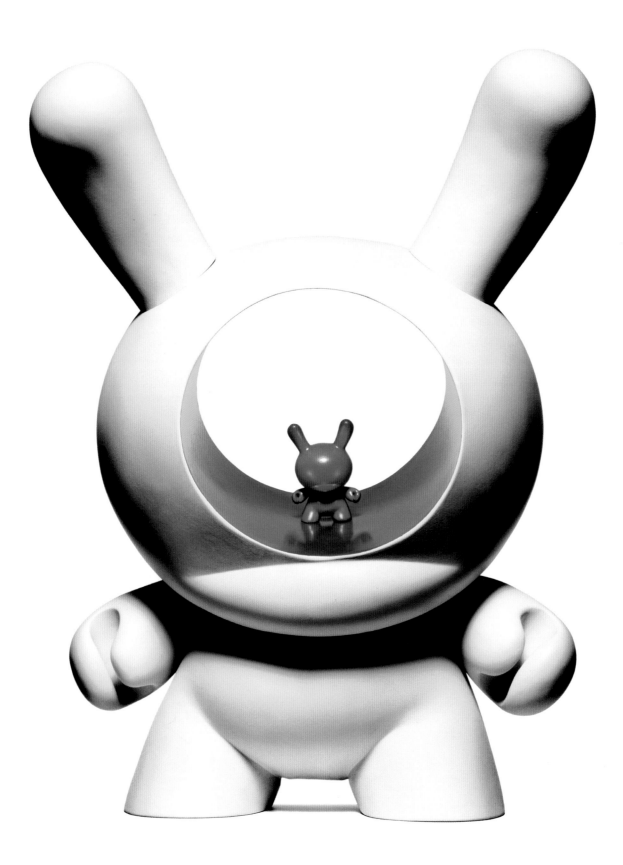

1

2

1

2

1. Helper (Flopdoodle.
com Exclusive), 2004
2. Helper (Glow-in-
the-Dark Version),
2004 3. Helper, 2004
4. Helper Finger Puppet
(NYC Exclusive), 2004
5. Helper (NYC Exclu-
sive), 2004

1. Helper (Flopdoodle.
com Exclusive), 2004
2. Helper (Glow-in-
the-Dark Version),
2004 3. Helper, 2004
4. Helper Finger Puppet
(NYC Exclusive), 2004
5. Helper (NYC Exclu-
sive), 2004

1–3

4–5

6. Helper Finger Puppet
(NYC Exclusive), 2004
7. Helper (Flopdoodle.
com Exclusive), 2004

From the set *Alphabeast*:
8. Calli (Back and
Silver Version), 2004
9–10. Calli (Hand
Painted Comic-Con
Exclusive), 2005

6–7

8–10

1. Gamagon (Orange Version), *Gama-Go*, 2005

From the set *Alphabeast*:
2. Pollard (Yellow Version), 2002 3. Pollard (Glow-in-the-Dark Version), 2002 4. Pollard (Red Version), 2003

1–3

4

5–6

7

8

DAVID HORVATH & SUN-MIN KIM

Nationality: American (David), Korean (Sun-Min)

Based in: Los Angeles, California

Websites: uglydolls.com; davidhorvath.com

Manufacturers: Critterbox, Kidrobot

From the set *Uglydolls*
(Plush): **1**. Wage, 2001
2. Babo, 2002 **3**. Jeero,
2002 **4**. Tray, 2002
5. Target, 2002 **6**. Ice-
Bat, 2002 **7**. Cinko, 2002
8–9. Uglydog, 2005
10–11. Wedgehead, 2004

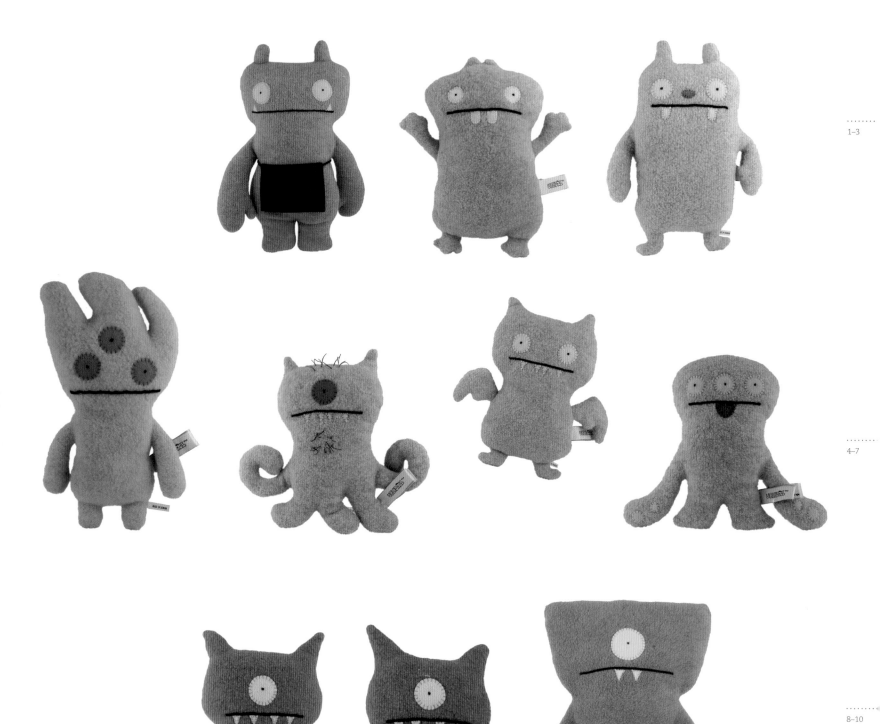

1–3

4–7

8–10

From the set *Uglydolls*, 2005:
1. Sleepy Chilly Ice-Bat
2. Winter Glow Ice-Bat
3. Lost His Cool Ice-Bat

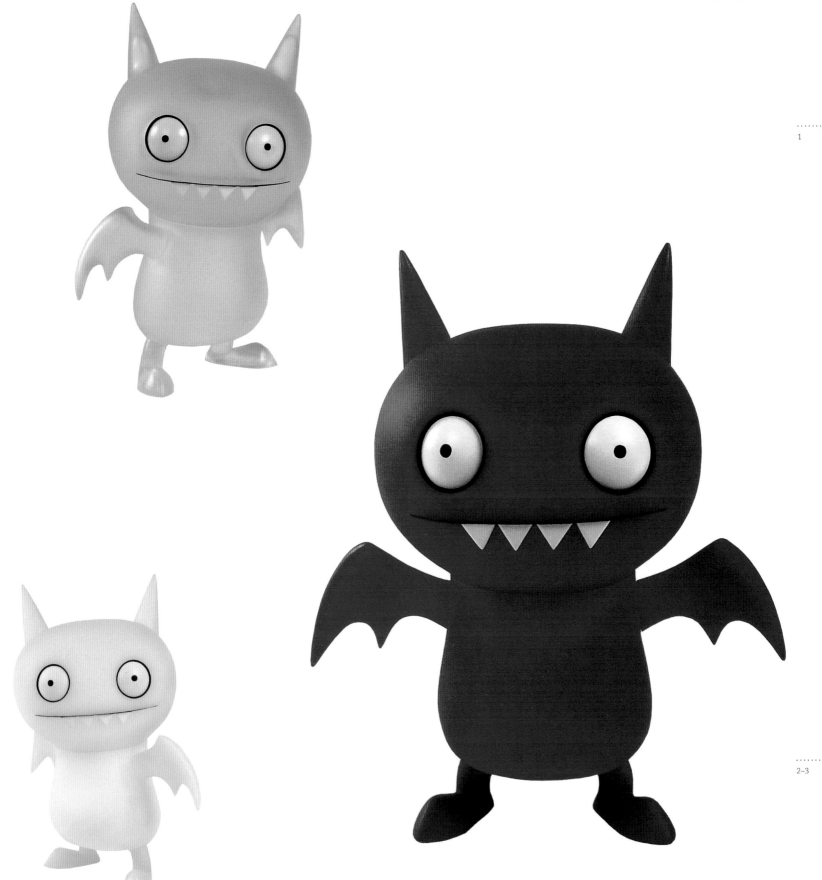

1

2–3

4. Sun-Min's Spider Boom,
Spider Boom Limited Edition,
2005

From the set *Uglydolls*, 2001:
5. Sun-Min's King Babo
6. Sun-Min's King Wage

4

5–6

From the set *Uglydolls*,
2004 (all vinyl figures):
1. Tray **2.** Wedgehead
3. Wage **4.** Target **5.** Ox

From the set *Uglydolls*,
2005 (all vinyl figures):
6. Uglydog **7.** Red Ugly-
dog **8.** Pink Uglydog

1–2

3–5

6–8

From the set *Uglydolls*,
2004 (all vinyl figures):
9. Ice-bat **10.** Babo
11. Cinko **12.** Jeero

9

10–12

From the set *David Horvath's 2-Faced Dunnys*, 2005: **1.** Noupa's Gel Dunny **2.** Sun-Min's Spider Boom Dunny **3.** Sun-Min Kim Dunny **4.** Zoltan Dunny

From the set *David Horvath's 2-Faced Dunnys*, 2004: **5.** 2-Faced Dunnys **6.** 2-Faced Dunnys Box Set

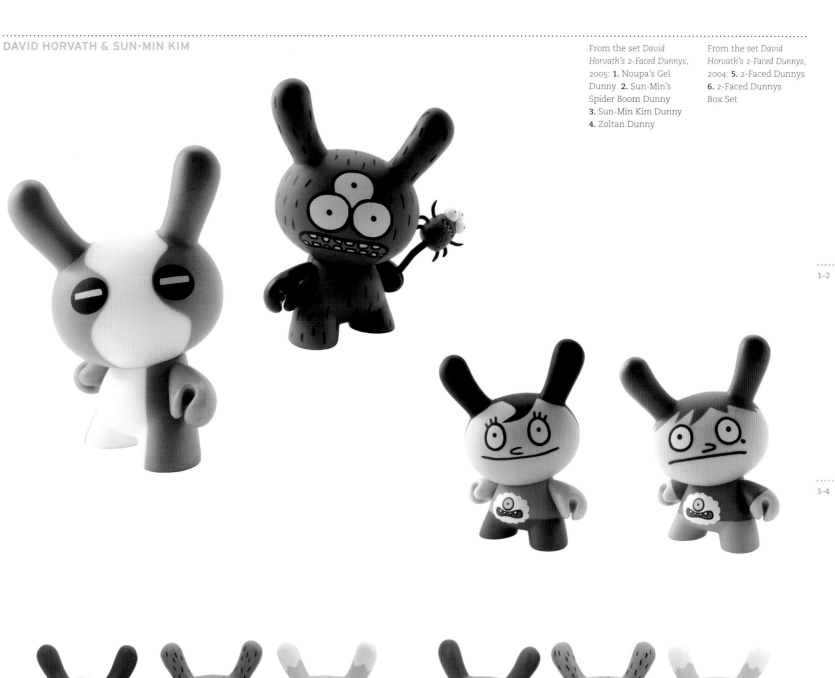

1–2

3–4

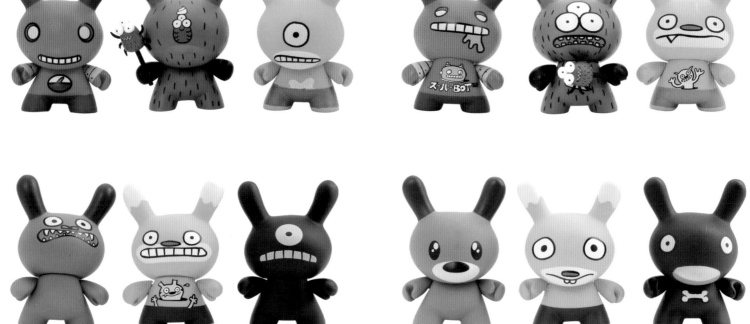

5

6

JEREMY FISH

Nationality: American

Based in: San Francisco, California

Websites: sillypinkbunnies.com; strangeco.com

Manufacturer: STRANGEco

7. Bunnyvan (Gold)
8. Bunnyvan

7

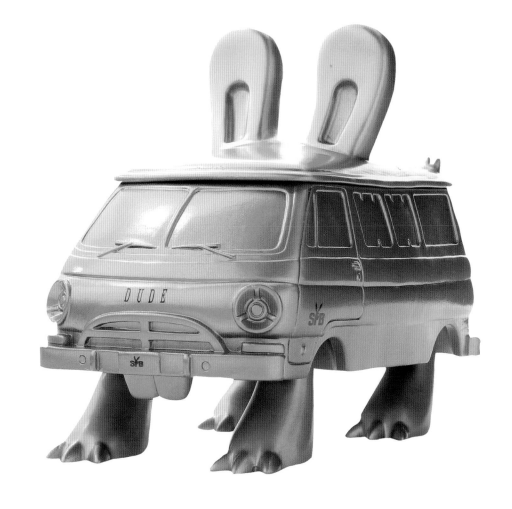

8

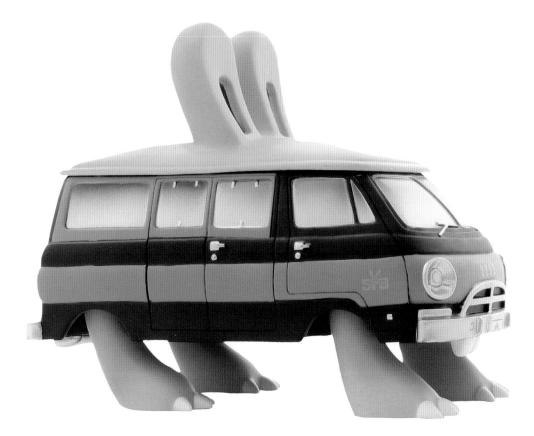

SUCKADELIC

Designer: Sucklord

Nationality: New Yorker

Based in: New York, New York

Website: suckadelic.com

1–2. DJ Trooper, 2002

3. Beast Box, *Technofear*, 2002

From the set *Super Suckfig Bootleg Series*:

4. Gay Empire Homotrooper, 2005

5–6. Another Bitch (You Didn't Get to Fuck), 2005

7–8. Sucklord 66, 2004

9–12. Necromancer, 2005

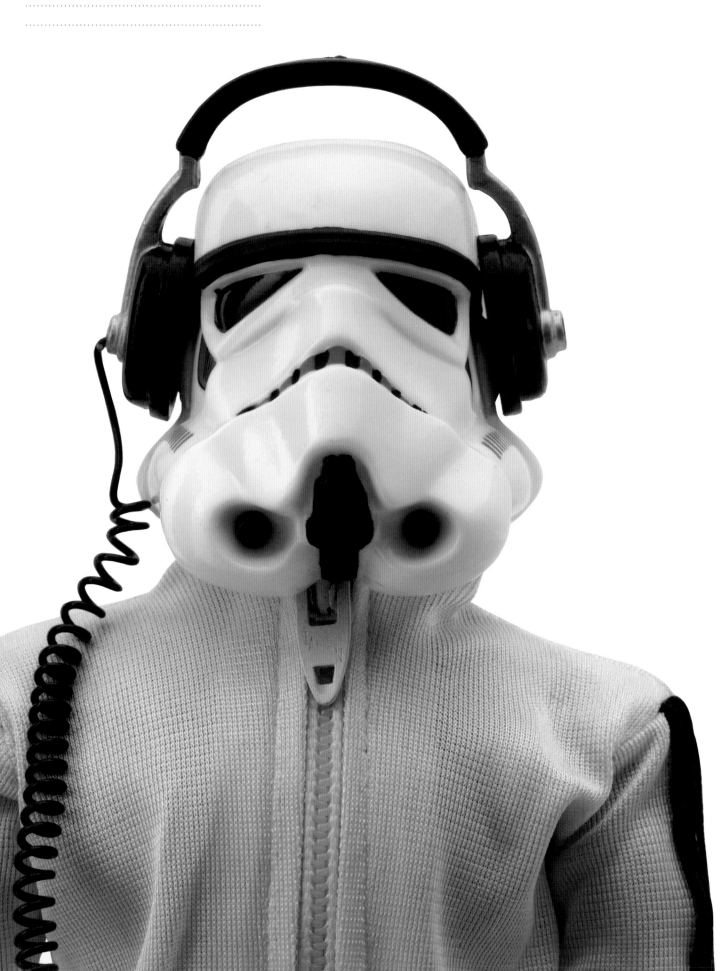

1

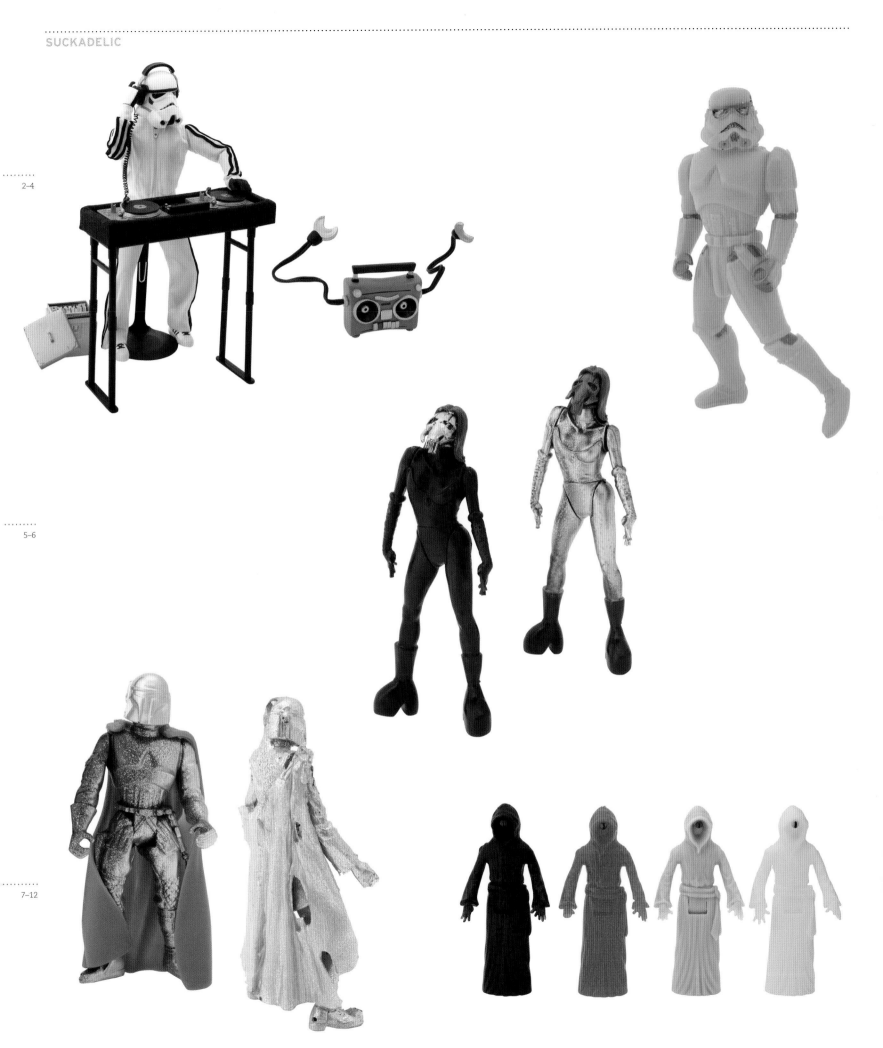

2–4

5–6

7–12

THUNDERDOG STUDIOS

Designer: Tristan Eaton

Nationality: American

Based in: New York, New York

Website: thunderdogstudios.com

Manufacturer: Kidrobot

1

2

3

4–7

8–9

10–11

JOE LEDBETTER

Nationality: American

Based in: Los Angeles, California

Website: joeledbetter.com

1–2. Exterminators Dunny, 2005 **3–4.** Evil Bunny Dunny, 2005 **5–6.** Pink Bunny Dunny, 2005 **7–9.** One Last Smoke Labbit, 2005

1–2

3–6

7–9

10

1–4

5–8

9–11

12–13

From the set *Crossover Show (Custom)*, 2005:
1. Moos*L **2.** Exus-Axtrx

1

2

From the set *The Creatures in My Head*, 2004:
3. Groob (Goo Edition)
4. Groob (U.H.F. Edition)
5. Groob (Nude Edition)

3

4

5

1. B.B.BIRDY CUTTER, *Funny Club Show (Custom)*, 2004 **2.** OH SHI* EN, *100 Punks Rule NYC (Custom)*, 2005 **3.** Face Off, *20-inch MAD*L Customs Show*, 2005

1

2

3

4

5–7

CHRISTOPHER LEE

Nationality: American

Based in: Sacramento, California

Websites: thebeastisback.com; wheatywheat.com

Manufacturer: Wheaty Wheat Studios

From the set *The Urban-ites*, 2006: **1.** M-X (Max) **2.** Mellow **3.** Cleabus

1–3

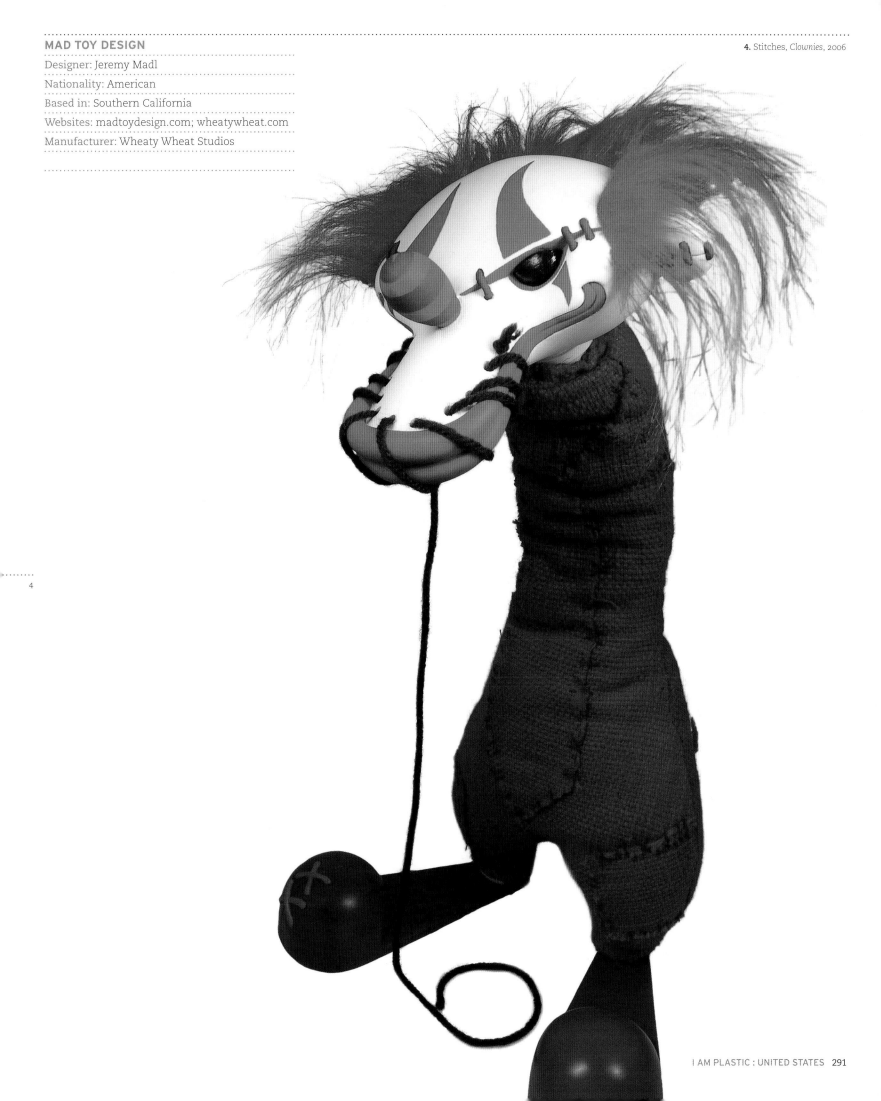

MAD TOY DESIGN

Designer: Jeremy Madl

Nationality: American

Based in: Southern California

Websites: madtoydesign.com; wheatywheat.com

Manufacturer: Wheaty Wheat Studios

4. Stitches, *Clownies*, 2006

4

From the set *Phase 2*, 2005: **1.** El Lucha **2.** Dominion **3.** Cry-On

4. Clops Skully, *Voo Doo MAD*L Prototype*, 2004 **5.** XX Skully, *Voo Doo MAD*L Prototype*, 2004 **6.** CAMO: 1, *Camo MAD*L Prototype*, 2004 **7.** Punk A$$ Sk8r, *MAD*L Prototype*, 2004

From the set *MAD*L Show 2K5*, 2005: **8.** 20-inch MAD*L Crest by MAD **9–10.** 20-inch Thugger by Tristan Eaton

1–3

4–7

8–10

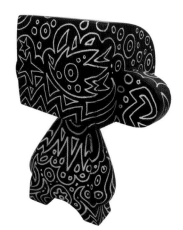

From the set *Private Collection*, 2005:
11. KB Custom MAD'L
12. Clear XX Skully Custom MAD'L
13. What the Hell? Custom MAD'L
14. MAD Splat SDCC Custom MAD'L
15. KING MAD'L SDCC Custom MAD'L **16.** Eye C U Custom MAD'L
17–18. The Man Custom MAD'L **19.** Abstract Custom MAD'L

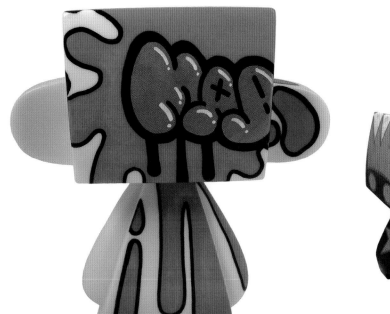

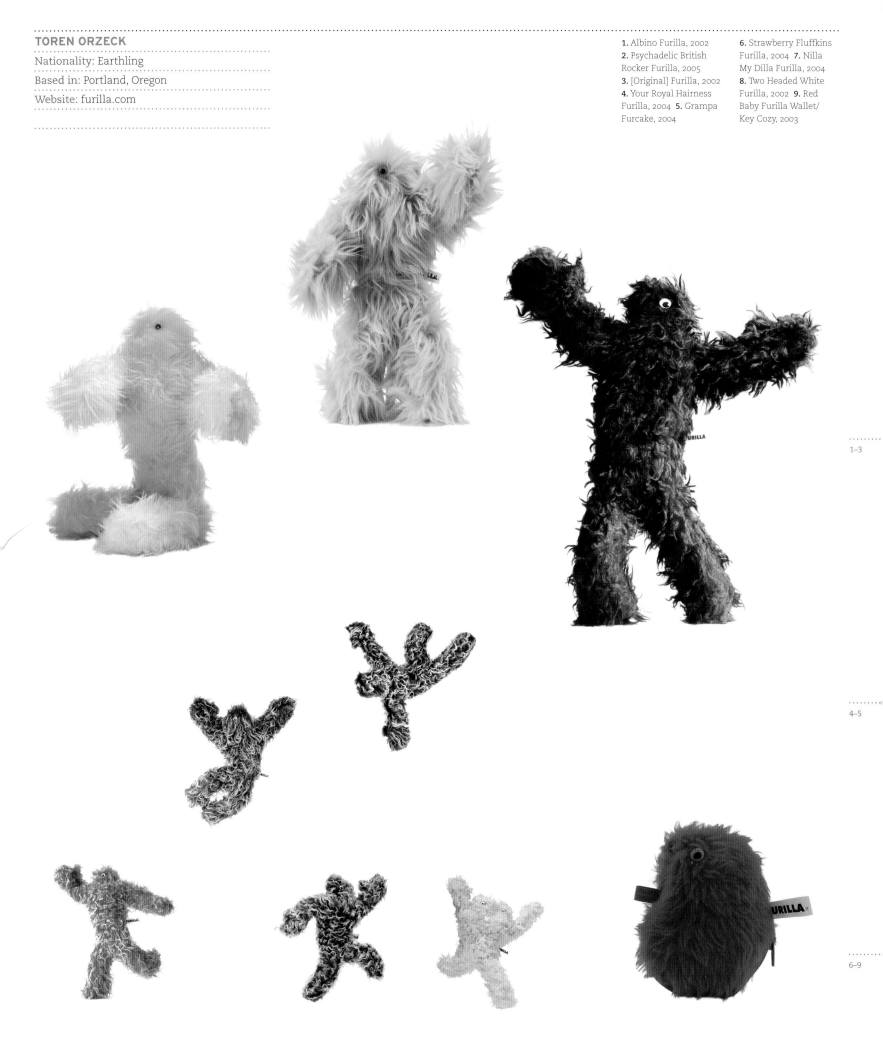

TOREN ORZECK

Nationality: Earthling

Based in: Portland, Oregon

Website: furilla.com

1–3

4–5

6–9

HEIDI KENNEY

Nationality: American

Based in: Waynesboro, Pennsylvania

Website: mypapercrane.com

From the set *Donut Plush*, 2004: **10.** Boston Creme **11.** Plain Chocolate Icing **12.** Sprinkled Chocolate Filled **13.** Pink Jelly White Icing **14.** Lemon Jelly

10

11

12–14

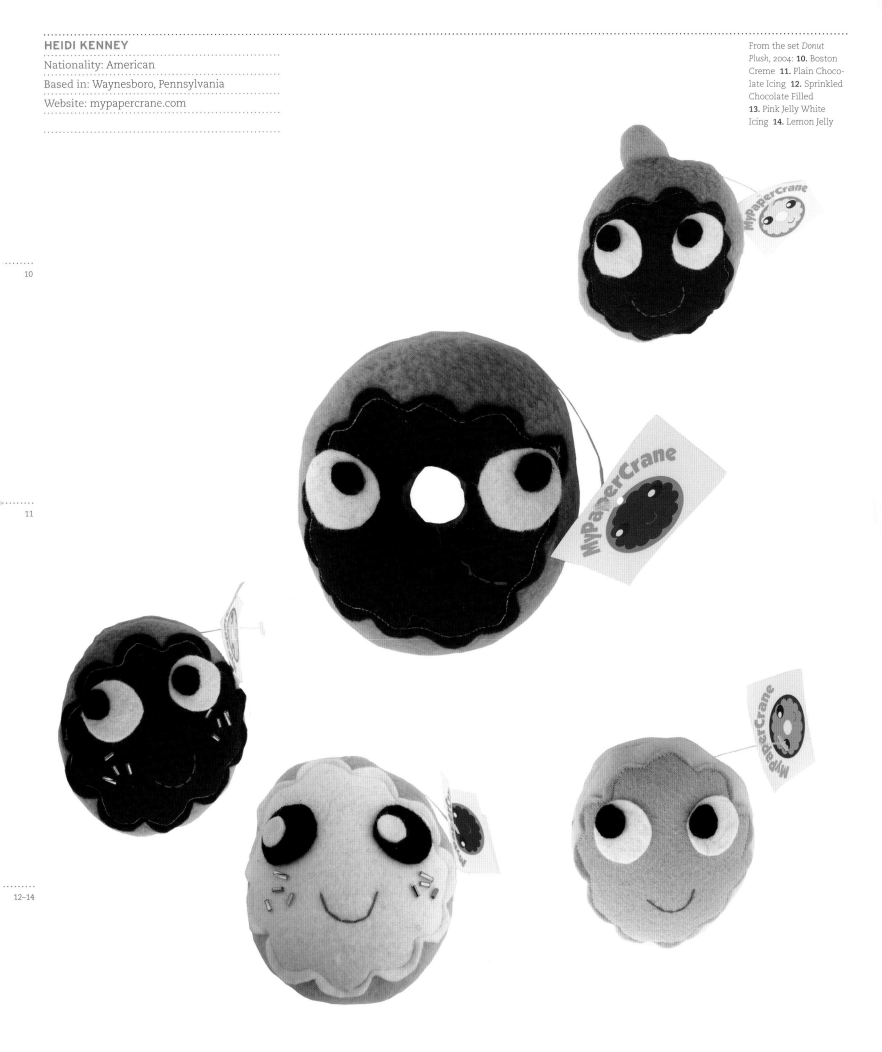

1. Pot Head, *Series 1,*
2004 **2.** 12 oz. Vandal,
Series 2, 2005

1

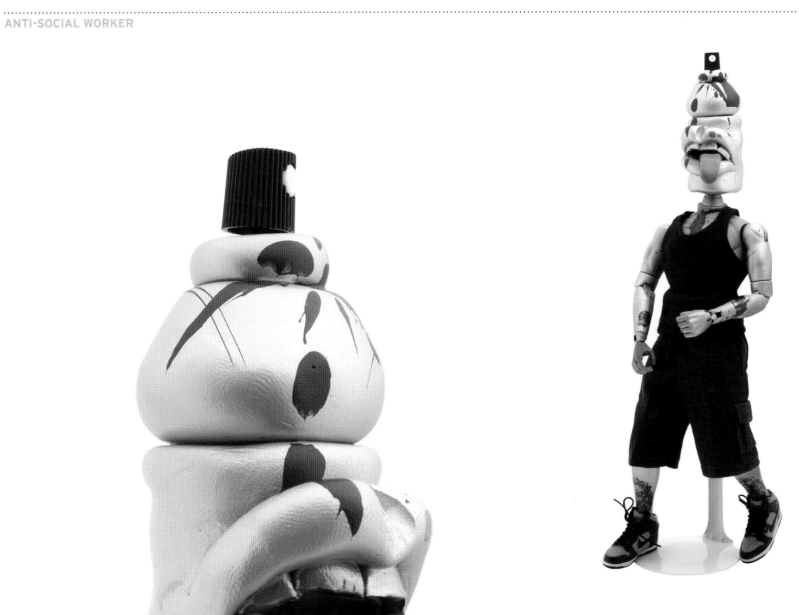

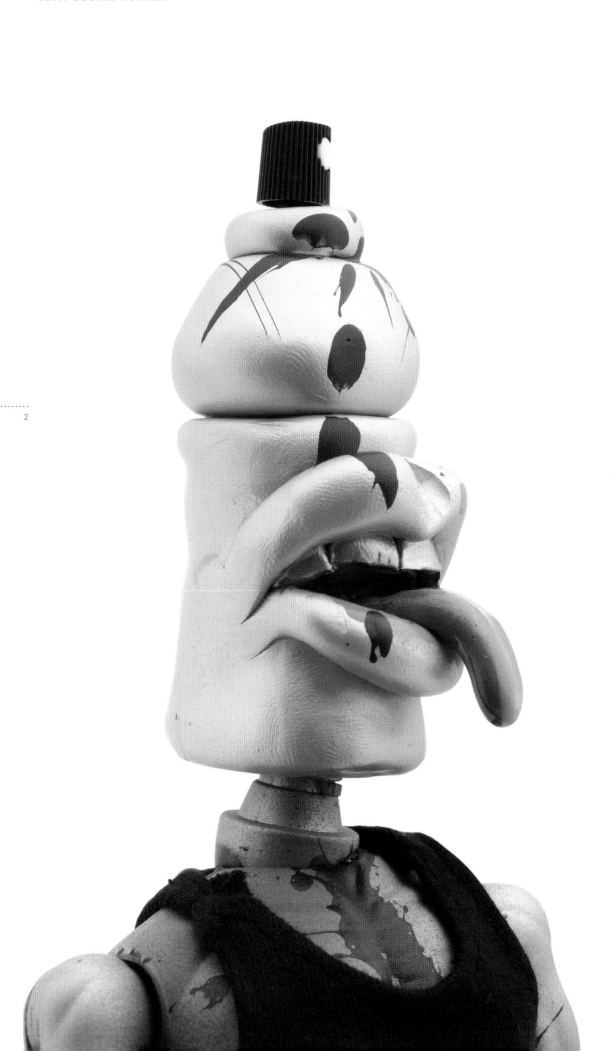

2

CIRCUS PUNKS

Designers: Various

Nationality: American

Based in: Fresno, California

Website: circuspunks.com

1–3

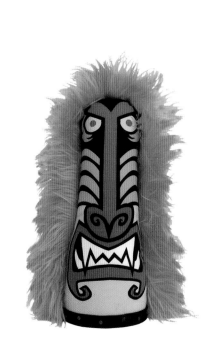

4–7

8. Wizard by MCA/
Evil Design, 2005
9. Punkzilla by Brian
Flynn, 2004 10. Waif:
Snowgirl by Angel-Devil,
2005 11. The Working
Stiff by Craiger, 2004
12. Robot by Monkey vs.
Robot, 2005 13. Nessie
by Gary Baseman, 2005
14–15. Peek-A-Boo
by Huck Gee, 2005
16. Twisted Thought
by MAD, 2005

8–10

11–13

14–16

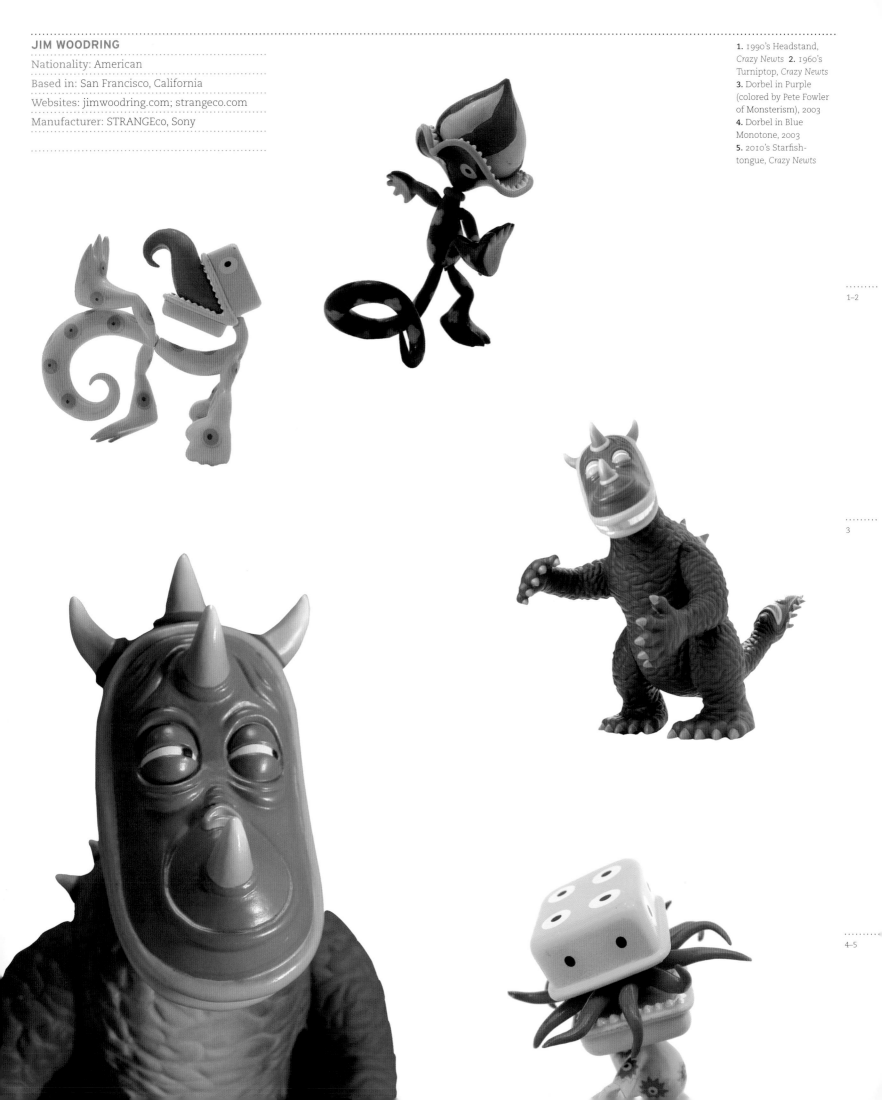

JIM WOODRING

Nationality: American

Based in: San Francisco, California

Websites: jimwoodring.com; strangeco.com

Manufacturer: STRANGEco, Sony

1. 1990's Headstand, *Crazy Newts* **2.** 1960's Turniptop, *Crazy Newts* **3.** Dorbel in Purple (colored by Pete Fowler of Monsterism), 2003 **4.** Dorbel in Blue Monotone, 2003 **5.** 2010's Starfish-tongue, *Crazy Newts*

1–2

3

4–5

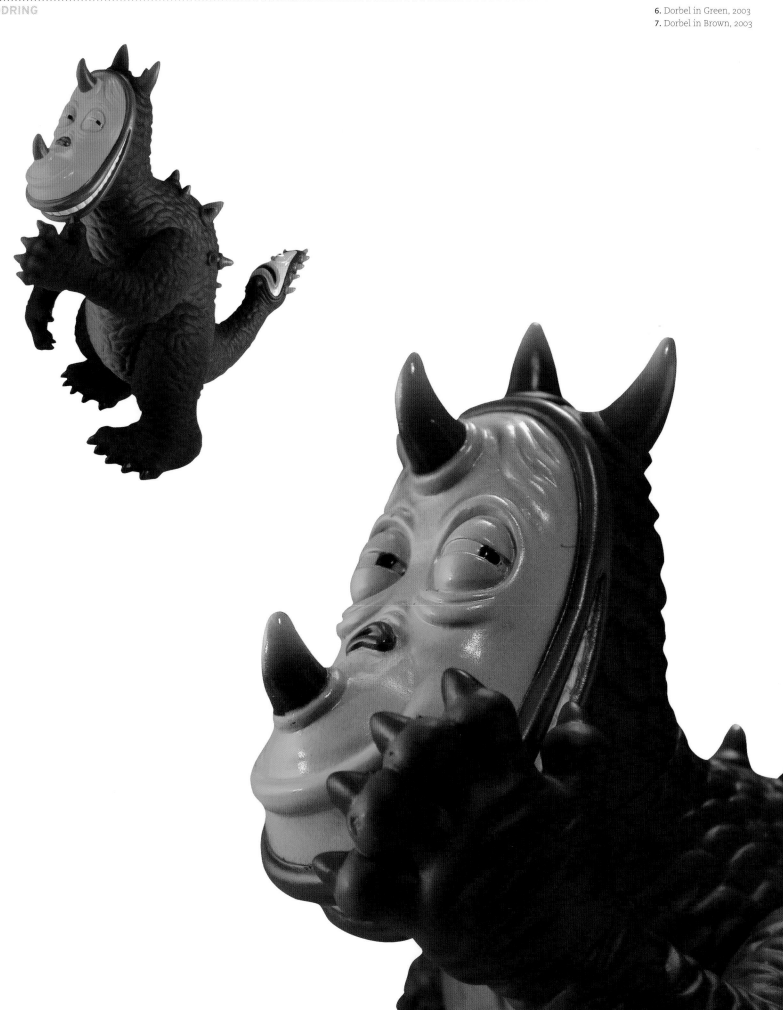

6

7

Designers: Derek Welch and Jason Bacon

Nationality: American

Based in: Portland, Oregon

Website: unklbrand.com

From the set *SUG*, *Series 1*, 2005: **1.** SUG B55 Cammo **2.** SUG B53 Primer **3.** SUG B54 Gun Metal

1

2–3

4–6

7–9

10–12

4. HazMaPo Fescue Deux, A1, 2005 **5.** Haz-MaPo Un Al Carbon, A1, 2005 **6.** HazMaPo, Tri-Yella, A1, 2005 **7.** HazMaPo Fescue Deux 2, A2, 2005 **8.** HazMaPo S7, *Super 7 Exclusive by Brian Flynn,* 2005 **9.** HazMaPo Red Cyclops, *Comicon Exclusive,* 2005

From the set *TinPo Series 1,* 2005: **10.** TinPo Trey 003 **11.** TinPo Whan 001 **12.** TinPo Sy 009 joined with Am 010 to make SyAm

1–2. Tequila, *Lucha Libre*,
2005

1–2

Nationality: Humanoid

Based in: Albany, California

Website: yumfactory.com

3

4

SARA ANTOINETTE MARTIN

Nationality: American

Based in: Brooklyn, New York

Website: sara-land.net

1

2

3–4

5

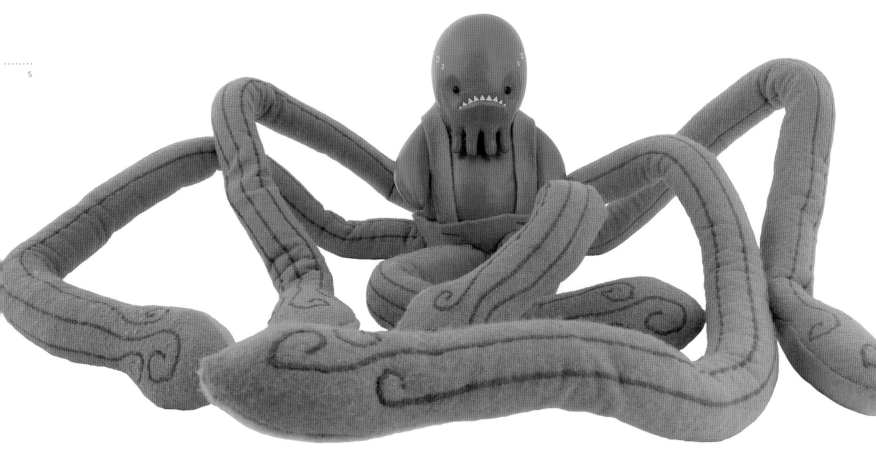

DB

Nationality: British

Based in: Brooklyn, New York

Website: djdb.com

Manufacturers: Breakbeat Science, BBS Tokyo,
Deaf Dumb & Blind Communications

From the set *Techheadz*,
2000: **1.** Deep (NY Edition)
2. Deep (Cali Edition)
3. Dark (Cali Edition)

1

2

3

From the set *Hoodz*, 2002: **4.** Vapor **5–8.** Signstein, Fatcap, Letterman, and Vapor

From the set *Run DMC Japan Exclusive* 2005, 2002: **9–11.** DMC, Jam Master Jay, Run **12–14.** Run, Jam Master Jay, and DMC

4–8

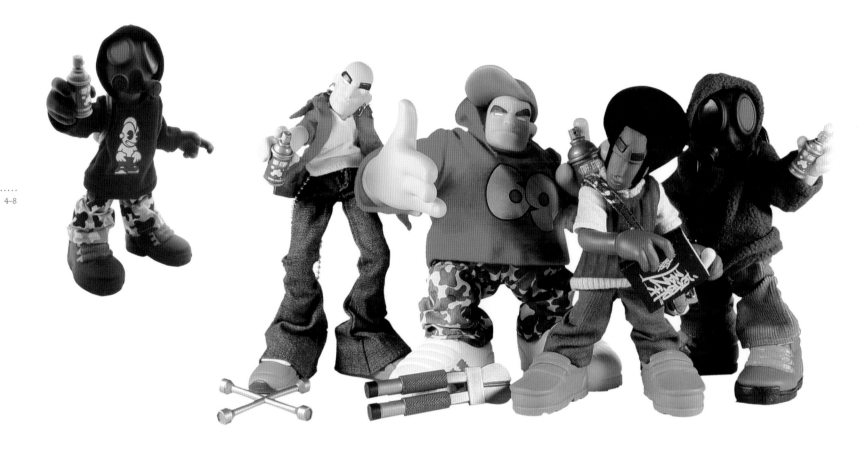

9–14

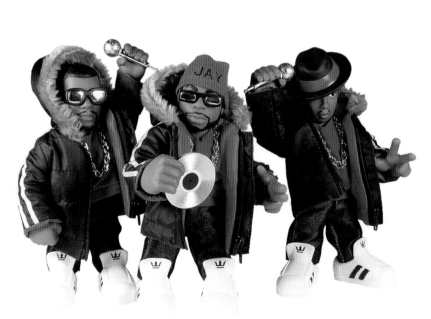

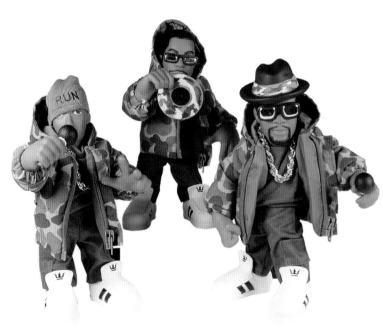

SCOTT MUSGROVE

Nationality: American

Based in: San Francisco, California

Websites: scottmusgrove.com;

strangeco.com; wootini.com

Manufacturer: STRANGEco/Wootini

1. Booted Glamour Cat
(Natural), 2005

1

2. Booted Glamour Cat
STRANGEco Edition
(Black), 2005 **3.** Booted
Glamour Cat Wootini
Edition (Ultraviolet),
2005 **4.** Booted Glamour
Cat (Spotted Indigo),
2005 **5.** Booted Glamour
Cat STRANGEco Edition
(Black), 2005 **6.** Booted
Glamour Cat (Indigo),
2005 **7.** Booted Glamour
Cat (Natural), 2005

2

3–4

5

6–7

JERMAINE ROGERS

Nationality: American

Based in: San Francisco, California

Websites: jermainerogers.com;

strangeco.com; wootini.com

Manufacturer: STRANGEco/Wootini

1. Shadow Dero and Orange Dero, 2005
2. Shadow Dero with Glow Eyes, Invisible Dero, Gold Dero, and Glow Dero, 2005

1

2

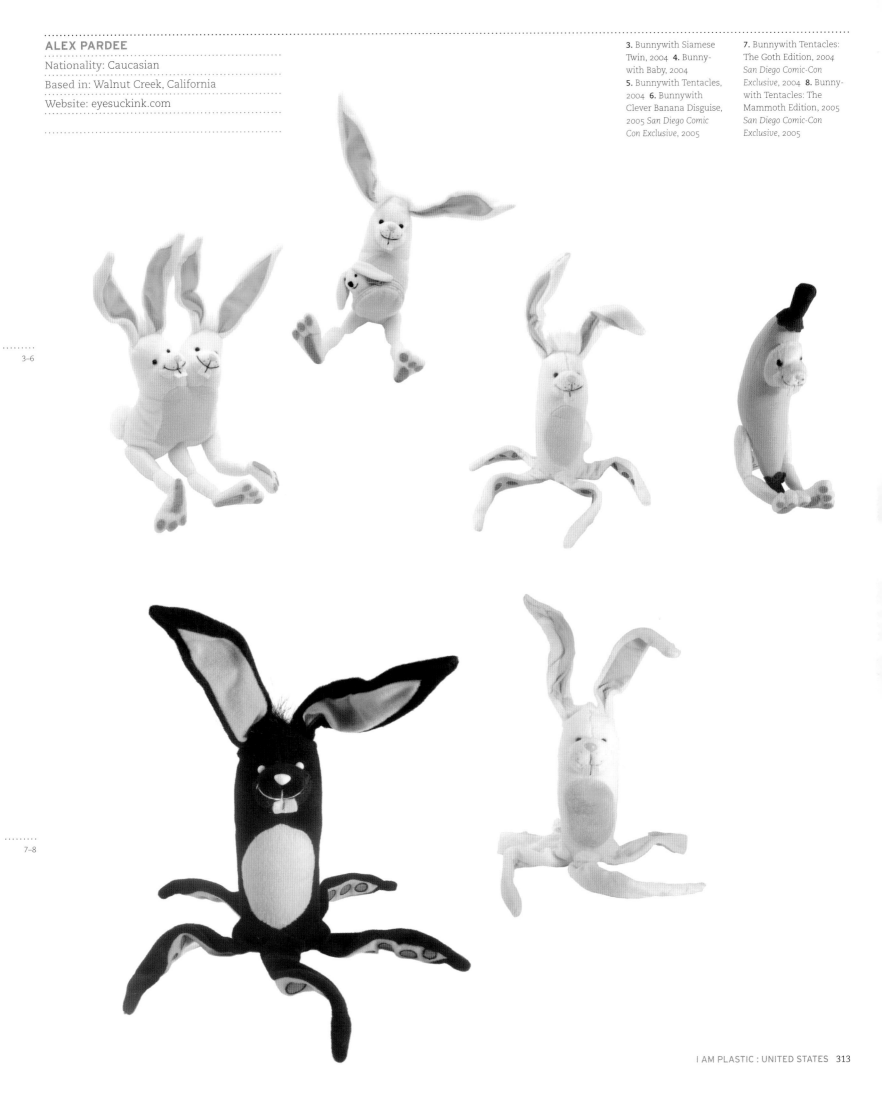

ALEX PARDEE

Nationality: Caucasian

Based in: Walnut Creek, California

Website: eyesuckink.com

3–6

7–8

3. Bunnywith Siamese Twin, 2004 **4.** Bunny-with Baby, 2004 **5.** Bunnywith Tentacles, 2004 **6.** Bunnywith Clever Banana Disguise, 2005 *San Diego Comic Con Exclusive*, 2005

7. Bunnywith Tentacles: The Goth Edition, 2004 *San Diego Comic-Con Exclusive*, 2004 **8.** Bunny-with Tentacles: The Mammoth Edition, 2005 *San Diego Comic-Con Exclusive*, 2005

TWEEQIM

Designers: miQ willmOtt and THUY3
(aka Mike Willmott and Thuy Phan-Willmott)

Nationality: American

Based in: Portland, Oregon

Website: tweeqim.com

1. miQmott's Convoluted
Spicy Spotted Conjoined
Monkey Twin Soup (for
Funny Club Show), 2005
2. miQee16 Custom Qee,
2005 3. Santo Circo Punk
Ante Los Sagrado Fuego
by miQ willmOtt and
THUY3 (for 100 Punks
Rule New York City
show), 2005

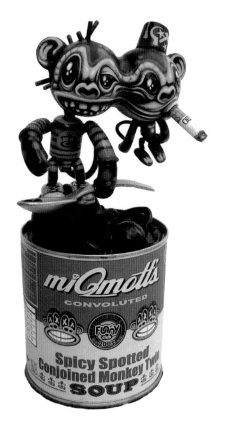

1

2

3

MARK BODE

Nationality: American

Based in: San Francisco, California

Website: markbode.com

Manufacturer: Kidrobot

4

5–8

4. Cheech Wizard, 2004 **5.** Cheech Wizard (Black and White/Glow in the Dark), 2004 **6.** Paint Your Own Cheech Wizard, 2004 **7.** Gold Edition Cheech Wizard, 2004 **8.** Scarecrow Lizard, 2005

EVIL DESIGN

Designer: MCA

Nationality: American

Based in: Boston, Massachusetts

Website: evildesign.com

Manufacturer: Toy2R

From the set *"No Music No Life" Evil Ape Qee Series*, 2005: **1.** NYC Punk Ape **2.** M.C. Ape **3.** Ape It

4. NYC Evil Baseball Ape, 2004

1–2

3–4

From the set *"No Music No Life"* Evil Ape Qee Series, 2005: **5.** Party Ape **6.** Apes Don't Cry **7.** Disco Nap Ape **9.** UK Punk Ape **9–10.** SK8 Punk Apes **11.** Ape of Death **12.** Soul Sonic Ape **13.** Sunset Ape

5–7

8–10

11–13

1. Evil Ape (White Prototype), 2005
2. Evil Ape Noir, 2005
3. Evil Grape Ape, 2005
4. Rusty Evil Ape (Prototype), 2005
5. Golden Evil Ape (France Exclusive), 2005
6. Evil Terrestrial Ape (France Mystery Exclusive), 2005
7–8. Evil-Fu Apes (San Diego Comic-Con Exclusives), 2005

1–2

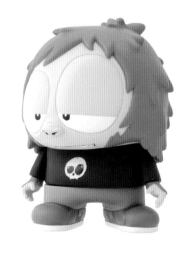
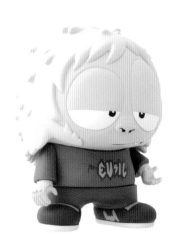
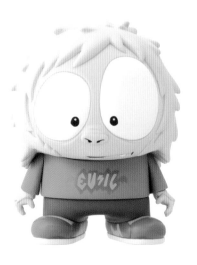

3–6

7–8

9. B-Boy, *Year of the B-Boy Hong Kong* 10. B-Boy, *Year of the B-Boy Paris* 11. B-Boy, *Year of the B-Boy Brazil* 12. B-Boy, *Year of the B-Boy NYC* 13. Little-Brooklyn.com, *LBK 24-inch Series*

9–11

12–13

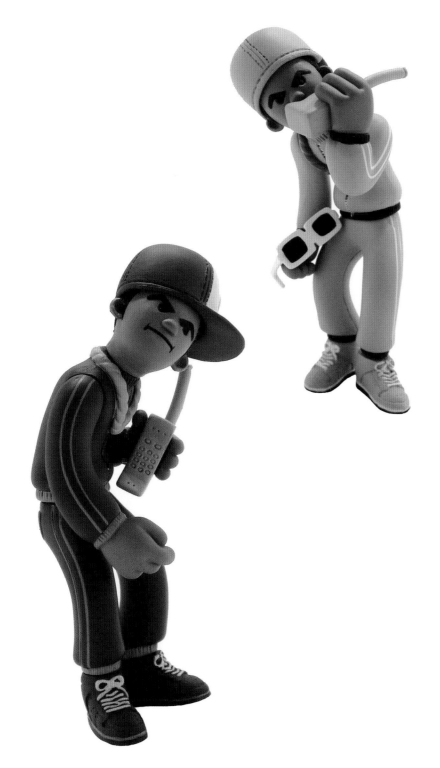

1

2. Spraycan Monster
(U.S. Edition), *Monsters
of Seenworld*, 2001
3. Squirt, *Monsters of
Seenworld*, 2006

2

3

From the set *Phony-Baloney*, 2005: **1.** Pig Patrol **2.** Pig Pen **3.** Porked **4.** Pork Grinds **5.** Roast Pork **6.** Pig in a Blanket **7.** In a Pigs Eye **8.** NY's Finest

1–3

4–6

7–8

Nationality: American

Based in: Brooklyn, New York

Manufacturer: 7 Enterprises

From the set *MOTUG
Qee Egg Series 1*:

9. GRAFHEAD 2.5-
inch (Brooklyn Edition
2) Qee Bear, 2003
10. GRAFHEAD 8-inch
Qee Bear, 2003
11–12. 2.5-inch Qee Egg,
2005

13. MOO-GOO, *Dunny
Series 1*, 2004

9–11

12

13

MELTDOWN

Designers: Devilrobots; based on logo design
by Dan Clowes; sculpted by Monster5

Nationality: American

Based in: Los Angeles, California

Website: meltcomics.com

1. Melto-Fu (Color), *First
set of 13th anniversary
Meltdown, Inc. product,*
2005 **2.** Melto-Fu Clear
a.k.a Ghost of Mel
(Edition of 200), 2005

1–2

STRANGECO/SUPER7

Designers: Various (Gary Baseman, Tim Biskup,
Seonna Hong, Todd Schorr, Kathy Staico-Schorr)

Nationality: American

Based in: San Francisco, California

Website: strangeco.com

Manufacturer: STRANGEco/Super7

From the set *The Neo
Kaiju Project*, 2004:
3–4. Gefilte and Pupik
by Gary Baseman
5–7. Steam Punk by
Todd Schorr, Trilomonk
by Kathy Staico-Schorr,
Pigdog by Tim Biskup
8–12. Humpty Djinn
by Todd Schorr, Birdu-
zasu by Tim Biskup,
Treebird by Kathy Staico-
Schorr, Tako Girl by
Seonna Hong, and Pupik
by Gary Baseman

3–4

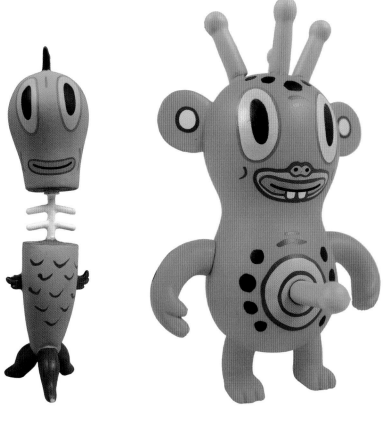

5–7

8–12

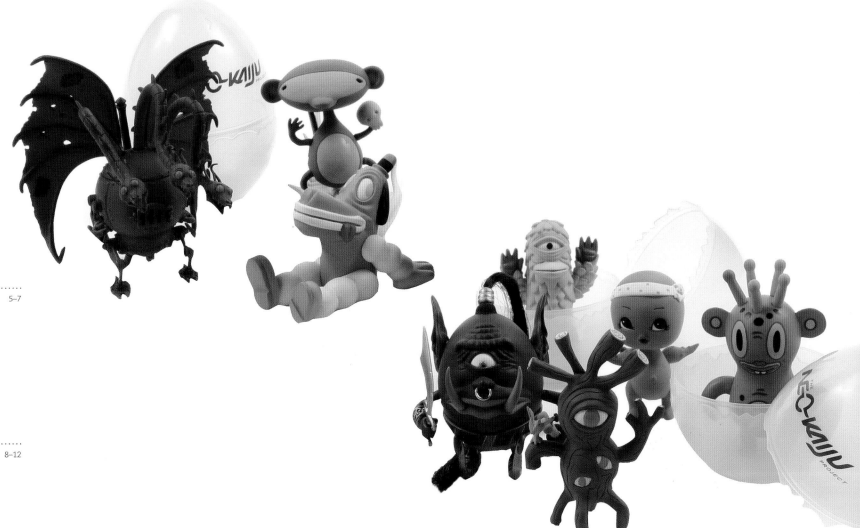

KIDROBOT/MUNNY

Designers: Various

Munny shape: Tristan Eaton and Paul Budnitz

Nationality: American

Based in: New York, New York

Website: kidrobot.com/munny

Custom Munnys from *The Munny Show*, 2005: **1.** by Brothersworker Kenny **2.** by Siu Yin and CW **3.** by Jason Siu **4.** by Dalek **5.** by Barneys New York **6.** by Everlast **7.** by Devilrobots **8.** by Jerry Abstract **9.** by Deph of to Die For® **10.** by Sucklord

1–3

4–7

8–10

11

1

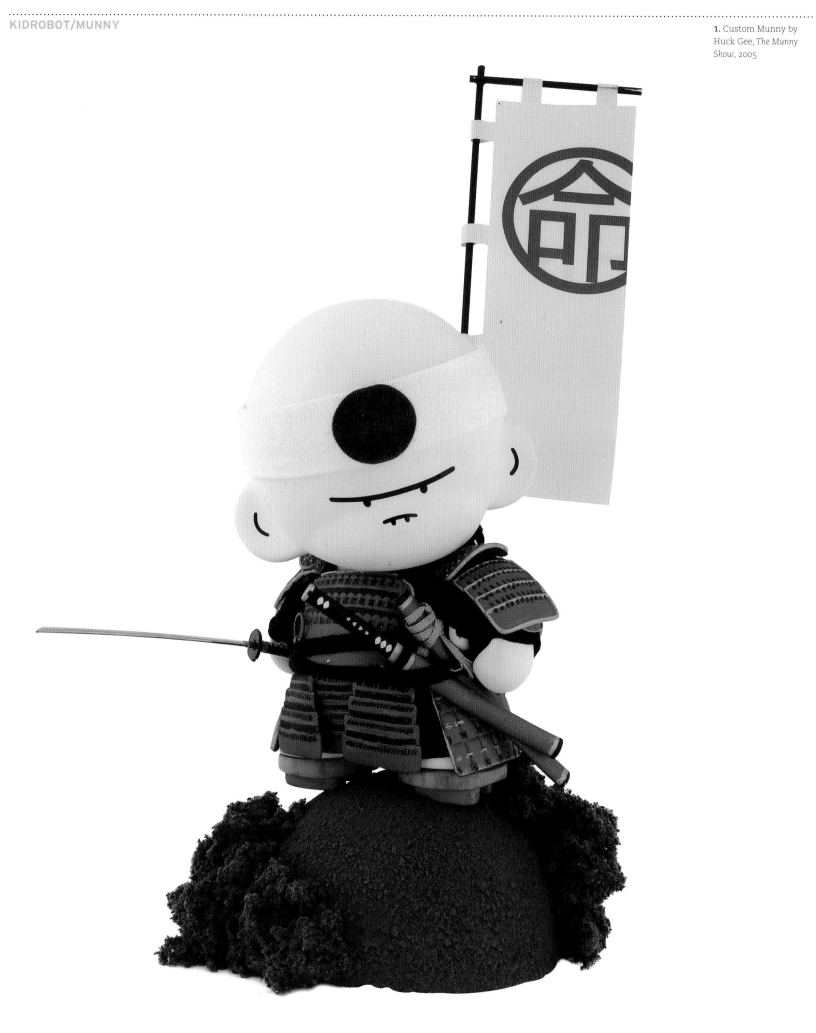

1

Custom Munnys from
The Munny Show, 2005:
2. by Tado **3.** by Sket One
4. by Mad Barbarians
5. by Nick Rhodes **6.** by
Gary Baseman **7.** by Mori
Chack **8.** by KOA

2–3

4–5

6–8

Custom Munnys from
The Munny Show, 2005:
1–2. by Tara McPherson
3. by Nancy Bacich
4. by Tilt **5.** by White

1–3

4–5

TOKIDOKI

Designer: Simone Legno

Nationality: Italian

Based in: Los Angeles, California

Websites: tokidoki.it; strangeco.com

Manufacturer: STRANGEco

From the set *Cactus Friends*, 2005:
6. Sandy **7.** Bastardino
8. Sabochan

6–7

8

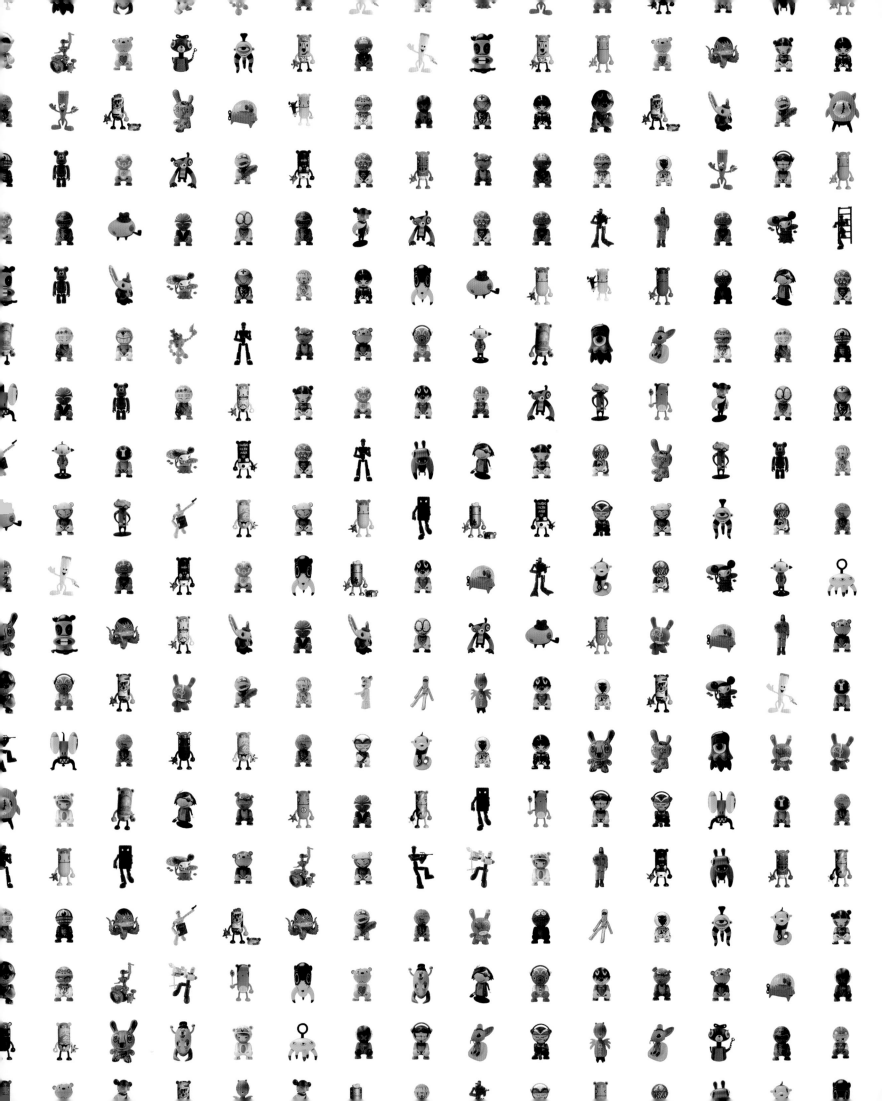

I AM PLASTIC : ELSEWHERE

NATHAN JUREVICIUS

Nationality: Australian

Based in: Toronto, Canada

Website: scarygirl.com

Manufacturer: Flying Cat

1. Treedweller, *Scarygirl*
Large Vinyl Series, 2004

1

2

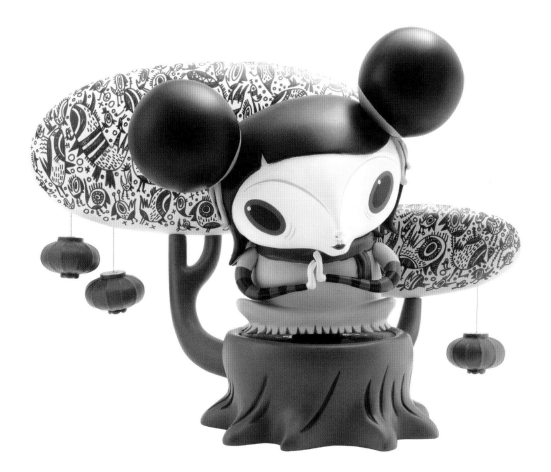

3

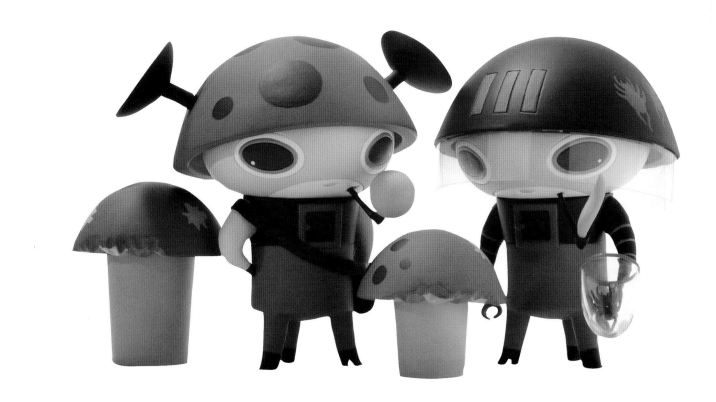

From the set *Mini
Scarygirl Series*, 2004:
1. Zombie Dock Worker
2. Snow 3. Scarygirl
4. Dr Maybee 5. T-Bear
6. Toycat 7. Bunniguru
8. Chihoohoo 9. Alice
10. Egg 11. Blister

1–4

5–8

9–11

From the set *Minitree-house Series 1*, 2003:
12. Roofis **13.** Dudson
14. Glamboosa
15. Heenie **16.** Klipper
17. Arkski **18.** Pegsti
19. Ziffrey **20.** Bennzi
21. Luuka **22.** Seoop

12–16

17–18

19–22

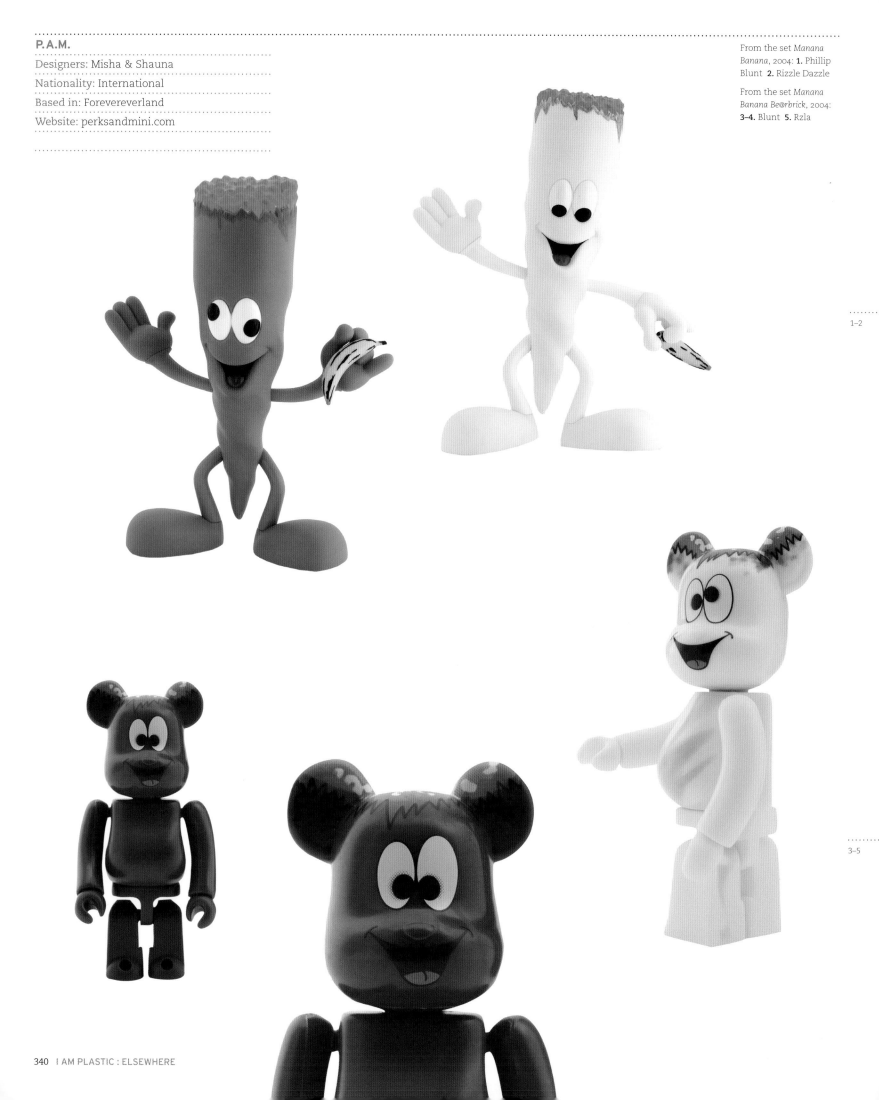

P.A.M.

Designers: Misha & Shauna

Nationality: International

Based in: Forevereverland

Website: perksandmini.com

From the set *Manana Banana*, 2004: **1.** Phillip Blunt **2.** Rizzle Dazzle

From the set *Manana Banana Be@rbrick*, 2004: **3–4.** Blunt **5.** Rzla

1–2

3–5

6

PLAY IMAGINATIVE/TREXI

Designers: Various

Trexi shape: Darren Gan and Jacky Teo

Nationality: Singaporean

Website: playimaginative.com

From the set *Trexi Series 2*, 2005: **1.** Ah Pook Trexi by Stephen Cicala **2.** Boom Trexi by Pixel Munky **3.** Chaps Trexi by fFurious **4.** Domina Trexi by Pinglet **5.** Empty Head Trexi by KOA **6.** Jap Trexi by Bupla **7.** Mr Tree Trexi by Cecilie Ellefsen **8.** O.D.M. Glow-in-the-Dark Trexi **9.** Polar Trexi by Tortoy **10.** Racer Trexi by Erwin Weber **11.** Skyzo Fred Trexi by Doze **12.** Spider Boom Trexi by Sun-Min **13.** Strike Archangel Trexi by Lesha **14.** Tiki Brown Trexi by Dave Silva **15.** Trexi in Wonderland by Kylie Kiu **16.** Wiz/ard Trexi by MCA

1–2

3–7

8–11

12–16

From the set *Trexi Series 1*, 2005: **17.** Intestine Brain Child Trexi by Gary Baseman **18.** Victory Boy Trexi by Mimic **19.** Aminal Trexi by Norio Ichikawa **20.** Heidi 04 Trexi by Tiziana Haug **21.** Itz A Bird! Trexi by Hixtril **22.** Lost Boy Scout Trexi by Jeremyville **23.** Nuukem Trexi by Kenn Munk **24.** One Eyed Willy Trexi by Tracy Tubera **25.** Peskimoon Trexi by Peskimo **26.** Punchy Bear Trexi by John Pinkerton **27.** Question What? Trexi by Tesselate **28.** Rad Blastin Trexi by Tracy Tubera **29.** Kong Trexi by Darren Gan

30. White Kong Trexi, *Playtimes Subscriber Exclusive*, 2005 **31.** Rex Blastin Trexi by Tracy Tubera, *Coca-Cola Singapore Exclusive*, 2005 **32.** Singapore Tourism Board Trexi, *Singapore Tourism Board Exclusive*, 2005 **33.** Motorola Flinko Trexi, *Motorola Singapore Exclusive*, 2005 **34–35.** Flesh Imp Trexi by Flesh Imp, *Flesh Imp Exclusive*, 2005

17–20

21–25

26–30

31–35

STIKFAS

Nationality: Singaporean

Based in: Singapore

Website: stikfas.com

From the set *Republic of Singapore Navy Recruitment*, 2004: **1.** Limited Edition Naval Systems Specialist **2.** Limited Edition Naval Diver **3.** Limited Edition Naval Officer

4. Exclusive "Peach" Beta Female Figure (Hobby Japan STIKFAS™ Fan Book), 2005 **5.** Alpha Male Rock Star, 2005 **6–7.** Alpha Male Frame

1–3

4–7

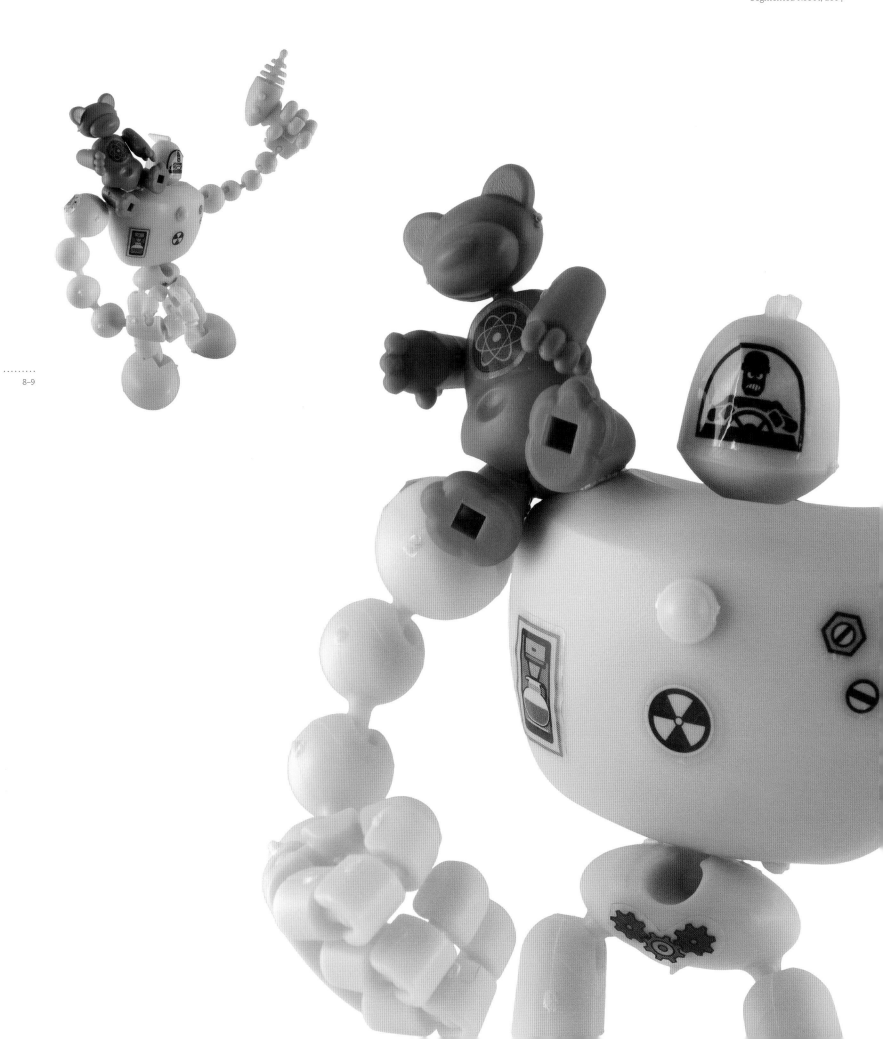

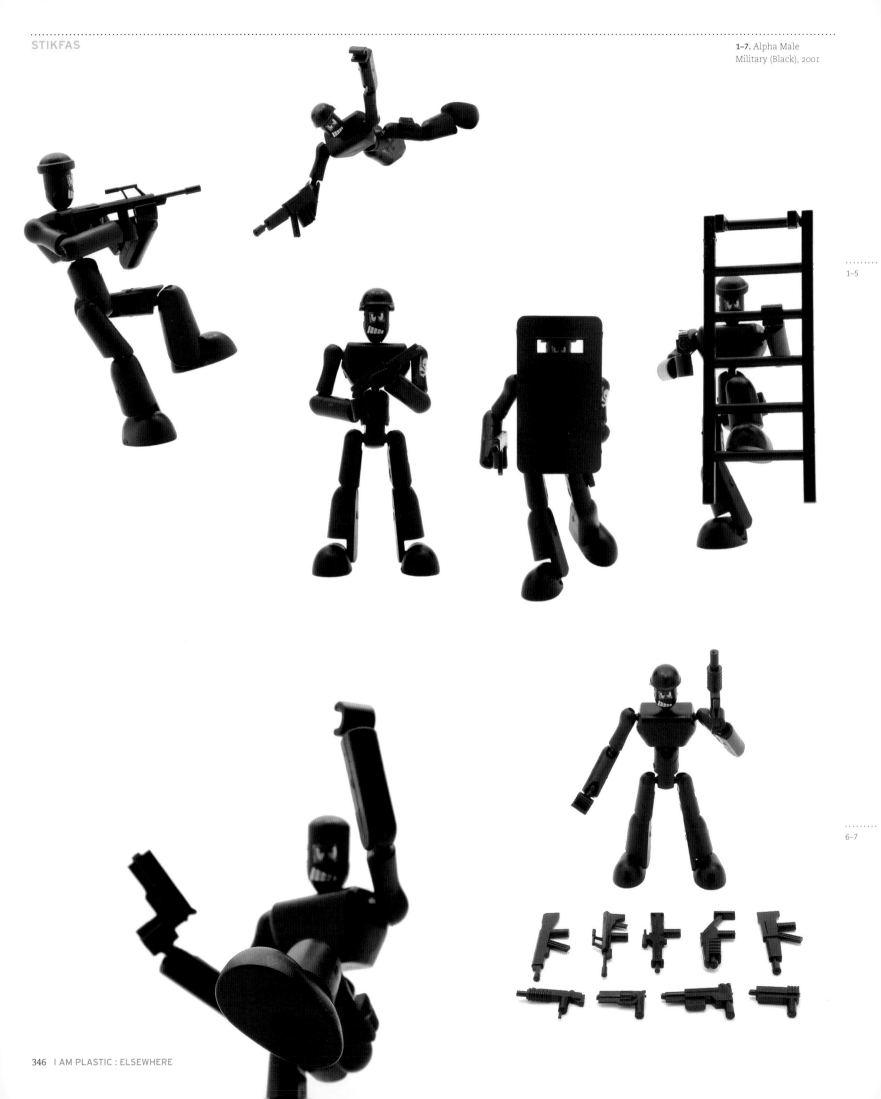

1–5

6–7

JEREMYVILLE

Nationality: Australian

Based in: Sydney, Australia

Website: jeremyville.com

8–9. "Surgeon General" Zombie, *Jeremyville x LMAC Exclusive Crossover,* 2005 **10.** "Lost Boy Scout" *Trexi, Trexi Series 1,* 2005 **11–12.** Dunny "Mushroom Farm," *Vinyl Klash 2 Exhibition (Detroit),* 2005

LMAC

Designer: Le Messie

Nationality: Gehenomian

Based in: Gehenom

Website: lmac.tv

1–5

6–7

8–9

10. Shadow Zombie, 2005
11. Reebok Zombie, 2005

12. Montana Colors x LMAC Zombie, 2005
13. Tado x LMAC Zombie, 2005 14. Vibes x Tom Thrasher x LMAC Zombie, 2005

10–11

12–13

14

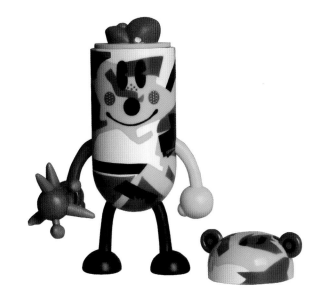

DOMA

Designers: Mariano Barbieri, Julian Pablo
Manzelli, Matias Vigliano, Orilo Blandini

Nationality: Argentinian

Based in: Buenos Aires, Argentina

Website: doma.tv

1

2

3–4

5–7

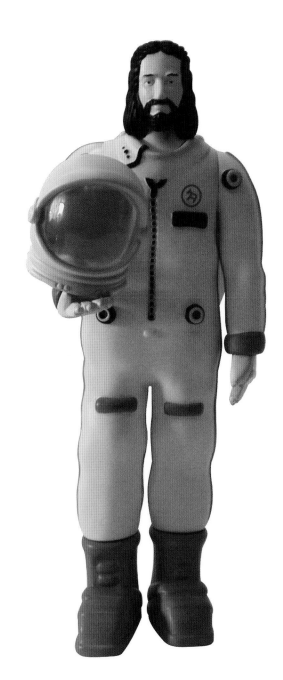

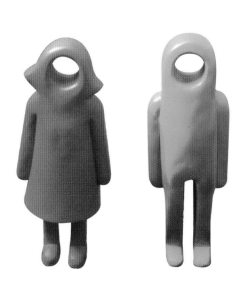

INTERVIEWS

What's your name?
BxH (Bounty Hunter) Hikaru.

Where were you born?
Sasebo, Japan.

Where do you live?
Meguro, Tokyo.

What's your favorite color?
Black.

How did you get the name Bounty Hunter?
It comes from Boba Fett of *Star Wars*. Boba Fett is my favorite.

Many people credit you for starting the toy craze in Japan and abroad. What was your very first toy, and what gave you the idea to make it?
There wasn't anyone making designed figures back then.

Where do you get the ideas for your toys?
In my daily life.

Are you influenced by American culture?
Yes, my mom used to work at a United States Naval base in Japan, and I grew up surrounded by American toys and snack foods.

What do you love?
Everything.

What do you detest?
Everything.

What's in your pocket?
Cigarettes.

What do you eat for breakfast?
Caramel chai.

Do you collect anything?
My desire to collect is my motivating power.

Describe your studio where you work.
I am surrounded by things I love.

What's your name?
Mori Chack.

Where were you born?
Osaka, Japan.

Where do you live?
Shibuya, Tokyo.

What's your favorite color?
I love red. I basically only buy red stuff.

What's on your iPod?
I don't have an iPod because I like to listen to the sounds around me when I'm out.

I understand that you began designing Gloomy Bear on postcards. Where did Gloomy Bear come from?
When I was a retained illustrator for a recruitment magazine, I was asked to draw a little girl holding a cute bear. I did it because it was my job, but I was thinking, "Bears aren't really cute and cuddly…" and I doodled a small picture of a bear attacking a boy on the side. This eventually became Gloomy.

How did Gloomy Bear become so popular?
You should be asking my fans or the professionals in the character market. I think there were just an unexpectedly large number of people who shared my views. I'm more excited by that than the popularity thing.

What is the story of Gloomy Bear? What is the message of this character?
If anyone really ran into a bear, they'd be terrified, right? If a real bear wandered into town, it would probably be shot. But in stuffed animal form, bears somehow become cute and cuddly. The same bear that we'd usually fear and kill. I convey the humor in this contradiction. There's also the unfortunate fact that animals age faster than humans. I've always had pet dogs and cats, but they've all died. When the boy Pity finds Gloomy, he was still a baby bear. Another message I want to convey is that abusing animals is just as bad as abusing children who are unable to defend themselves. There are many messages within the Gloomy story and I can't name them all, but each reader will probably understand it in his own way, which is the best way.

Gloomy Bear and Pity by Mori Chack

Do you collect anything?
I collect things that are red. I've also started collecting unfinished figurines. I like them pure white before they are painted because they're like plaster sculptures. But this is something recent, so my collection is still small.

What's your favorite thing you ever bought?
My car. I've always loved car models and remote control cars, so it's an extension of that.

What was your favorite toy when you were a kid?
Gundam models, remote control cars, and electronic games. That's it.

What influences you?
Nothing in particular. If anything, my desire not to become a useless adult, like some of those around me.

Describe your studio.
A chair, desk, pencil, and paper. And a Mac. That's all I need to do what I do.

If you could be someone or something else, who or what would you be?
God. Because there isn't one.

If you could have invented a toy that someone else made, what would it be and why?
I don't get your question.

What's your Pantone color?
485C 2x.

Are you influenced by Japanese culture?
I don't know if you'd call it culture, but since I was born in and live in Japan, I guess I'd be influenced by it in some way.

Are you influenced by American culture?
Probably, because I like American comics and stuff. I'm not consciously influenced by it, though. I like their toy packaging design, it's cute. I also love those huge hamburgers they serve at American restaurants.

What do you love?
Nothing right now. But there are many things I truly hold dear. My wonderful staff, my drinking buddies.... Some may call this love, but since it's not one thing in particular, I wouldn't call it love.

What do you detest?
God, if he existed. He killed my mom.

What's in your pocket?
A chewing gum wrapper.

What's your name?
My name is "Hiddy."

Where were you born?
Osaka, Japan.

Where do you live?
Yoyogi, Tokyo.

What's your favorite color?
I love clear (transparent) color!

When you're not designing toys, what do you do?
I am hanging out with girls!

Where did you get the name Secret Base?
Hikaru of Bounty Hunter named Secret Base for us.

What was your first toy, and what made you decide to make it?
The first figure I designed was Skull Bee. Back in the day, Sakamoto of Cocobat (a band) came up with a figure called Fink Shit, which inspired me to make Skull Bee.

What is your favorite thing that you have ever made?
My favorite is Skullmantis (Halloween Version).

Do you collect toys? What are your favorites? Do you collect anything else?
Yes, I do collect toys! For Japanese toys, I am into Transforming Cyborg and Astro Mu 5. For American toys, I am into Madballs and Jerms.

What influences you?
I am influenced by Nike sneakers and lovely (hot) girls.

Describe your studio.
I do not have a design studio. I work in a space behind our shop. But, I could say the city itself is my studio space. I get a lot of ideas from walking around Osaka.

If you could be someone or something else, who or what would you be?
The most entertaining comedian in Japan, and entertain the whole of Japan with laughter!

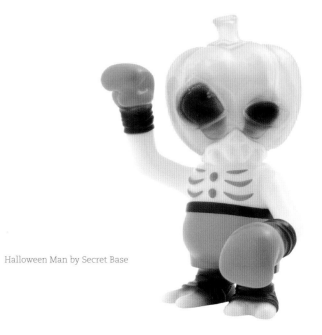

Halloween Man by Secret Base

If you could have invented a toy that someone else made, what would it be and why?
I do not have such a person.

What's your Pantone color?
I love yellow and orange.

Are you influenced by Japanese culture?
Of course. I am really proud of Japanese culture, and I am really happy that I was born in Osaka, Japan.

Are you influenced by American culture?
I am a big fan of American culture, from its food culture to toy culture. I love the American spirit in general!

What do you love?
Girls! And my own entertainment.

What do you detest?
I hate the Japanese food called *natou* (fermented soybeans).

What's in your pocket?
Laughter and ambition!

What's your name?
Jason Siu.

Where were you born?
Hong Kong, China.

Where do you live?
Hong Kong, China.

How did you get the idea to put speakers on toys?
It's a coincidence. I made a gift for celebrating the grand opening of my friend's toy store. That little gift was my first speaker.

Did you initially have any electrical background?
A little bit, but not professionally.

What was the first toy you ever designed?
Frey Mui.

What are you working on now?
Creating new artworks.

What makes a good vacation?
Having new inputs in our life to inspire our thoughts.

What was your favorite toy when you were a kid?
It was a little train bought by my father as a birthday gift.

What influences you?
Lots of inputs from my daily living, e.g., music, film, the news.

Do you collect anything?
Jeans and shoes.

What's on your iPod?
My concept, "Speak your mind."

What was the last show you went to?
The "3er" exhibition in Times Square, Hong Kong.

Describe your studio.
I moved to a new studio; it's two floors and around 1,400 square feet. It's not located in a commercial area, but in a more peaceful environment. The upper floor is a warehouse, downstairs are the showroom and two offices. It's white and orange.

What's your favorite thing you've ever made?
No definite favorite thing as different designs carried different messages and ideas.

What do you love?
Movies, music, and all creative things that inspire me.

When you're not designing toys, what do you do?
Read books, observe different things or people around me.

Is it art?
It depends on your concept of art. People may have different ideas towards art. For me, art is a medium for artists to present their own thoughts through different elements. Toys can be one element for artists.

How do toys touch people's minds?
A toy is likely to be easily accepted by people. And it is user friendly. Each person may have at least one favorite toy in their life, and people have different memories of their favorite toy.

Spearhead by Jason Siu

What's your name?
Pete Fowler.

Where were you born?
Cardiff, Wales.

Where do you live?
London, England.

What's your favorite color?
Caramel.

Describe your studio.
One big room: a long desk, a dartboard, a TV, tons of CDs, and, of course, toys.

What's on your iPod?
Nothing, it wiped itself two weeks ago!

Talk about your relationship with Super Furry Animals.
I've been working with them since their second LP in 1997 after they saw my artwork in a Welsh-language magazine. I've been providing them with art for their LP and single covers, merchandise, promo videos, stage shows, and whatever they throw at me. It's a great relationship for me as an artist to work with them, as they usually let me get on with my own ideas and as we share similar attitudes and tastes. We get along very well.

What are you working on now?
I'm working on the fourth Kia car commercial for TV here in the United Kingdom, which is using stop motion animation at the Aardman studios in Bristol. I'm planning new toy figures and art prints for release in 2006 and have just finished a Monsterism Island comic strip for *Vice* magazine. Also, my Monsterism Island animation project is gathering momentum and I hope to release a short or pilot episode sometime next year.

What's your favorite thing you ever bought?
Mrs. Moore in Space. It's a book of paintings by the mother of Britain's favorite eccentric astronomer, Patrick Moore. I bought it as a kid for next to nothing at a book sale. Her paintings are her idea of life on other planets and are very bizarre.

What was your favorite toy when you were a kid?
I had a teddy bear that I liked a lot, then came *Star Wars*….

How did you get into toy design?
I did sculpture during my fine art degree and went on to make one-off figures for myself and friends out of clay. About six years ago I got a studio to make larger sculptures, and after a show in Japan I was approached by Sony Creative Products and offered the opportunity to create a range of toy figures.

Do you collect anything?
I collect records, western shirts, and anything Shigeru Mizuki, but I'm probably most serious about collecting records.

What influences you?
I have a lot of things that feed my creativity. I love the natural world, animals, myths, folklore, psychedelic music, food, friends, films, books…. Whatever catches my eye and imagination from day to day.

What was the last show you went to?
I don't go to too many art shows actually! Maybe the folk art exhibition at the Barbican in London.

If you could be someone or something else, who or what would you be?
H.R. Pufnstuf.

If you could have invented a toy that someone else made, what would it be?
The rabbit vibrator.

What's your favorite thing you've ever made?
So far, it's the last couple of paintings I'm working on. I'm working very slowly on them.

What's your Pantone color?
471U.

What do you love?
Psychedelic music.

What do you detest?
Idiots with technology.

What's in your pocket?
£6.52 in change and used train tickets to Stockport.

Why do people relate to your characters?
I think although they are a little sinister, they have a friendly persona or character people relate to. I never really think why, I'm just thankful to do what I do.

Saphii by Pete Fowler

What are your names?
Mike and Katie.

Where were you born?
Mike: Newcastle, United Kingdom
Katie: Loughborough, United Kingdom.

Where do you live?
A quaint little town called Sheffield, where the sun always shines and blue birds sing from the hedgerows.

How did you get your name? What does it mean?
Tado is a magical word that we invented. If you say it six times, and then give a flower to the first stranger you see, something wonderful will happen. Try it for yourself.

What's your favorite color?
One that hasn't been invented yet.

What's on your iPod?
A bit of everything, from Minor Threat to Madvillian, Melt-Banana to M.I.A. And a hysterical sticker of a cucumber playing electric guitar.

What's your favorite thing you ever bought?
Mike: My BMX.
Katie: My first pet, a hamster called Arthur.

Do you still ride your BMX?
I still ride when I get the rare chance, but unfortunately the lazy summers spent lolling around skateparks all day are long gone!

Do you feel like your designs are particularly "European"?
We think our work is definitely British! We like brown ale and baked beans.

At the same time, I see a lot of Japanese or Chinese influence in your work. Is this true?
Yes, of course. We are very heavily influenced by the aesthetics of places like Hong Kong and Tokyo—the brightness and madness of everything. They just look much better than Sheffield in our opinion! Also, the fact that the prettier half of Tado comes from a Chinese family probably adds a lot to our style!

What was your favorite toy when you were a kid?
Mike: a plank of wood and two half bricks.
Katie: a caterpillar name Toby.

How did you get into toy design?
We've been into toys for a long time, maybe five or six years now. When we graduated from university we started to work freelance, and came to know the guys at Playlounge in London. When we showed them our stuff they forwarded it on to Toy2R. The rest is history.

Do you collect anything?
Toys. Many, many, many toys. Prints, books, and Tamiya radio-controlled cars!

Which toys are your favorites?
Our favorite toys are things like our Elphonso Lam figures, Bounty Hunter, the old James Jarvis stuff, older Bape figures, Balzac stuff, Gloomy Bear, Scarygirl, etc. Our biggest passion, however, is To-Fu. WE LOVE TO-FU! We also love all the retro stuff, too, Anapanman, Gachapin, Parman, Doraemon, etc. We've been collecting together now for about five or six years, so we really need some more room! Current stuff we're really excited about includes Rolito's new stuff, some of the Secret Base stuff, Nanospores, the new Minitreehouse figures, and of course anything To-Fu!

What influences you?
Our friends who do the same kind of things as us. Being able to bounce ideas off like-minded retards is the best thing!

What was the last CD you bought?
A TDK 700MB blank CD-R. Which we promptly used to copy two other albums!

What was the last show you went to?
Doodlebug Day at the Cornerhouse in Manchester. It's nice over there.

Describe your studio.
A cupboard with far too much stuff in it. Lots of boxes of stuff that we have no room to unpack! It stinks of a large collection of vinyl toys, too. Lovely.

What's your favorite thing you've ever made?
Homemade Shepherd's pie, with Yorkshire puddings, roast parsnips and potatoes, peas, and pale gravy.

What's your Pantone color?
813C.

Are you influenced by Japanese culture?
Of course. They have the best game shows.

Are you influenced by American culture?
Of course. You have better wildlife than us.

What do you love?
Eating pies. Chow Chow dogs. And cuddles.

What do you detest?
People who are impolite.

What's in your pocket?
Holes.

If you could have a super power, what would it be?
Iamese-Sissy-Morph!

When you're not designing toys, what do you do?
Feed the ducks in the village pond.

What do you eat for breakfast?
Too much.

What do your toys say?
We can't write that kind of thing here.

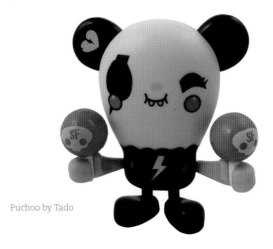

Puchoo by Tado

What's your name?
Tilt.

Where were you born?
Toulouse, South of France, the best city in the world.

Where do you live?
Toulouse, South of France, the best city in the world. I told you that somewhere I guess!

What's your favorite color?
Pink.

How did you come up with the idea to paint on women around the world?
I wanted to mix what I like the most: graffiti, girls, and traveling around the world with my camera. So it was obvious that the BubbleGirls concept come through. I also started doing pictures from all the countries I visited. I didn't want to only come back home with pictures of graffiti. That's cool, but a bit not enough. My ex-girlfriend, who I used to travel a lot with, was my first model, a kind of muse. We did many photos in different crazy places during a California road trip. That really put me into girl's pictures. So it was evident even when we separated that I still wanted to shoot nice sexy Babitches.

How easy is it to get girls to pose for Fetiltism?
I think girls like and trust me, that's it!!! I probably look like a cool guy that you can do crazy things with and not feeling ashamed or guilty. Or maybe I'm just super lucky.

Do you say anything special to convince them?
The main idea is to leave them 100% free to show what they want to show me. If a girl doesn't even want to be naked, I won't push her at all. At the same time if she wants to be nasty or play the "flasher" I won't ask her to put on this or that kind of clothes, like a stylist. Then girls feel that they can do what they want. And you can see that on the pictures, I guess. There is also another thing that might encourage them to do it—it's the idea of having their name painted in their own city with my bubble graffiti style. Girls love Bubbles!!!!

Who is your ultimate Bubble Girl?
The one I am still looking for.

How does it feel to have the best job in the world?
It makes even my father jealous about my job.

What was your favorite toy when you were a kid?
Probably my pirate's boat from Playmobil.

Do you collect anything?
High heels for girls (I have about forty pairs, they are my sex toys) and Nintendo '80s games.

What influences you?
So many things like old school Powell-Peralta skateboard videos, Richard Kern pictures, my friend Tober, Bettie Page, New York '80s graffiti, and the clouds though the window in the plane when I'm traveling the world.

Describe your studio.
A little atelier in the garden of my house with my skateboard ramp in front of it. It's full of tags, throw ups on the main wall, and has got thousands of drops on the floor. I've also got some other canvases from friends and of course spray cans, brushes, acrylics, canvases, markers, and my famous dripping card that is my secret weapon.

If you could have a super power, what would it be?
To be able to do all the skateboard tricks that I want to land or have the power to convince all the BubbleGirls to have sex together for a special kinky shooting.

What do you love?
Amanda Lepore's mouth, sushi, very red high heels, skateboarding with my friends on a Sunday afternoon, Vespas, being on a plane, all kind of drips, even the dirtiest, spanking picky girls, my digital camera, Amsterdam mushrooms, walking in the red-light district, girls with too much lipstick, and, more than all that, my parents and my lovely Spanish grandmother.

What do you detest?
TV.

What's in your pocket?
Nothing, 'cause I'm just wearing boxers when I'm answering this interview alone in my room.

What do you eat for breakfast?
It depends if I wake up alone in my bed or not. In the first case, it would be a giant bowl of cereal with fresh fruits, chocolate chips, and milk. Mmmm!!!

Custom Munny by Tilt

What's your name?
James Marshall.

Where were you born?
New London, Connecticut.

Where do you live?
Brooklyn, New York.

What's your favorite color?
All of them.

What was your first character? How did you come up with the Space Monkey character that is now so famous?
Who knows…I scribbled all sorts of characters forever before the early days of the monkey. The Space Monkey character was as random as any of my scribbles. There must have been some sort of spark. I don't know. It just sort of evolved of its own volition.

Your characters are very appealing graphically, and then at the same time there's something terrifying about them. There are lots of hammers and bags of money and knives. And farts and even blood. Is there some kind of message you're trying to send? What do the characters represent when you make them?
There are all sorts of messages in the work. What do the characters represent? Being human in a world full of humans.

How does graffiti relate to toys?
I don't know that it does, other than there are graffiti writers making toys.

Why do people relate to your characters?
You'd have to ask them.

Word has it that you used to work for Takashi Murakami. What was it like?
I did for a while. It was a good experience for me.

Do you feel like you learned anything specific from working with him?
All sorts of things.

Your work is super-precise—the lines are almost computer-perfect and the color shading is just brilliant. When you think about line and color, what goes through your mind?
Not much, it just sort of happens…. Thinking will f*** you up in those situations. You just roll with what you know.

What was your favorite toy when you were a kid?
Star Wars toys.

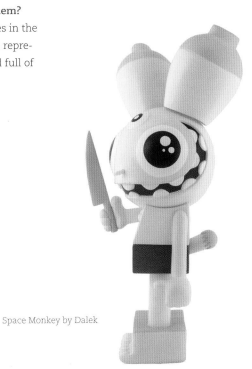

Space Monkey by Dalek

Any ones in particular?
I liked the Snow Speeder and the Ad-At. Those were my favorites. X-Wing was pretty tight as well. And the Hoth playset.

How did you get into toy design?
Sony Creative, The Vanimal Zoo Project…. That kicked it off.

How did that happen?
They dropped by the studio and asked if I'd like to participate. I said yes.

What influences you?
Anything and everything.

Describe your studio.
It's pretty bare, just a table to work on, some paints, panels to paint on, and a few objects here and there.

If you could have invented a toy or character that someone else made, what would it be and why?
I'll have to think about that one. Either Darth Vader or Homer Simpson.

Why Homer Simpson?
Because he is Homer Simpson.

What's your favorite thing you've ever made?
My sons.

You are amazing with color. How do you think about color in your work?
Thank you. I just sort of start with a background color and build everything off of that. It's all pretty natural though, not a lot of forethought in anything I do.

Are you influenced by Japanese culture?
Not really, although especially with the Murakami connection and the fact that I lived there for years, a lot of people assume I am. I am sure there is some level at which it is at work, but barely.

Are you influenced by American culture?
Pretty much. I look at American cartooning and comics for visual direction. The topics of the work all deal with American social and behavioral phenomena. I mean it's my home. It's what I see everyday and what I exist in. I can't help but be influenced by it.

What do you love?
My family and friends. Folks that make an effort to be decent.

What do you detest?
There isn't enough room in the book for that. But essentially anybody who feels the need to be shitty to other people on any level, for whatever reason.

What's in your pocket?
Nothing. I just woke up.

What are your names?
Samuel Albert Borkson and Arturo Sandoval III.

Where were you born?
I was born on a plantation, and Tury was born in Cuba.

Where do you live?
Miami, Florida.

What's your favorite color?
I like primary colors a lot. Depends on the day and time of day.

What's on your iPod?
Don't have one, but it would be maybe some reggae tunes or other POWER 96 Hip Hop.

What's your favorite thing you ever bought?
My favorite things aren't bought, they are gifts or made things.

Like what, for example?
I have a Grimace Christmas cookie jar, given to me by Tury, that I love, an African mask that looks just like me given to me by Josh Kay of Schematic; some special Chinese figurines given to me by my sweetest little Gramma Rosalyn; a little golden pen given to me by my grilfriend's *abuela*; a pre-teen modeling picture in a frame of my friend Jason that is absolutely hysterical; a Dalí print given to me by my dad. Those are some of my favorites off the top of my head.

What was your favorite toy when you were a kid?
This multicolor worm, with all different textures and a bell on the end.

I can kind of see that coming out in your work, especially in Mr. TTT for some reason. What do you think?
For sure!

How did you get into toy design?
I just started making them and sewing with Tury. We wanted a way to spread our art to the world, and this is the best way right now.

When was that? How long have you been making the Friends toys? Which was the first one, and was there a moment when you just said, "I need to make toys"?
About three or four years ago now. Time goes fastest when you are loving it! Albino Squid was one of the first along with Red Flyer. I guess I wanted to do toys at the moment when I just decided it would be the best way to spread an idea and artwork around the world, instead of just a nice painting in one rich person's house, we would invade the house of thousands and thousands of great people!

What was your first toy ever?
My blanket.

Where did Malfi come from?
Malfi is kind of like a magic spirit guide who has been leading me from inside for years. He is a trickster and an adventurer.

I really loved the movie you made for Nike. Are there more movies coming?
For sure, there are a ton already made. We do them pretty much for each installation. There is a little Hello Kitty video we made for a Hello Kitty show in China, and tons of great little movies that we make for the likes of MTV and other fun places that give us the freedom to make what we like! There will be more and more and more, and soon a show!

Do you collect anything?
Little golden things, paintings I make, comics, and weird movies, but I'm not an avid collector of anything.

What influences you?
People, especially Tury. World religions in their base form, philosophy, power, and collective conscience.

What was the last show you went to?
Lightning Bolt.

Describe your studio.
Lots of funny things. Costumes, a giant squid head, magical altars, lots of paintings, a fun computer, and tons of art supplies.

Is it a big place? Do you have a lot of equipment around or supplies for making toys?
It's big for a one bedroom apartment, I guess. Miami is nice like that. There are definitely tons and tons of supplies that are constantly replenished and over and over!

If you could be someone or something else, who or what would you be?
Nothing else, nowhere, but I would like to go back to Asia soon and lots more places.

Super Smiling Malfi by Friends With You

If you could have invented a toy that someone else made, what would it be and why?
Mmm, nothing else.

What do you love?
I love passion, I love the world, I love the underdogs, bums, and weirdos. I love dogs and my friends. I love pizza, sushi, bagels, lox, and cream cheese. I love making art. I love lots more, oh and the tingling feeling on the top of my head that I get from hearing a beautiful piece of music or singer.

What do you detest?
I detest certain people, blocked signals, and the "too cool" attitude.

What's in your pocket?
Home Depot receipt, Publix (our local grocery store) receipt, and a ticket for fresh food and cold cuts.

Do you play with toys?
I play all day and night.

If you could have a super power, what would it be?
I have one, but it's a secret. If I could have another, I would use telekinesis to transfer my spirit into the universe or any animal I wish.

What makes a good vacation?
Fun, friends, food, adventure, trouble, and great moments of life.

What do you eat for breakfast?
All the time? Sometimes I don't eat breakfast.

What do your toys say?
Listen carefully. You are all god and the devil. Make anything you want happen. Believe in it and follow it forever. Magic luck and friendship! Oh and something that sounds like a squeak, but in slow motion.

How did you get your name? What does it mean?
Friends with You is the observation of the universe, spirits, energy, and microscopic entities that are all around you all the time. Pay attention and they will give you magic. It's also a philosophy of acceptance and instant approval, and we want to be down with you!

Why are we interviewing you?
Because you care. Thank you.

What's your name?
Frank Kozik.

Where were you born?
Spain.

Where do you live?
San Francisco, California.

What's your favorite color?
Clear.

What's on your iPod?
I don't own an iPod.

What was the first toy you ever designed, and how did that come about? How did you end up working with Bounty Hunter and Kidrobot?
The right place at the right time, and my personal contacts.

What's your favorite thing you ever bought?
Eyeglasses.

What was your favorite toy when you were a kid?
Plastic soldiers.

How did you get into toy design?
I was a life-long collector. Now I live the dream!

Do you collect anything?
Yes, yes indeed.

What influences you?
Fear, greed, and hunger.

Describe your studio.
Boring.

If you could be someone or something else, who or what would you be?
A large cactus.

If you could have invented a toy that someone else made, what would it be and why?
Silly Putty.

What's your favorite thing you've ever made?
Dr. Bomb.

What's your Pantone color?
Red 032.

Are you influenced by Japanese culture?
Yes.

What do you love?
Coffee.

What do you detest?
People that honk a lot, and also car alarms.

Tell us your craziest fan story.
Fan falls to knees in tears, bangs head on pavement in supplication, randomly on the street, Osaka, 1998.

When you're not designing toys, what do you do?
Ride motorcycles.

What is your favorite motorcycle?
Ducati 999R.

Smorkin' Labbit by Frank Kozik

What's your name?
The Super SUCKLORD.

Where were you born?
New York City.

Where do you live?
New York City.

What's your favorite color?
What?

How did you get your name? What does it mean?
I am the Master of the Suckrealm and it is an inherited title.

What's the craziest situation Sucklord has found himself in?
Most recently getting kicked in the helmet by a goth anime stripper spinning on a pole on the number 2 train at 2:00 a.m. last Monday.

What does Sucklord think of Morgan Phillips?
He's useful.

What rockin' beats do you play on your ghetto blaster?
The Supervillians and Star Wars Breakbeat.

Any new themes you can tell us about for your upcoming album?
No.

What's on your iPod?
What's on your iPod, guy? Don't ask me that.

What was the last show you went to?
Stay out of my business.

What influences you?
Money, power, revenge, *Star Wars*.

Describe your studio.
A bunch of boxes stashed in my mom's house.

What do you love?
Fame, props, girls.

What do you detest?
Cornball fratboys taking over New York City.

What's in your pocket?
Not fair, it can't ask us that precious.

What do you eat for breakfast?
These questions suck, who wrote them?

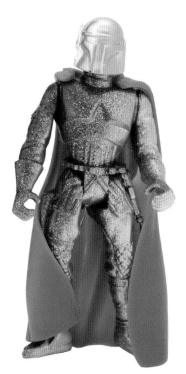

Sucklord by Suckadelic

What's your name?
Doze Green.

Where were you born?
Washington Heights. Represent.

Where do you live?
Brooklyn, New York.

What's your favorite color?
That depends. The colors that I gravitate toward most are green and blue hues.

What's on your iPod?
I didn't know everyone had one.

What do you think of the evolution of graffiti art?
A necessity for its survival as a form.

What do you think the future holds for graffiti artists?
I don't know that's in the future.

What's the one thing you miss most about back in the day?
I don't miss anything. I visit often in my memories…snore. Ok, that's not true. I guess I miss the spontaneity of the creative spirit, the ritual, the law and codes. The respect and honor amongst the Hip Hop Soldiers. Art, music, and dance.

What are you working on now?
New paintings and sculptures for upcoming stuff.

What's your favorite thing you ever bought?
Vinyl records.

What was your favorite toy when you were a kid?
In 1969 there was a series of nine figures from the so-called nine planets of our solar system. I forget the names but they were my all-time favorites, I was four or five. My second favorites would be astronaut figurines and original G.I. Joes in the shoe box packaging.

Do you collect anything?
My name is Sanford. I have a son.

What influences you?
Girls with large bottoms and my mom (sorry, mom).

Describe your studio.
Narnia middle earth Habitrail. But I'm cleaning soon. It's spring.

If you could have a super power, what would it be?
To be invisible. Hey, wait a minute, I already am!

What do you love?
You.

What do you detest?
The word "detest."

Tell us your craziest fan story.
I don't consider people who dig my work fans—just freaks like me, but once there was this chick who was mad thick and, well, I'll let you fill in the dots. Aight?

What's your name?

Bill McMullen.

Where were you born?

San Diego, California.

Where do you live?

New York City!

What's your favorite color?

Orange, of course.

Through all the amazing projects that you have done, which is the most memorable?

My involvement with the Beastie Boys's *Hello Nasty* album has really been a milestone in my career. As a big fan already, it was cool to get to work with them.

Is there anyone who you are dying to work with?

No one in particular, but I do have several ideas I'd like to get out there.

Is there a pair of shoes that you would give your left arm for?

Probably an original pair of air gum sole, micropacer, concrete safari-pattern Space Jam laser-etched Skechers. Or I would go for an original pair of the Air Max 95 (neon lime/gray colorway, of course) with the air-pressure numbers on the bubbles. None of the reissues have that. I know one guy who still has them: MC Serch. But dude has bigger feet than me so there's no lighting-strike home-invasion planned.

If you HAD to choose: shoes or toys?

That's a hypothetical situation that simply cannot be broached.

What's your favorite thing you ever bought?

I bought an early Eames chair, one of their first wooden chairs, manufactured by Evans, before Herman Miller took over. I also have animation frame from the opening sequence from *Wild Style*, an original Zephyr piece. I paused the bootleg video tape I had on the frame to make sure it was really used when I first got it; it was before DVDs. That's one of my favorite things, and it killed my bank account when I bought it at an auction. I ate ramen for weeks after that.

What's on your iPod?

The Low End Theory, *It Takes a Nation of Millions to Hold Us Back*, *93 'Til Infinity*, *Power, Corruption & Lies*, compilation playlists of all sorts of New York and southern hip-hop bangers. Papoose, T.I., anything with someone getting nice lyrically. Other playlists full of The Clash, The Damned, and Public Image Limited songs. I like '90s Britpop, too. Really, it's usually a "shuffle" situation. Bill Radio. Early test versions of my new podcast *American Mixtape* to see if it's any good....

What was the last show you went to?

Deitch Gallery.

What do you love?

Quality and workmanship. Clever ideas.

What do you detest?

Haters and their ways.

If you could be someone or something else, who or what would you be?

Syd Mead.

If you could have a super power, what would it be?

Invisibility would be my thing. You could probably get away with a lot of nonsense. Like staying in the bank or museum until they close, at least the ones with no motion sensors. Sneak out with the next several years' rent. Useful.

What's in your pocket?

Phone/pda thing, keys, wallet.

What do you eat for breakfast?

Lunch.

Describe your studio where you work.

I work from my home. I have a room that's filled with my toys, cameras, computer, drum machines, and video games. My friend Colby Parker Jr. saw it and nonchalantly christened it the "mancave." Unfortunately, the name has stuck. I work in the "mancave."

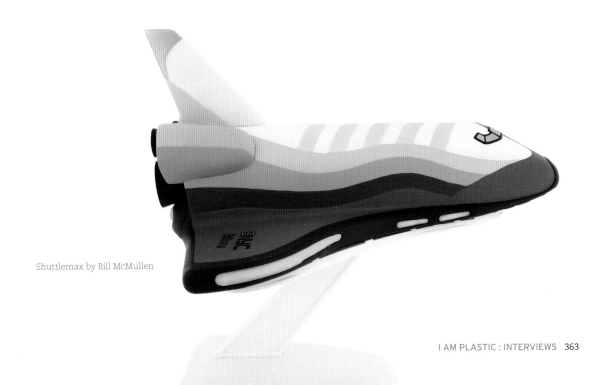

Shuttlemax by Bill McMullen

What's your name?
Joe Ledbetter.

Where were you born?
Los Angeles, California.

Where do you live?
Pasadena, California.

What's your favorite color?
Green.

What was your favorite toy when you were a kid?
Star Wars action figures.

How did you get into toy design?
Trying to impress my girlfriend.

Did you expect the hysteria that happened when your vinyl figures finally were released?
No.

You have a very unique style. What about your style do you think appeals to your fans?
What I hope is that people find humor and craftsmanship in my work, and that I've captured a delicious moment. I really like to lure the viewer in with cuteness and then smack them over the head with something sinister, subversive, too just painfully true. Much like being the loving owner of a rabid dog.

Who would win in a drinking contest ... Mr. Bunny or Fire-Cat?
Well, Mr. Bunny would be the one to challenge Fire-Cat to a drinking duel, but Fire-Cat would drink him under the table.

Are more friends going to be joining those two for adventures soon?
YES!!

Do you collect anything?
Lots of picture books and vinyl toys.

What influences you?
Cartoons.

When you're not designing toys, what do you do?
Painting and eating burritos.

Describe your studio.
Organized chaos.

If you could be someone or something else, who or what would you be?
An intergalactic freedom fighter.

What do you love?
Avocados.

What do you detest?
Bullies.

What's in your pocket?
Cell phone, twenty-three cents, keys.

What do you eat for breakfast?
Granola and rice milk.

What's your name?
Lev.

Where were you born?
Brooklyn, New York.

Where do you live?
In a gallery.

What's your favorite color?
Orange.

When did you first start collecting toys?
In the '80s.

What is your most prized toy?
The Futura spraycan prototype, and Futura and Kaws original artwork.

When did you open your store?
In 2000.

You have long-standing relationships with Futura, Kaws, BxH, and many other toy artists. How did this come about?
Just meeting these guys and hanging out with them whenever I have the chance, like with Futura, going to Hawaii to celebrate his fiftieth birthday, and Hikaru, just meeting him in Tokyo and talking about Batman toys for hours and hours.

What was your favorite toy when you were a kid?
I did not have a favorite toy when I was a kid. I liked collecting baseball cards.

What do you love?
I love my friends.

What do you detest?
I detest my enemies.

What's in your pocket?
A pocketknife.

Do you play with toys?
Of course!

What's your favorite city?
New York!

Why are you in this book?
Because you asked me to be in the book.

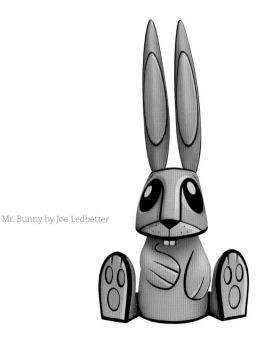

Mr. Bunny by Joe Ledbetter

The author would like to acknowledge the staff of Kidrobot, the
many artists whose work fills this book, and the courageous fans
and customers who realize that all miracles require sacrifice.

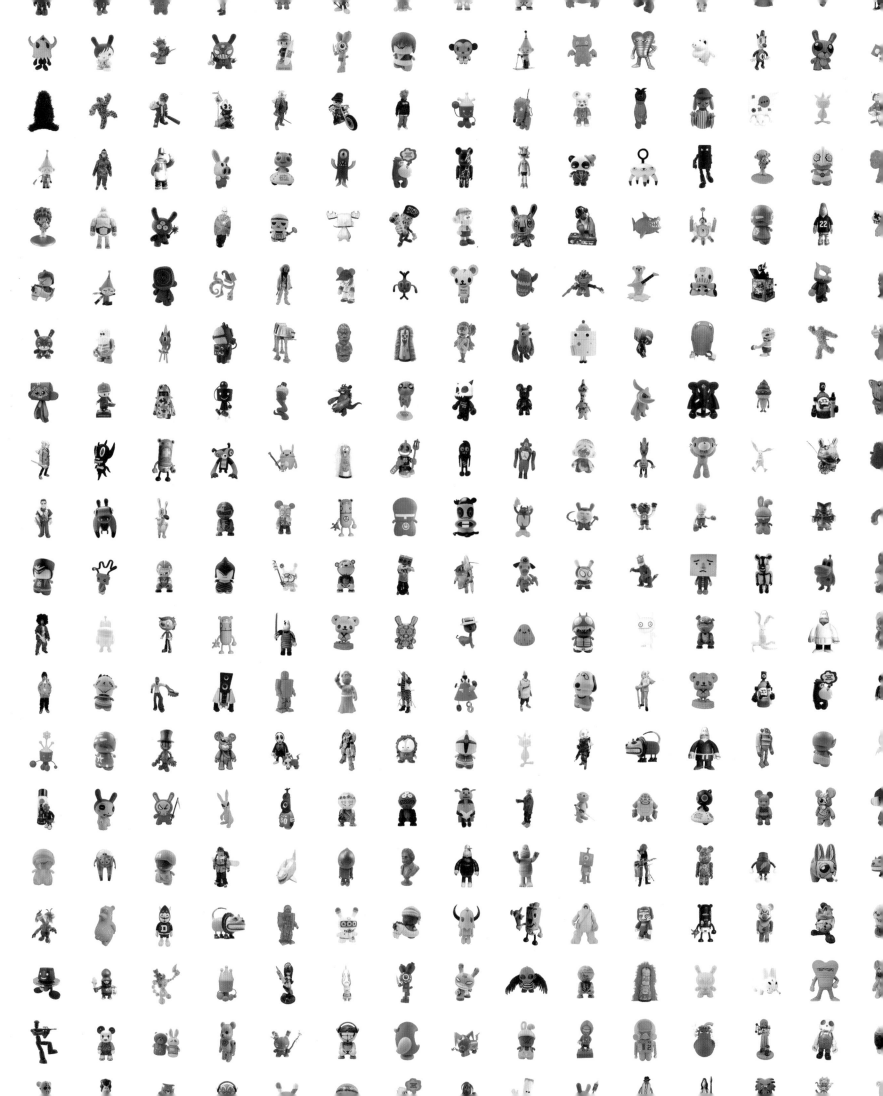

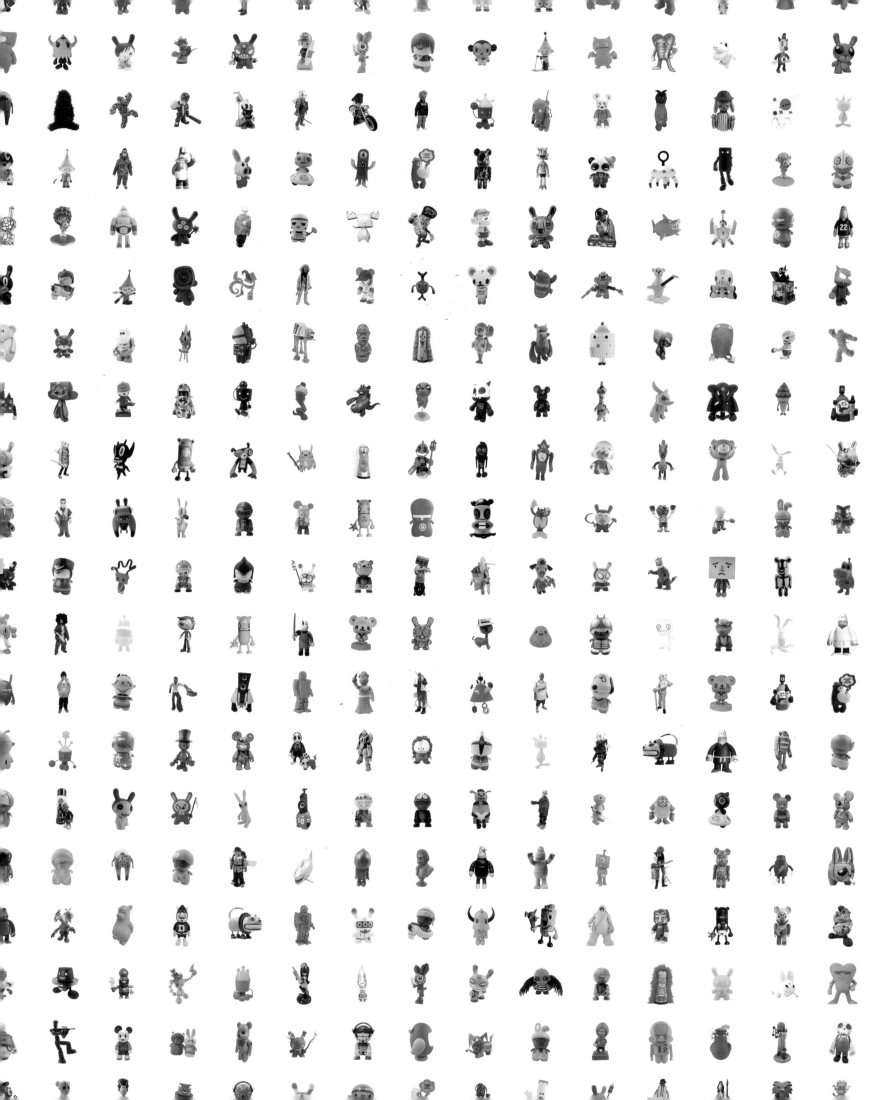